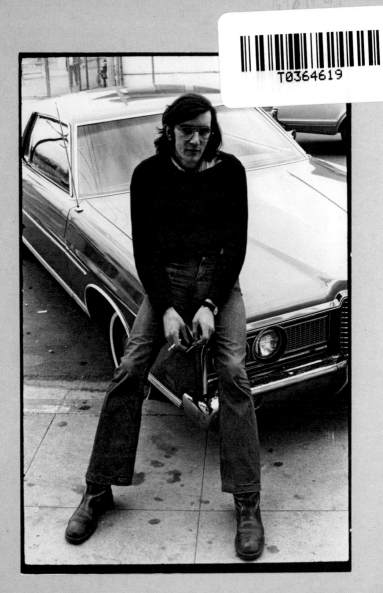

ICH VENICE FEB. 1972

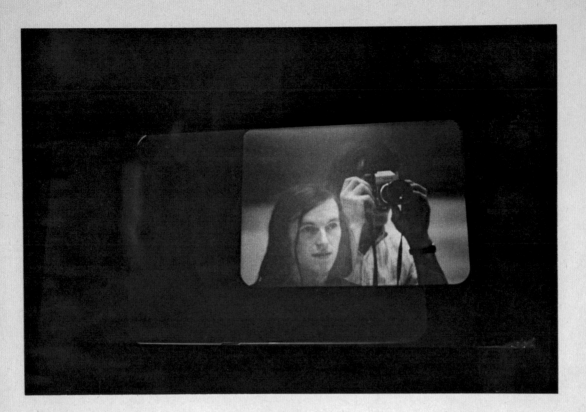

JEAN-FRÉDÉRIC ICH 70/71
 DAVOS

2 **Film sequence with Jean-Frédéric Schnyder and Balthasar Burkhard, Davos, 1970/71**

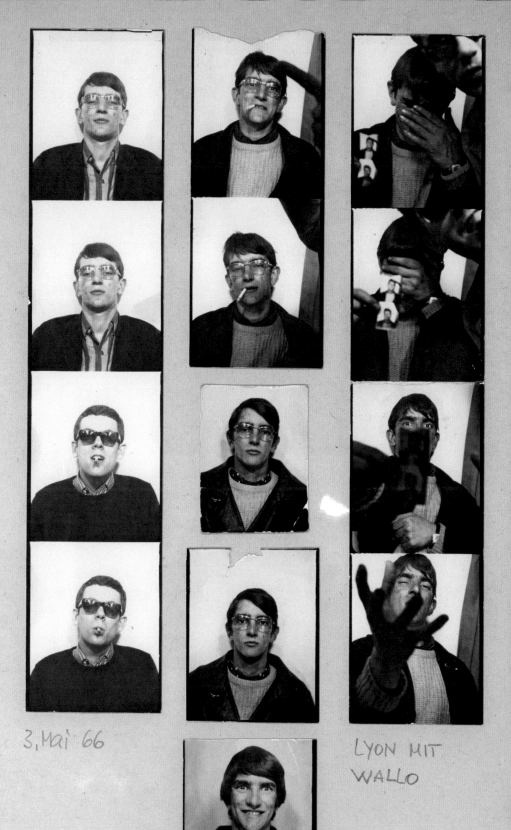

3, Mai '66

LYON MIT
WALLO

Photo booth portraits of Balthasar Burkhard and Walo von Fellenberg, Lyons, 1966

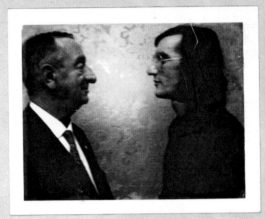

Self-portraits with Balthasar's father, Markus Burkhard, ca. 1970

Balthasar Burkhard, 1944, Fotograf
Junkerngasse 25, Bern (031) 22'07'16

Balthasar, as pictured in publications on the Swiss art scene, ca. 1970

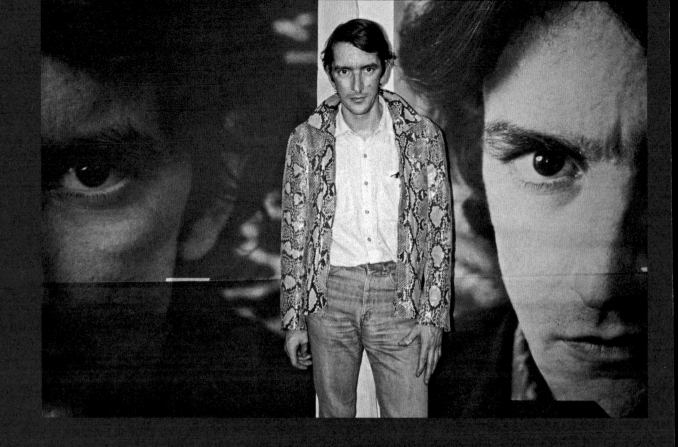

⬆ **Making the *Snakeskin Box*, Chicago, 1976** ⬆ **In his New York apartment, 1970s**

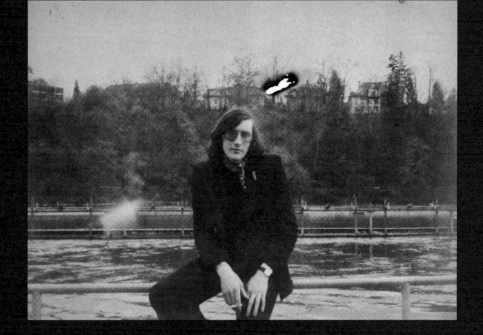

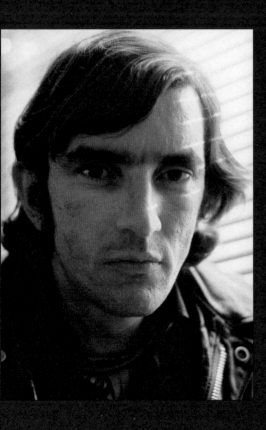

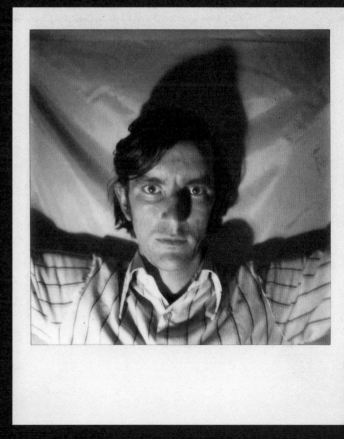

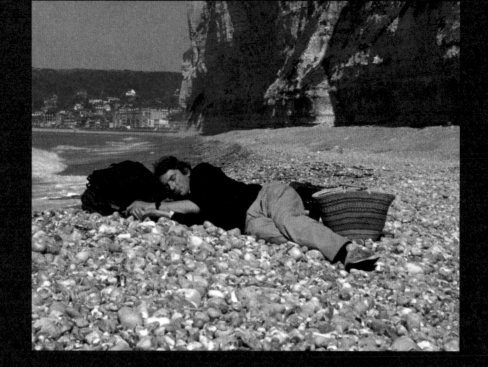

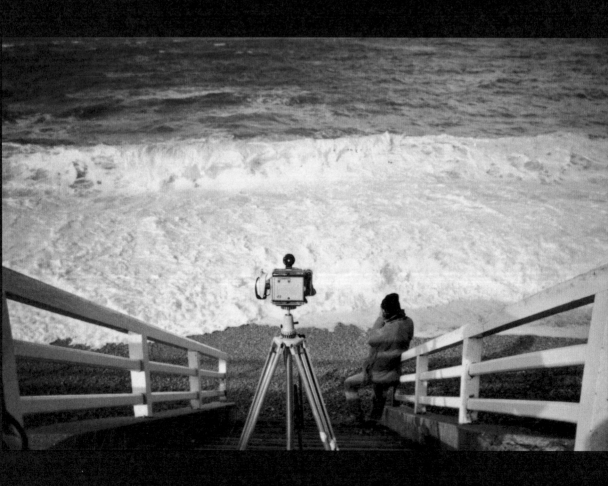

↑ **In Bern, 1990s** ↑ **Taking pictures for** *"Click!" Said the Camera*, **1995**
▲ **Vida and Balthasar Burkhard in Chicago, 2004**

9

Balthasar Burkhard

Museum Folkwang Fotomuseum Winterthur / Museo d'arte della Steidl
 Fotostiftung Schweiz Svizzera italiana

Foreword

Balthasar Burkhard (1944–2010) created a body of work whose development reflects the artistic liberation of photography in the latter part of the twentieth century. In this period, when visual artists without any professional background in photography were beginning to use the medium in an original way, Burkhard went in the opposite direction. He served an apprenticeship under Kurt Blum, one of the leading Swiss photographers of the postwar decades, and was also inspired by an early, enduring enthusiasm for the work of Jakob Tuggener. He turned this exposure to two generations of documentary photography into something completely new. From his first innovative photographs in the late 1960s through to his late work, the traditions of classical photography continued to exert a constant influence behind all the vibrant resonance of the new conceptual art.

Now, for the first time, an exhibition and publication are devoted to the entire artistic career of this quiet, sensitive, and exceptional talent. By revealing the breadth of Burkhard's creative output, this exhibition not only expands our understanding of the work that is already known but also at long last clearly illustrates its crucial significance in the international context. The exhibition and accompanying catalogue will thus fill a large gap, as the career of this important photographer and artist is now presented to a German and Italian audience and to the English-speaking world. Those already conversant with his work on the Swiss and French scene can now also discover a different Balthasar Burkhard.

This project was made possible by the dedicated collaboration of a wide variety of people. We are indebted first and foremost to Vida Burkhard. She has supported, encouraged, and enriched our project right from the start. We are also grateful to all those who have lent exhibits, both museums and private collectors. They have generously agreed to part with their works, some of them fragile, for the duration of the exhibition.

Our thanks are also due to all the authors and the many close associates of Balthasar Burkhard who have contributed texts to this catalogue, illuminated our research into the life and work of the artist, and offered their advice and support in making the exhibition a success: Adrian Scheidegger, René Wochner, Christina Gartner-Koberling, Markus Raetz, Hans Peter Litscher, Ralph Gentner, Violette Pini, Thomas and Elenor Kovachevich, Jacques Caumont, Jennifer Gough Cooper, Hendel Teicher, and Ingeborg Lüscher.

Just as importantly, we wish to sincerely thank the curators of the exhibition, Florian Ebner, Martin Gasser, and Thomas Seelig. The management of the project, the exhibition installation, and the production of the catalogue were undertaken by staff in the Department of Photography at the Museum Folkwang, a team comprising Petra Steinhardt, Christina Buschmann, Annegret Küppers, and the young curators Stefanie Unternährer, Katharina Zimmermann, and Svenja Paulsen, who carried out intensive research and skillfully organized this major undertaking. Our heartfelt thanks to all of them for their unstinting efforts.

Finally, we would like to say a big thank you to our sponsors Pro Helvetia, Schweizer Kulturstiftung for their generous support of this unusual inter-institutional cooperation, and to E.ON SE, who steadfastly put their trust in the collaboration and provided backing for the exhibition in Essen. We also thank the many long-term supporters of the Fotomuseum and Fotostiftung in Winterthur as well as Crédit Suisse, partner of the Museo d'arte della Svizzera italiana, for the presentation in Lugano.

Tobia Bezzola, Museum Folkwang
Peter Pfrunder, Fotostiftung Schweiz
Thomas Seelig, Fotomuseum Winterthur
Marco Franciolli, Museo d'arte della Svizzera italiana

Apprenticeship and Early Works

During his apprenticeship with Kurt Blum, one of the best-known Swiss photographers at the time, Balthasar Burkhard produces his first independent photographic projects. His photographs on Bristol board are reminiscent of book maquettes and are inspired by the photo books and humanistic photography of the postwar period, while his early portraits depict the way of life of the young generation in the late 1960s.

Schulreise, 1952 – Pictures by Balthasar Burkhard, aged 8

15

Haus Distelzwang, ca. 1963 – Architecture assignment for the young apprentice

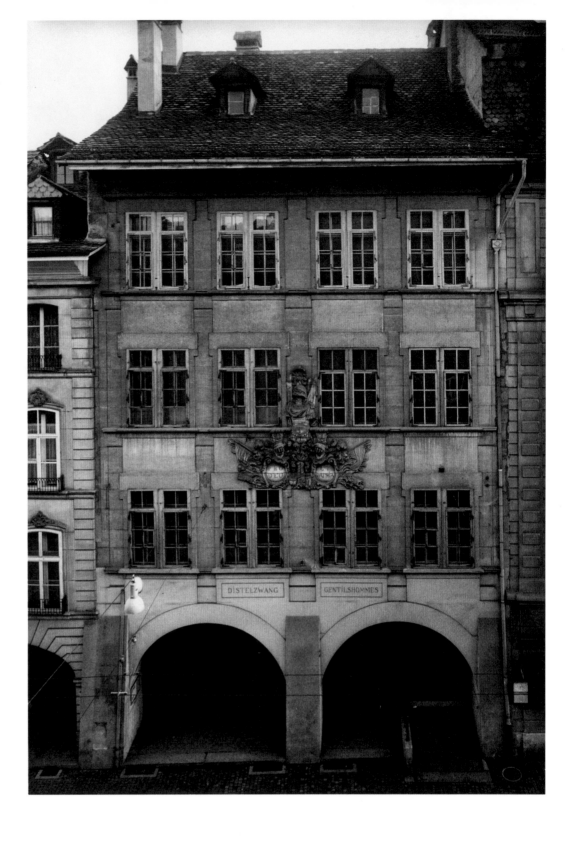

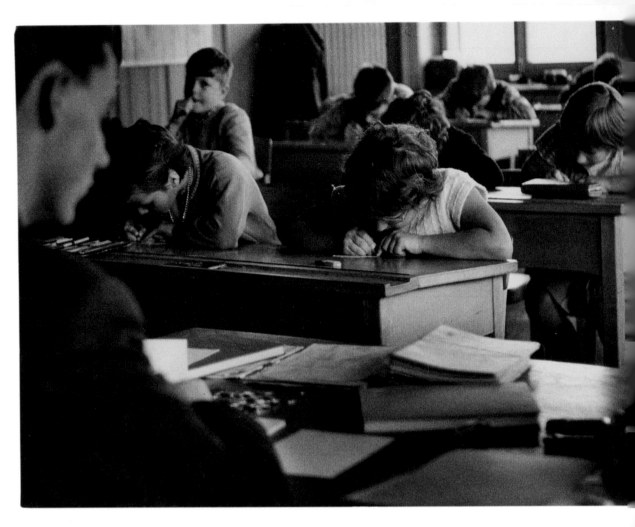

18 *Das Klassenzimmer,* 1962 – **A sequence of images as a leporello**

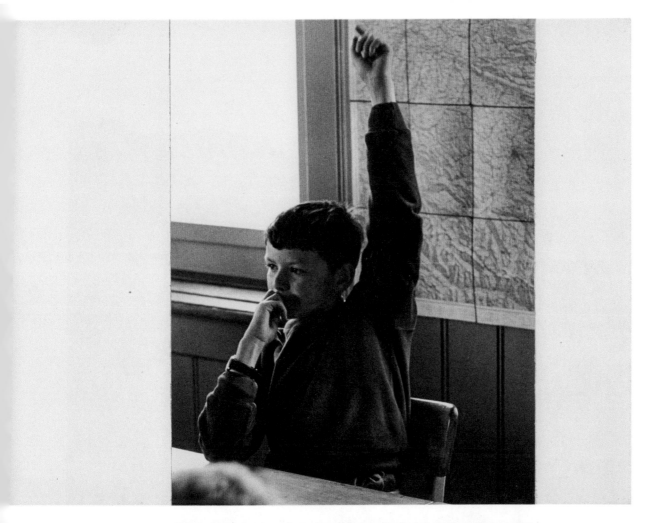

➤➤ **Pages 20–23:** *Die Alp,* 1963 – **Draft layout for a book**

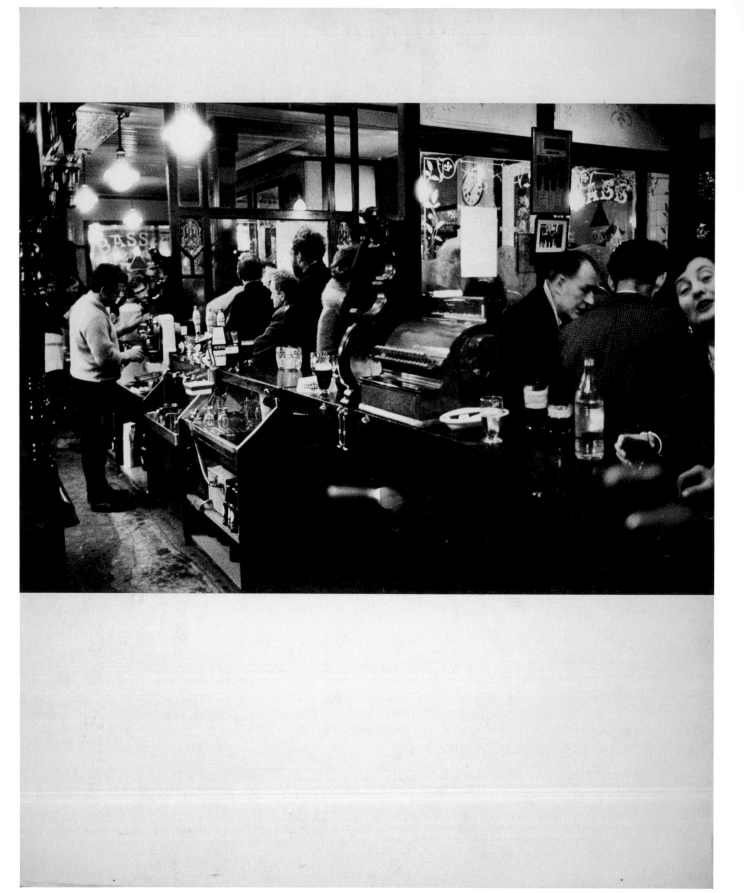

▸▸ **Pages 24–27:** *London Bar,* 1964/65 – **Draft layout for a book**

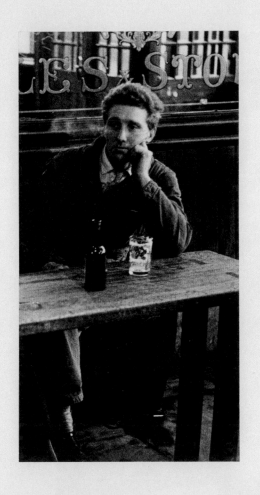

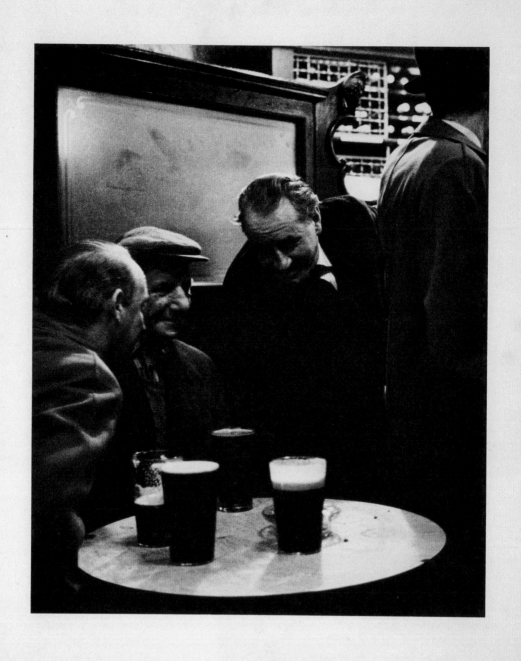

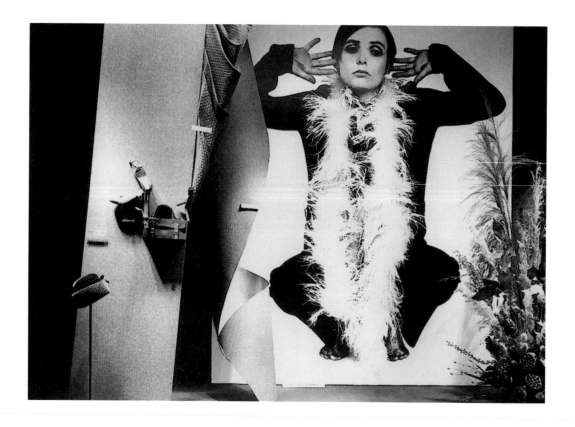

28 ⬆ **Esther Altorfer, Bernese artist, ca. 1967** ⬥ **Window installation in the Loeb department store, Bern, 1967**

Objekt MR –
Ende 60-er
"Esther"

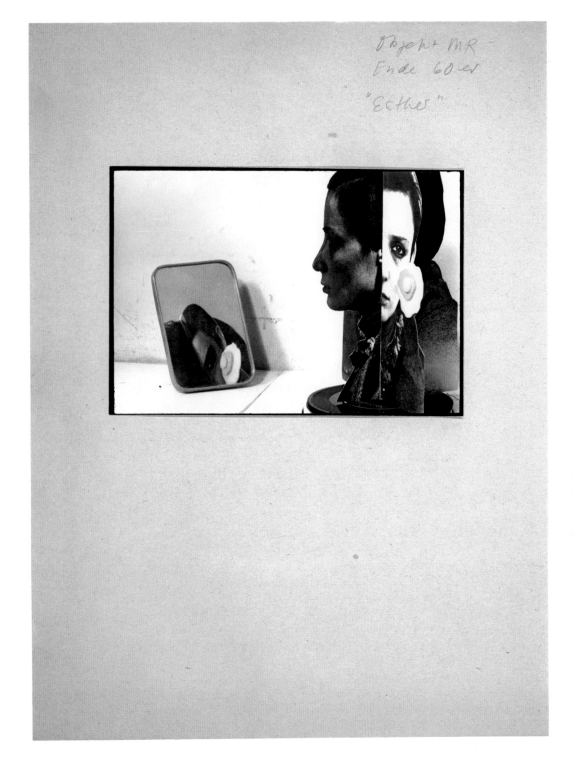

30 **Esther Altorfer, photo by Balthasar Burkhard …**

… and a graphic interpretation by Markus Raetz, ca. 1967

Martin Gasser

Balthasar Burkhard – Photographer

It is commonly assumed that Balthasar Burkhard's artistic career begins with the landscape pictures he took in the winter of 1969/70. These photos featured prominently in an issue of *Camera* magazine published the following year by Bucher in Lucerne. But Burkhard the artist did not simply come out of thin air, as the cover of the magazine seems to suggest (p. 93).[1] Even if Matthias Haldemann's text in a catalogue on Burkhard asserts that his oeuvre is essentially outside the purview of photographic history,[2] it was nonetheless created in the context of this history and helped shape the development of photography in Switzerland from the 1970s on.[3] Burkhard always admitted to his photographic roots and saw himself first and foremost as a photographer and only secondarily as an artist. Or, as Harald Szeemann neatly put it, "Balthasar was and is a photographer."[4]

Lecture
"Since my first encounter with photography—in other words since I was snapped in my second year at school by a professional school photographer together with my friends from class—I have been fascinated by the technology, which sometimes *really* captures reality, and I inevitably made various attempts to emulate the school photographer. In the same year—twenty-four years ago—my father gave me a simple camera to take on a school excursion with the well-intentioned admonition that wherever possible I should not let telephone poles dominate the frame. The result was that I took snaps of landscapes."

In 1976, as visiting lecturer at the University of Illinois in Chicago, Burkhard gave a slideshow presenting himself and his photographic work.[5] In it he spoke of these first baby steps in photography. As an illustration he showed two of the "telegraph pole photos" (p. 15) that had come out of this field trip, commenting, "It was impossible to completely get rid of the poles." But they no longer bothered him: "Quite the contrary, they divide the space, and the wires convey the impression of space and perspective. There is nothing banal or dreary about the

repetition of a vertical pole all the way to the horizon and the idea that the wire carries information and connectivity. It's something I find fascinating."[6]

Although Balthasar—or Balz, the standard Bernese abbreviation of the name, which he liked to refer to himself as—evidently kept taking pictures during his time at school, his photographic activities certainly did not culminate in the desire to become a photographer. On the contrary, as his school days drew to a close, he seems to have been completely clueless about his choice of profession. In any case, a graphologist was tasked with making an assessment to help advise him on a career. In the report, the thirteen-year-old was considered not only to be hard-working, patient, and tenacious but also to have a distinct "talent for drawing" and "good spatial sense." According to the assessment, "the boy's strengths lie in his ability to observe and the faithful, uncomplicated rendering of what he perceives; his powers of imagination are less well developed." The profession that the consultant ultimately recommended for Balz was that of "a solid draftsman, a capable teacher, or a conscientious, level-headed civil servant [...] in a mid- to high-level position."[7] Balthasar's father, himself a high-ranking civil servant and director of the Swiss civil aviation agency,[8] interpreted his son's abilities rather differently and sent him off—perhaps based on his own interest in photography—to do an apprenticeship in this field. In his Chicago lecture Burkhard gave the following account: "In 1961, acting on my father's advice and without any particular preconceptions or goals, I embarked on an apprenticeship with Kurt Blum, a photographer with a good reputation in Bern. He belonged to the generation of pioneers of modern Swiss photography, along with people like Tuggener, Bischof, Senn, and Schuh."[9]

Apprenticeship
As Burkhard senior would have said to himself, if you're going to train in photography, you might as well learn from the best. Blum was a federally certified photographer, a member of the Swiss Werkbund (SWB), and was considered one of the most eminent photographers in the country at the time. Together with Jakob Tuggener, Werner Bischof, Paul Senn, and Gotthard Schuh, he was a member of the Kollegium Schweizerischer Photographen (College of Swiss Photographers), which had been formed in around 1950 to give fresh impetus to Swiss photography following the lead of various postwar movements such as Subjective Photography, which had been established in Germany by Otto Steinert.[10] The aim of the college was to

posit an independent, more artistic stance as a counterweight to the pragmatic and journalistic nature of the "applied" photography established in Switzerland. Blum only joined the group as a successor to Paul Senn, a native of Bern, who died in 1953. Another latecomer to the group was Robert Frank, whom Gotthard Schuh had persuaded to participate in their joint, widely acclaimed exhibition in Zurich *Photographie als Ausdruck* (Photography as Expression).[11]

Kurt Blum was put in the public spotlight in 1951 when he won first prize in an international competition run by *Camera* magazine,[12] which at the time was managed by Walter Läubli. His submission included shots from artists' studios in Bern, such as that of sculptor Max Linck, or from the painting school of Max von Mühlenen (fig. A). On the basis of this early accolade, some of his pictures—among them the extraordinary *Studie* (Study; ca. 1948; fig. B)—were included in the first exhibition of Subjective Photography in Saarbrücken in 1951. Blum's pronounced interest in modern art had not only played a crucial role in shaping his visual language but also led to a long-term collaboration with Arnold Rüdlinger, the former director of the Kunsthalle Bern.[13] Blum created untold numbers of artist portraits, studio reportages, and exhibition documentation for Rüdlinger and Franz Meyer, who succeeded him in 1955. Armed with his camera, he also attended boisterous artist parties and lively gatherings at the Café du Commerce. This bistro, located directly opposite Blum's studio in Bern's Gerechtigkeitsgasse, one of the main streets in the old city, was a favorite meeting place for the art crowd: Blum—and often his apprentices too—liked to eat lunch there with artists or curators.[14] Almost incidentally Blum also did ordinary photographic jobs, ranging from portraits to product pictures, and regularly published his work in the family magazine *Sie und Er*. In February 1956, for example, he did a kind of "insider" story on Harald Szeemann, who was still causing a stir at Bern's Kellertheater with his one-man cabaret.[15]

From the latter part of 1958 onward, after a hiatus of one and a half years when he worked as the UNESCO expert on photography and film in Pakistan, Blum's time was taken up by a whole range of large-scale projects: he took photographs and designed books on the city of Genoa, the Cornigliano steelworks, the operas playing at Europe's major venues, and the town of Morat near Bern. He also started working for Swissair and founded his own studio producing industrial films and commercials. This led on to a trip to the USA in January 1962 with Arnold Rüdlinger, who was by then director of the Kunsthalle Basel and had made a name for himself as a pioneer of new American painting in Europe. Artist Rolf Iseli was one of the party and together they visited Mark Rothko, Barnett Newman, Willem de Kooning, Al Held, and Jim Dine. Blum also met Robert Frank in his loft on Third Avenue near the Bowery. To mark the occasion of Frank's exhibition at the Museum of Modern Art, an entire issue of the prestigious culture magazine *Du* had been recently devoted to him.[16]

Thus, when Balthasar's father sought out an apprenticeship for his son in early 1961, Blum had more than enough to occupy him. A young woman, Regula Altherr, was already apprenticed to him and was helping him to deal with incoming work. Burkard was therefore obliged to start his training at another location—as a "mere" lab technician in the photographic business of a certain Ernst Christener.[17] He started there in April 1961 and stayed for a little over a year, learning the basics of lab techniques before eventually going on to join Blum.[18] His new master soon allowed him to carry out lab work on his own: developing films, producing contact prints and sticking them on sheets of card, keeping the archive in order and up to date—and, most importantly, making enlargements. Blum had very high standards in this area and the enlargements often had to be redone several times before they met his expectations. Communicating more via the work on his photos than through verbal explanations, Blum imparted a feeling for image composition, gray tones, and contrast—he was a master in this. Above all, Blum's students—as his first apprentice, Fritz Mäder, recalls—learned how to look and how to deal with ambient light.

One of Blum's special areas of expertise was big enlargements, and none of the apprentices graduated to that. It demanded skill and finesse to develop and fix the meter-wide lengths of photographic paper in a rolling movement in the "coffins," the baths that Blum had designed himself. Architectural photography was also an important thematic area, and the rather stiff photographic documentation of the historical offices of the Distelzwang guild, which were also located on Gerechtigkeitsgasse, may be evidence of Burkhard's first steps in this field (pp. 16–17). His work also included assisting on film shoots, where Fritz Mäder often acted as cameraman. Balthasar would likely have been particularly impressed by the shots taken for the film commissioned by the Von Roll steelworks (in Solothurn) for the Swiss national exhibition of 1964, Expo64: an experimental color film in CinemaScope, which involved three separate but mutually complementary elements being simultaneously projected onto three large screens.[19] Almost forty years later, long after

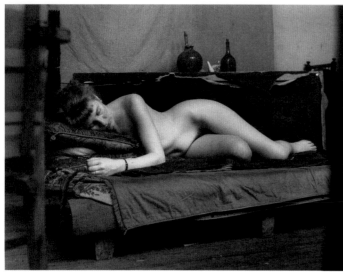

A

B

C

D

A Kurt Blum, reclining nude in the
 Mühlenen painting school, 1948
B Kurt Blum, Study, 1948
C *Ein Dorf wohl, ein rotes Dorf,*
 double-page spread from a
 portrait of Urs Dickerhof in book
 form, 1962
D Installation of the exhibition
 Jean Dewasne, Kunsthalle Bern,
 1966

Balthasar had achieved his "big breakthrough," his former teacher wrote to him to say that he had noticed his talent early on and that "I am rather proud that I may perhaps have 'modeled' the proper path for you in your youth."[20]

Own Works
The two earliest independent works by Balthasar Burkard that have been preserved in their original form date from the latter part of 1962, in the period shortly before his apprenticeship with Blum began. They were probably intended as samples for his future teacher, to demonstrate his technical abilities in the lab and also to show that he was already a photographer to be reckoned with. One is a ring-bound series of portraits of the artist Urs Dickerhof entitled *Ein Dorf wohl, ein rotes Dorf* (Indeed a Village, a Red Village; fig. C) and the other is the *Klassenzimmer* (Classroom; pp. 18–19) leporello—both contain a text by the writer Peter J. Betts.[21] Burkhard's artist portrait is, of course, a direct reference to Blum's activities on the art scene and his *Klassenzimmer* also relates to a theme that Blum was thoroughly conversant with. But it is, above all, the layout of the works, which resemble book maquettes, and the wide variety of formats, which are strongly reminiscent of the "Eintritt frei" (Admission Free) series of books, for which Blum produced a volume on opera during this period.[22]

A third work was produced a year later: a series of pictures about life on an alp—a quintessential Swiss theme, which Blum had suggested to Balz, who he thought was giving himself rather too many airs as an "artist" (pp. 20–23). Regula Altherr recalls that Balthasar revered his teacher and was in awe of his proximity to the art scene. This tempted him into imitating his nonchalant style. Balthasar later told the students in Chicago, "The alp where these pictures were taken is inhospitable, the hills are tedious and block the horizon, the mist is often thick, and the farmers are slow and forbearing. They are afraid of nothing, not even when faced with a camera. My family comes from this area. It stimulated me and prompted me to do my first independent work."[23]

Burkhard's photographs, organized in a kind of book layout on eight large-format pieces of card, do indeed reflect something of the inhospitableness and almost mystical atmosphere of an alp in the hills of the Napf region, which to this day still exudes this original character. Working with his teacher, Balz would have fine-tuned the prints and presentation until late 1963, when he applied with this work for a federal grant for applied art, which he promptly won.[24] For the editor of the *Schweizerische Photorundschau*, Jacques D. Rouiller, who produced a detailed commentary at the time on the grant competitions, Burkhard's alp represented the classical "*Life*-style"—as it was still practiced, for example, in the illustrated weekly *Die Woche*—in contrast to René Mächler's color abstractions or Roland Schneider's alienated industrial landscapes, which would "conjure up new realities" with a whole new visual language.[25]

This initial success must have encouraged Burkhard to try his luck as a freelance photographer after his final apprenticeship examination in April 1964.[26] But first of all he went on a trip to England and returned with a photo story on London pubs (pp. 24–27). The presentation of this work resembles his work on the alp, and the dark, atmospheric pictures of drinking men, their faces, gestures, and the details of the bars are reminiscent of Blum's bleak but lively shots from the Café du Commerce.[27] The work seems never to have been published, not even when Balthasar subsequently attempted to follow up on it and offered the magazine *Du* a photo story on London focusing on young artists, beat musicians, fashion, and the faces of anonymous people on the street.[28] The idea of doing a whole series of reports on the theater scene in Europe for *Sie und Er* also evidently failed to generate interest.[29] The same fate befell another project that he proposed in June 1969 to the *Schweizer Illustrierte* for the national holiday on August 1: a photo report on the most important battlefields in Switzerland. He wrote, "In order to make the story more interesting for readers, you could possibly intersperse shots of tin soldier battle scenes […] to show that a battlefield now lives to a large extent only from the power of historical imagination and that it is now often presented only as a field, which in some cases may even be built on."[30] The idea that the heritage or monument protection agencies might lend financial support did not have the desired outcome, and it is understandable that this undertaking, which looked more like an art project than a conventional magazine story, did not get off the ground. Nevertheless, Balthasar's ideas reflect his increasing concern with the problem of how to perceive reality and represent it—an interest that had probably been ignited to a degree by the artist Markus Raetz, whom Burkhard had met around 1963/64 and who was to become one of his most important artist friends.[31]

Art Scene
Burkhard would not have been unduly distressed by the fact that his efforts to place photo stories in magazines did not meet with any success. His work—at least some of it certainly paid—for Harald Szeemann, who had been director of the

Kunsthalle Bern since 1961, had in any case become far more important for him.[32] Blum had clearly moved away from the artistic milieu—the avant-garde trends that Szeemann represented weren't his thing. He only worked there very occasionally in collaboration with Balz—in 1966, for example, for the installation of the exhibition showcasing the work of the French artist Jean Dewasne (fig. D).[33] Burkhard's first cooperation with an artist took place that same year: an artist's book instigated by Urs Dickerhof about the tiny village of Curogna in Ticino. Burkhard helped with the design and contributed three pictures of the overgrown ruins of houses (fig. E).[34] From 1968 on, he was also regularly called in by the architects' group Atelier 5 to document their buildings, which led him to engage in an important critical examination of architecture. As he explained in his lecture in Chicago, he was able in the process to learn a great deal that contributed to his own personal work.[35] In this period he also worked with Markus Raetz to design a display window for the Loeb department store near the station in Bern with large-format portraits, or rather fashion shots, of the Bern artist Esther Altorfer. This commission was probably procured via Raetz's girlfriend Monika, who ran a fashion studio and had also worked for Altorfer as a model.[36] The pictures represent Burkhard's first real collaboration with Raetz. His girlfriend obtained make-up and accoutrements for the model; Balz was responsible for the photos and Raetz took care of the postproduction work on the photographs (p. 28).[37] Without going into detail about the contextual background of the display window, Burkhard recounted the episode in Chicago as follows: "I passed Rätz [sic] a photo of one of our female friends. She did […] good drawings. She is now in a place we may also end up in tomorrow—the asylum. At the time she was the most beautiful girl in Bern. Rätz altered the photo."[38]

Burkhard elaborated on the subject of friends in the lecture: "My first friends after my apprenticeship were painters. They had given up their careers in the early 1960s to dedicate themselves entirely to their search for new possibilities of artistic expression. The stars were favorable. Art and entertainment had formed an excellent alliance since the war. We conducted our experiments, listening to the Beatles and the Rolling Stones. Harald Szeemann's exhibition at the Kunsthalle Bern was the first in Europe to show the American art of these years and the work of European artists, which only later became known under the rubric 'individual mythologists.' At the time I was the chronicler of the Bern art scene. My involvement extended to my friends and artists whose work meant something to me" (fig. F).[39] Aside from Szeemann and Raetz, one of the most important people for Balz was Jean-Frédéric Schnyder, who was also a trained photographer. Schnyder was initially fêted as a rising star and honored with membership of the Swiss Werkbund, but he subsequently rebelled against the established professional photographers and eventually made his mark in Szeemann's circle as a conceptual artist.[40] Wherever Szeemann appeared, Balthasar was there too with his camera; through him he had access to artists, studios, and big events like documenta in Kassel and the Venice Biennale. He got completely enraptured by the burgeoning avant-garde movement, on which the charismatic Bern curator had a considerable influence. In retrospect, Szeemann credited his "court photographer"—despite a certain distance and detachment in his point of view—with a maximum of feeling for atmosphere and an unerring eye for the right detail.[41]

photo actuelle suisse
The optimistic mood of the 1960s prevailed not only in the art world but also in the Swiss photo scene. Young talents made their mark—Rolf Schroeter, for example, who had trained at the Ulm School of Design and caused a stir with his *Wahrnehmung einer Brücke* (Sense of a Bridge), a photographic work reduced to moving patches of light, or Roland Schneider, who studied under Otto Steinert at the Folkwang Academy in Essen before making headlines with his expressive industrial landscapes. Many of them were awarded federal grants for applied art, mostly associated with an exhibition at the Gewerbemuseum Bern and publication in the *Schweizerische Photorundschau*. In 1966, under the aegis of the American Allan Porter, *Camera* magazine started presenting the portfolios of young Swiss artists along with new photography from the USA—Porter naturally included Robert Frank among their ranks. And, just as important, a gallery scene gradually emerged that was interested in new photography, above all in Zurich, where Galerie Form played a pioneering role in this respect. In Bern, Galerie Aktuell made a name for itself in 1967 with the world's first exhibition of concrete photography. Founded by Christoph Megert, the gallery showed works by Roger Humbert, René Mächler, Rolf Schroeter, and Jean-Frédéric Schnyder. They all drew on concrete art in order to question—as was very much in vogue at the time—the relationship between reality and image and at the same time reclaim photography as an autonomous artistic medium.[42]

Balthasar Burkhard was also part of this young photographers' scene, which first came to the public's attention in May 1969 with the

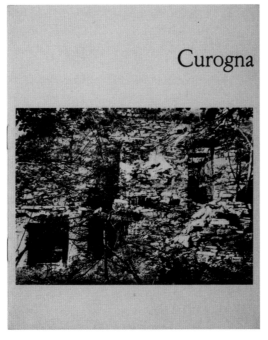

E

F

G

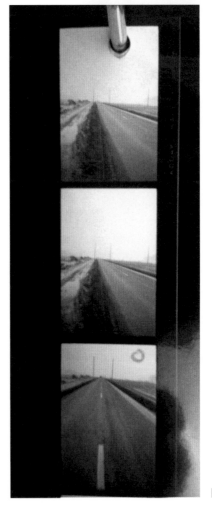

E *Curogna*, announcement
 for the artist's book, edited by
 Urs Dickerhof, Bern, 1966
F The Beatles on TV, undated
G *Creative Photography*, installation
 shot of the exhibition at Galerie
 Impact, Lausanne, 1970
H Detail from a contact print,
 1969/70

H

exhibition *photo actuelle suisse* at the Musée de la Majorie in Sion. It was one of the first photo exhibitions to be staged in a Swiss art museum, and it brought together the latest works by "ten of the best contemporary Swiss photographers": Balz Burkhard, Rosmarie Hausherr, Marcel Imsand, René Mächler, Allan Porter, Jacques Rouiller, Helen Sager, Hans R. Schläpfer, Roland Schneider, and Rolf Schroeter.[43] We can no longer be sure who it was exactly that instigated the exhibition. Allan Porter probably figured in the background, and no doubt Rouiller, who presented the show the following year at the Galerie Impact in Lausanne (fig. G).[44] Under the new characteristically English title *Creative Photography*, the press gave the exhibition far more coverage than it had had the year before in Sion. It received consistently good reviews and was described as a paragon of new trends in photography, trends which, as was stated somewhat grudgingly, were evidently much more advanced in the German-speaking part of Switzerland than in the west of the country.

Burkhard was represented in this exhibition on current Swiss photography with the landscape pictures that he had made with Markus Raetz in the winter of 1968/69. As was often the case at the time, they had gone off together to find motifs, on this occasion in the Bernese Seeland in the area around Schüpfen. There they came upon a series of earth mounds of equal size at the edge of a field half covered in snow. These were reminiscent of the earthworks that were now beginning to appear in contemporary art. Raetz, who also had a camera with him, was interested above all in the different perspectives that were produced by different camera angles.[45] As is evident from Burkhard's contact prints, there were also pictures of the country road leading into the distance that are strongly evocative of *U.S. 285, New Mexico* in Robert Frank's *The Americans* (fig. H). Burkhard would have known the image; indeed this was the first photo book that he had bought for himself as an apprentice.[46] Among the many variants of views of earth mounds and furrows, above all portrait or landscape formats with a deep horizon, two completely different pictures stand out on the contact prints: a view looking up toward the sky in which a small plane can be made out, and one directed diagonally downward to the soil, whose high horizon line is lost in the mist. Interestingly, it was these two shots that were immediately used for practical purposes: *Himmel* (Heaven), as Burkhard later titled the image, as an invitation to an exhibition of Markus Raetz's work (fig. J),[47] and *Erde* (Earth) as a background motif for the exhibition poster for *When Attitudes Become Form* (p. 101)

and for the object *Live in Your Head*, which Burkhard, Schnyder, Raetz, and Szeemann—the only four Swiss to take part in the exhibition—signed together (p. 100).[48] There is no sense of any scale in the pictures: *Erde* looks like a kind of aerial photograph and seems to anticipate the urban images that Burkhard later produced, which were taken at a flat angle and had almost no horizon.[49]

One critic, who reviewed the exhibition *Creative Photography* in the *Gazette de Lausanne*, was fascinated by Burkhard's mysterious blue-tinted shots of the sky and compared them with Japanese painting.[50] By contrast, Jacques Monnier, writing in *Feuille d'avis de Lausanne*, interpreted the landscapes—which are framed in brown—in the context of historical photography and arte povera: "This exposure is meant to take effect in the developing bath: we find Balz Burkhard's investigations satisfying in this respect. Adept, in his way, in 'arte povera' and feigning an economy of means, the artist allies himself with the photographs of the nineteenth century and works in delicate tones. Better still, he takes care to frame his photographic documents with a thin line in the old style. Staged like old-fashioned exposures, his plates record the vast, dreary toils of the fall, a limitless sky highlighted by the ludicrous little cross of an airplane at great altitude. They describe nothing, illustrate nothing, speak of nothing, yet they particularize the void."[51] In his review of the exhibition in *Schweizerische Photorundschau* Jacques Rouiller only briefly addressed these landscapes, but wrote in detail about the most recent works that Burkhard had produced in cooperation with Markus Raetz: the large-format photos on canvas, which had attracted attention shortly beforehand in the exhibition *Visualisierte Denkprozesse* (Visualized Thought Processes), curated by Jean-Christophe Ammann (pp. 106–10).[52] With a view to giving his readers an impression of the exhibition, Rouiller published at least two of the works that were not on display in Lausanne, *Bett* (Bed) and *Atelier* (Studio) from 1969/70.[53] The critic at the *Gazette de Lausanne* discussed these "trompe l'oeil images on canvas" that lead human perception *ad absurdum*, and concluded his review with the following words: "Following the path of irony, Burkhard looks to us like the Beckett of photography."[54]

Actually, the "Beckett of photography" would also have happily shown his own pictures at the exhibition in Lucerne in addition to these photo canvases—specifically, the images from the project—"The First Hundred Days of the Seventies"—that Burkhard and Raetz had started together and which the photographer Pablo Stähli, who went on to become a gallerist,

subsequently joined. As Raetz explained in a letter to Jean-Christophe Ammann published in the catalogue, the idea was to produce a picture every day, which would be shown more or less immediately in the exhibition, so that visitors could photocopy it then and there and take it home with them.[55] A letter from Burkhard to Ammann—which was also intended as a contribution to the catalogue and was accompanied by a selection of photographs—should be seen in this context as well (p. 104). Burkhard writes to the curator, "Here are some photos that I took this morning—Bern is misty and monotone—over the course of about an hour. Without making any special selection, I am sending you the images that I think are worth airing. Any ordinary routine thing is worth airing. If I meet Iseli, for example, or Eggetschwiler [sic]. Or if the lift cabin on the platform catches my eye." He envisaged that Ammann would be inspired by these banal pictures to take his own photos. And he hoped that exhibition-goers would also have a camera at their disposal in order to enter into a kind of photographic dialogue with him by means of their own pictures: "I am interested in every photograph; no image leaves me indifferent: your photo, the picture in the magazine, or the image on TV."[56] However, Ammann, who had very clear ideas about his exhibition, seems to have ignored Balthasar's proposal.[57]

Camera
Although Balthasar Burkhard's landscapes from 1969 attracted considerable interest in the exhibitions in Sion and Lausanne, his breakthrough as an independent photographer, as indicated above, only came with the publication of these images—all of them only under his own name—in the May 1971 issue of *Camera* magazine, entitled "Information."[58] Raetz had deliberately refrained from mentioning his co-authorship because perceptions of the canvas images they produced together in Amsterdam were strongly influenced by him as a comparatively established artist.[59] However, Burkhard's reputation was launched not only by this but also by the choice of images and the way the photographs were contextualized in the magazine. The photograph *Himmel* with the circling airplane on the cover, the photo of a landing that took place in 1928 on the Aletsch Glacier (taken from his father's aircraft, p. 97)—and then the landing on an earth (*Erde*) resembling a lunar landscape, where all we can make out are clumps of earth and a few stones, can all certainly be interpreted as the beginning of something new. Porter stages Burkhard as a kind of pilot (like his father)—or even an astronaut (as in the first moon landing, which had recently taken place)[60]—who finds himself in no-man's-land after the landing and

sees his surroundings with new eyes. The impact of the series of pictures may well have had something to do with the fact that they were immediately followed on the cover by a promotion for Konica cameras advertising the capturing of "new visual worlds" with a picture of a supersonic plane "storming the heavens" (fig. K).[61] Burkhard naturally sees with the eye of an artist, as Jean-Christophe Ammann puts it in his accompanying text, an artist who does not reproduce reality in an "expressionist," stylized abstract," or "engaged" fashion but "tries to achieve a matter-of-fact objective view of reality" and thus also helps to give new impetus to photography.[62] In his text on the theme of "information," Allan Porter highlights the proximity of this new photography to contemporary forms of art like land art or conceptual art and concludes with the almost prophetic statement, "And even if all of these exponents of the avant-garde [i.e., Burkhard and the other photographers represented in the magazine] are yet to be mentioned in the books on the history of photography, […] there can be no doubt that their influence will have an impact on photography in due course."[63]

Burkhard later explained to the students in Chicago that the landscape images he produced at the turn of the 1970s actually marked a watershed for him: "These photos confine any statement they make to a minimum. [More] important than the 'interiority' is the formal reduction; the empty space is key. Yet here it is still formal. Markus Raetz prompted me to produce the landscapes. I wanted to omit everything that related to me so that what remains is what really concerns me: I distanced myself from my object. I generated a sense of detachment from myself and from my work."[64] One of the pictures from the series, *Erde*, also found its way into the first overview exhibition on Swiss photography, organized in 1974 by the Stiftung für Photographie at the Kunsthaus Zürich, where it was part of the "Nature" section (fig. L). There was only this one image and it was not even reproduced in the catalogue.[65]

Addendum
A year or so after his teaching stint in Chicago, Burkhard made another trip to the city, although he did not really know why and would actually rather have gone to Los Angeles or New York. Toward the end of 1978, he wrote from there to Allan Porter in Lucerne in the hope that he could get access to the Polaroid large-format camera—the company was based in Cambridge, Massachusetts. He said apologetically, "Sorry I'm asking you to give me this help—because you were the first who published my work how I liked it the most." At the same time he told him

J

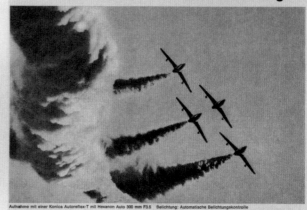

K

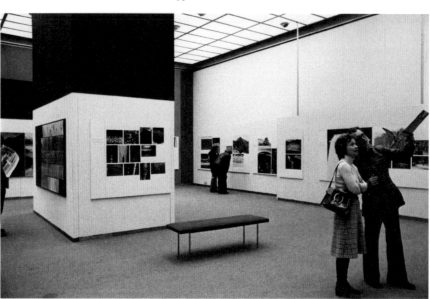

L

J Invitation to an exhibition by
 Markus Raetz, Galerie
 Bischofberger, Zurich, April 1969
K Konica advertisement, *Camera* 5
 (May 1971): 2
L Installation shot from the "Nature"
 section of the exhibition *Photo-
 graphie in der Schweiz von 1840
 bis heute*, Kunsthaus Zürich, 1974

that he was increasingly looking at photo books, that he had indeed discovered the book as a new medium, as it were, and was himself working on a book project.[66] Frank's *The Americans* may have been one of the books that inspired him. Perhaps he even remembered Frank's original Guggenheim project, which he had probably seen for the first time in *Du* or *Camera*.[67] In any event, it seems to have resonated in the background, when Burkhard applied for a Guggenheim Fellowship in this period with a letter of application that we cannot be sure he ever actually sent:

"Dear Ladies & Gentlemen of the Jury: My art has been conveyed through the format of large photo canvas; its content necessitating a one-to-one scale. [...]

I am currently working on a new series; however, I have another project which is pressing me to be completed. Since having traveled across this country, I have felt the need to record the design of our culture. This material is being organized in book form which I have layed-out. This will be a quality book, a perfect book; a pure book that will clearly read the images presented in it.

Granted the tone is and will be somewhat subjective, however, coming from a background as a documenter of art and the art scene of the 60's and the 70's, I feel qualified to take my professional and artistic vision one step further into the 80's and record the environment that is in one way or another affecting our daily life.

I hope you will support the completion of this book.
Sincerely,
Balthasar Burkhard"[68]

Martin Gasser has been curator of the Foto-stiftung Schweiz in Winterthur since 1998. The museum houses an extensive collection of prints, archival prints, and negatives with an emphasis on Swiss photography in the twentieth century. His research has had a particular focus on the development of Balthasar Burkhard's early work in Bern.

FOTO BALZ
GOTT ERHALT'S

1 *Camera* 5 (May 1971).
2 Matthias Haldemann, "Poésie: Zum Werk von Balthasar Burkhard," in *Balthasar Burkhard*, exh. cat., Kunsthaus Zug (Baden, 1994), 55.
3 See, for example, Annemarie Hürlimann, "Fragment Fotografie," in *Kunstszenen heute*, ed. Beat Wyss (Disentis, 1992), 189–93.
4 Harald Szeemann, in *Balthasar Burkhard: Lob des Schattens* (Geneva, 1997), 200. See also the film by Bernhard Giger, "Balthasar Burkhard," DVD 1 in *Photo suisse*, ed. Christian Eggenberger and Lars Müller (Baden, 2004). In her unpublished licentiate thesis on Balthasar Burkhard, Eveline Suter undertakes a detailed discussion of the difficulties involved in perceiving Burkhard as either photographer or artist. Eveline Suter, "Fotografie oder...? Das Werk von Balthasar Burkhard" (Institute of Art History, University of Zurich, 2005).
5 Lecture, Chicago, typescript, German, undated (drafted in collaboration with Walo Fellenberg; held on June 14, 1976), p. 1, and a small poster for the lecture in the course of an exhibition at the Ward Gallery, Archiv Balthasar Burkhard (hereafter Archiv BB). From 1976 (the precise date is unknown) to June 1977, Burkhard had a position as visiting lecturer for photography at the University of Illinois at Chicago Circle, Department of Art, College of Architecture and Art. The application from February 15, 1977 (Archiv BB) for an extension to his contract seems to have been unsuccessful. On his teaching activities in Chicago, see also François Grundbacher, "Vor und hinter der Kamera: Balthasar Burkhard; Ein Fotograf der existentiellen Leere," *Prisma: Das Schweizer Monatsmagazin* 9/10 (September/October 1979): 50–51.
6 Lecture, Chicago, 1976 (see n. 5), 2.
7 J. Pelix, graphological report, February 20, 1959, pp. 2 and 3, Archiv BB.
8 See contract of apprenticeship for commercial vocations, Bern, April 12, 1961, p. 1, Archiv BB.
9 Lecture, Chicago, 1976 (see n. 5), 2.

10 See *Camera* 3 (March 1951): 74–95. Alongside Bischof, Senn, Schuh, and Tuggener, the fifth founding member of the college was the editor of *Camera*, Walter Läubli. Burkhard had an intellectual affinity not only with Blum but also in particular with Tuggener. In February 1972 he invited him to present his film work at a matinee in his apartment in Junkerngasse. See various shots of the occasion on February 26, 1972, which Szeemann and Raetz both attended (see p. 50), as well as the entry with the remark "big success, big audience" in Tuggener's diary (*Lebensbüchlein*), Archiv BB and Jakob Tuggener-Stiftung, Uster.

11 *Photographie als Ausdruck*, exh. cat., Helmhaus Zürich (Zurich, 1955), see *Camera* 3 (March 1955).

12 See *Camera* 2 (February 1951): 38–41.

13 On Rüdlinger, see Bettina von Meyenburg-Campell, *Arnold Rüdlinger: Vision und Leidenschaft eines Kunstvermittlers* (Zurich, 1999).

14 See Sylvie Henguely, "Kurt Blum und die Kunstszene," in *Kurt Blum: Gegenlicht*, ed. Martin Gasser (Zurich, 2012), 163–86.

15 "Läbe i de Bude," *Sie und Er* 5 (February 1956): 15.

16 *Du* (January 1962), published to coincide with the exhibition *Photographs by Harry Callahan and Robert Frank* at the Museum of Modern Art in New York; Blum attended the vernissage.

17 See contract of apprenticeship, 1961 (see n. 8). Burkhard's first master was Ernst Christener, Foto – Kino – Projektion, Marktgass-Passage, Bern: no further details are known about him. The contract ran from April 10, 1961, to April 9, 1964.

18 An addendum, dated November 12, 1962, on the last page of the contract of apprenticeship records Balthasar's transfer to undertake "training as a photographer!" with Blum. Regula Altherr had not yet completed her apprenticeship at that point, so Balthasar worked together with her for a few months. The following remarks are based on email correspondence (August 26, 2016) and conversations (December 19 and 28, 2016) with Mäder and Altherr.

19 See Thilo Koenig, "Kurt Blum in der Fabrik," in *Kurt Blum: Gegenlicht* (see n. 14), 91–92.

20 Letter from Kurt Blum to Balthasar Burkhard, July 8, 2003, Archiv BB.

21 In the early 1960s, Burkhard and Betts belonged to the circle around Urs Dickerhof. The texts *Begegnung mit Urs Dickerhof* (Encounter with Urs Dickerhof; dated August 26, 1962) and *Gedanken zum Klassenzimmer* (Thoughts on the Classroom; dated fall 1962) were specially written by Betts for the two works. Emails from Peter J. Betts, March 26 and 29, 2017, and conversation with Urs Dickerhof, May 5, 2017.

22 See Jean-Pierre Moulin und Yvan Dalain, eds., *Eintritt frei: Oper* (Lausanne, 1963), design by Jacques Plancherel. See also Olivier Lugon, "J'aime le Music-Hall," in *Schweizer Fotobücher 1927 bis heute: Eine andere Geschichte der Fotografie*, ed. Peter Pfrunder / Fotostiftung Schweiz (Baden, 2011), 252–59.

23 Lecture, Chicago, 1976 (see n. 5), 2.

24 See minutes of the 101st meeting of the Eidg. Kommission für angewandte Kunst, February 6/7, 1964, Bundesamt für Kultur (BAK), Bern, Archiv BAK, Bern. Architect Alfred Roth officiated as president; Kurt Blum and Jean Mohr were brought in as experts on photography. Between 1964 and 1973 Burkhard took part a total of seven times in the federal competition for design, as the grant competition is now called, winning in 1964 and 1972. Email from Andreas Muench, December 16, 2016. In 1972 Burkhard won the competition with a series of portraits and announced that he would use the prize money to go on a study trip to Mexico. Grant application, dated December 24, 1971 (Burkhard's twenty-eighth birthday), Schweizerisches Bundesarchiv, Bern. In the end he did not travel to Mexico but went instead to the USA with Jean-Christophe Ammann (1972).

25 Jacques D. Rouiller, "Eidgenössische Stipendien für Photographie zum Jahre 1964," *Schweizerische Photorundschau* 6 (March 26, 1964): 162. One of the first alp pictures is reproduced in issue 7 (April 11, 1964): 194.

26 Certificate of competence as a photographer, April 15, 1964, Archiv BB.

27 Burkhard must have done the work dated January 1965 immediately before reporting for duty (as a photographer with the air force) at the cadet school (February 21 – May 29, 1965). See Dienstbüchlein (service booklet), p. 20, Archiv BB. Burkhard probably submitted the series mounted on nine large-format pieces of card for a federal grant, evidently without success.

28 Letter from Burkhard to the editorial staff of *Du*, February 21, 1967, and discouraging answer from chief editor Manuel Gasser, March 7, 1967, Archiv BB.

29 Letter from Burkhard to the editorial staff of *Sie und Er*, May 19, 1966, Archiv BB.

30 Letter to the editorial staff of *Schweizer Illustrierte*, June 20, 1969, Archiv BB. Burkhard's idea anticipates later works by Christian Vogt (*Schlachtfelder*, 1991) and Stefan Schenk (*Kreuzweg*, 2014).

31 They got to know each other in the milieu of Hugo Ramseyer, the songwriter and subsequent founder of the Zytglogge publishing house, perhaps at a meeting in the Café du Commerce. At the time he was editing a magazine with the title *Linie*, in which Burkhard wanted to publish his photo story on the alp. Conversation with Markus Raetz, March 24, 2017.

32 Before Szeemann came to the Kunsthalle, he worked as a graphic designer, among other things, and in 1957/58 he assisted with the exhibition *The Family of Man* (MoMA, New York, 1955) at the Kunstmuseum St. Gallen. See "unter 40," *Du* 11 (November 1962): 4, and Gerhard Johann Lischka, "Die Agentur für geistige Gastarbeit: Harald Szeemann; Vom 'Einmann-Kabarett' zum 'Museum der Obsessionen,'" in *Tatort Bern*, ed. Urs Dickerhof and Bernhard Giger (Bern, 1976), 45–49.

33 Prints stamped by the two photographers can be found in the Archiv der Kunsthalle Bern. See *Jean Dewasne*, exh. cat., Kunsthalle Bern (Bern, 1966), and Jean-Christophe Ammann and Harald Szeemann, *Von Hodler zur Antiform* (Bern, 1970), 117.

34 *Curogna*, with a text by Urs Jaeggi, lithographs by Urs Dickerhof, etchings by Daniel de Quervain, and photographs by A. von Allmen and Balthasar Burkhard, print run of fifty-seven copies (Bern, 1966), no. 22/57 in the Archiv BB. Burkhard was friends with all the artists involved and on several occasions spent time with them in Ticino. Conversation with Urs Dickerhof, April 24, 2017.

35 Two members of Atelier 5—Ralph Gentner and Niklaus Morgenthaler—had, together with Harald Szeemann, been responsible for getting Burkhard his position of visiting lecturer (Morgenthaler had previously taught at the same school). See letter of recommendation, dated December 1975, Archiv BB, and conversation with Ralph Gentner, April 21, 2017.

36 On Monika Raetz, see Madeleine Schuppli and Aargauer Kunsthaus, Aarau, eds., *Swiss Pop Art: Formen und Tendenzen der Pop Art in der Schweiz 1962–1972* (Aarau, Zurich, 2017), 500–501.

37 Esther Altorfer was a neighbor of Raetz and would also socialize in the Café du Commerce. Raetz used the commission to color the photographs using a special masking procedure (Maskoid). Conversation with Markus Raetz, March 24, 2017. A picture of the display window is reproduced in *Lob des Schattens* (see n. 4), 168, fig. 3

38 Lecture, Chicago, 1976 (see n. 5), 5. From the early 1970s on, Esther Altorfer, a trained ceramicist whose drawings Harald Szeemann had exhibited in Biel in 1964, had repeated stays in psychiatric clinics.

39 Ibid., 3. The term "individual mythologies" appears in 1972 in the context of documenta 5, which was directed by Harald Szeemann. The exhibition was titled *Questioning Reality – Pictorial Worlds Today*.

40 See, for example, Jean-Fréderic Schnyder, "Ein bisschen viel …," *Schweizerische Photorundschau* 22 (November 25, 1967): 931–32. Szeemann showed Schnyder's installative work in the exhibitions *12 Environments* (1968), *22 junge Schweizer*, and *When Attitudes Become Form* (both 1969). On Raetz, Schnyder, and the Bern art scene, see Harald Szeemann, "Junge Schweizer Künstler" and "Die Berner Kunstszene in den sechziger Jahren," in *Bern 66–87*, exh. cat., Kunsthalle Bern (Bern, 1987), 9–11 and 31–35.

41 Harald Szeemann, letter of recommendation, December 2, 1975, Archiv BB.

42 See Jacques D. Rouiller, "Photographie concrète," *Schweizerische Photorundschau* 4 (February 25, 1967): 138–40. The gallery, which had been founded in 1964, was, together with the Kunsthalle, one of the main venues for contemporary art in Bern. See Silvia & Kurt Aellen and Ladia Megert, "Die Galerie aktuell," in *Bern 66–87* (see n. 40), 22–26.

43 See Bernard Wydler, "Sion, Musée de la Majorie," *Le Confédéré*, May 24, 1969, 3, and Jacques D. Rouiller, "Recherche et expérimentation," *Schweizerische Photorundschau* 3 (February 10, 1970): 96–102. The exhibition was on show from May 21 to 25, 1969.

44 *Creative Photography*, Galerie Impact (augmented by the rooms at the Galerie de l'Académie), Lausanne (May 12 – June 4, 1970). Galerie Impact was launched in 1968 by the Groupe Impact, which Rouiller was also a member of, and continued until 1975.

45 Conversation with Markus Raetz, March 24, 2017. Raetz can be seen in some of the pictures with his camera. See contact prints of five b/w 35 mm films, Archiv BB.

46 See Bernhard Giger, in *Photo suisse* (see n. 4). Allan Porter had also published this iconic image as one of Frank's first pictures in the April 1966 issue of *Camera* on the subject of Guggenheim fellows (p. 64).

47 The image is printed in a silvery gray color. See invitation, *Markus Raetz*, Galerie Bischofberger, Zurich (April 21–29, 1969), Archiv BB.

48 The object evokes one of the icons of minimal art: the installation *Diagonal of May 25, 1963* by Dan Flavin. We can only speculate on whether the montage of a neon light more or less on the soil should be seen as an ironic allusion to this.

49 They can also be seen as a precursor of *Bodenfolge*, which was shown in the exhibition *Visualisierte Denkprozesse*. These oblique views of different kinds of "terrain" (such as parquet, grass, farmland/earth, water, etc., on canvas)—also produced in collaboration with Raetz—have sadly been destroyed by the sulfur diffusing from the works of Gérald Minkoff. See conversation with Markus Raetz, March 24, 2017, and installation photos and contact prints, Archiv BB.

50 F. J., "Creative Photography," *Gazette de Lausanne: La gazette litteraire*, May 23/24, 1970, 32. One of Burkhard's photographs, "whose color cannot be reproduced here," is the article's only illustration.

51 Jacques Monnier, "Neuf photographes alémaniques révèlent une autre manière de voir," *Feuille d'avis de Lausanne: Art et lettres en suisse*, May 15, 1970, 27.

52 *Visualisierte Denkprozesse*, Kunstmuseum Luzern (February 14 – March 29, 1970). Jean-Christophe Ammann was Harald Szeemann's assistant at the Kunsthalle Bern from 1967 to 1968, before he was appointed to the Kunstmuseum Luzern. The exhibition was conceived as a kind of sequel to Szeemann's *When Attitudes Become Form* and was meant to represent a "stocktaking of recent art in Switzerland." See minutes and memos of the Lucerne Art Society, Stadtarchiv Luzern (Bestand D018 – Kunstgesellschaft Luzern KGL), and the unpublished licentiate thesis by Anna-Maria Papadopoulos-Schori, "Visualisierte Denkprozesse: Eine Ausstellung zur Schweizer Kunst um Neunzehnhundertziebzig" (Institute of Art History, University of Zurich, 2008).

53 Jacques D. Rouiller, "Creative Photography sous le patronage de la maison Nikon," *Schweizerische Photorundschau* 10 (May 25, 1970): 432–42.

54 Jacques Monnier, "Neuf photographes alémaniques" (see n. 51), 27.

55 Letter from Markus Raetz to Jean-Christophe Ammann, January 1, 1970, with two Polaroid portraits by Burkhard and Raetz and a selection of seals, "The First Hundred Days of the Seventies," in *Visualisierte Denkprozesse*, exh. cat., Kunstmuseum Luzern (Lucerne, 1970), n. p.

56 Letter from Balthasar Burkhard to Jean-Christophe Ammann, January 1 [1970], with a selection of photographs, Archiv BB. Rolf Iseli and Franz Eggenschwiler were artist friends of Burkhard's.

57 Not only did Ammann have clear ideas, he even gave the artists instructions that they did not altogether agree with. Schnyder, for example, did not want to take part in the exhibition "to order" and backed out. See licentiate thesis by Papadopoulos-Schori (see n. 52). Raetz also had difficulty asserting his own ideas. See letter from Raetz to Ammann, November 21, 1969, Stadtarchiv Luzern (Bestand D018 – Kunstgesellschaft Luzern KGL).

58 *Camera* 5 (May 1971): cover and 4–12. Porter's choice of topic, "Information," relates directly to the first comprehensive museum exhibition on conceptual art, which was staged in 1970 under the same title at the Museum of Modern Art in New York ("Information" also appears in the subtitle of Szeemann's exhibition *When Attitudes Become Form*).

59 For example, in *The Swiss Avant Garde*, the exhibition curated by Willy Rotzler in New York, all the canvases went under the name of Markus Raetz. See *The Swiss Avant Garde*, exh. cat., The New York Cultural Center (Zurich, 1971), 76–77. The collaboration with Burkhard is only mentioned in the work list (p. 103).

60 He watched the television broadcast of the first lunar landing on July 21, 1969, and recorded the historic moment of man's first step on the surface of the moon with his camera. See 35 mm film A 160 *Mondlandung am Ferni* (Moon Landing on TV), Archiv BB.

61 *Camera* 5 (May 1971): 2. As already mentioned, Burkhard had completed his military service as a photographer with the air force (Dübendorf airfield).

62 Jean-Christophe Ammann on Balthasar Burkhard, in *Camera* 5 (May 1971): 4.

63 Allan Porter, "Information," *Camera* 5 (May 1971): 23 and 43. In addition to Burkhard, Roland Schneider, François and Jean Robert, and Pierre Cordier also featured in the issue.

64 Lecture, Chicago, 1976 (see n. 5), 6.

65 See various documents on the loan and installation process in the Archiv der Fotostiftung Schweiz. Burkhard only features in the exhibition catalogue with a short biographical entry. See Stiftung für Photographie, ed., *Fotografie in der Schweiz von 1840 bis heute* (Niederteufen, 1974), 309. His work is only acknowledged by Urs Stahel in the new, fully revised edition published in 1992, in which the canvas work *Bett* from 1969/70 is reproduced. See Urs Stahlel, "Künstlerische Projekte mit Photographie," in *Photographie in der Schweiz von 1840 bis heute*, ed. Schweizerische Stiftung für die Photographie (Bern, 1992), 254–55.

66 Letter from Burkhard to Allan Porter, undated [late 1978], and reply from Porter, January 5, 1979, Archiv BB.

67 See *Du* (January 1962): 11, and *Camera* 4 (April 1966).

68 Undated letter with a handwritten note "Guggenheim Fellowship," [ca. 1979], Archiv BB. No trace can be found of Burkhard's application in the Guggenheim Archive, emails from André Bernard, Vice President and Secretary of the John Simon Guggenheim Memorial Foundation, New York, March 3 and 7, 2017.

Photo credits: A: collection of the Fotostiftung Schweiz, Winterthur; B: Photographic Collection, Museum Folkwang, Essen; C: Estate Balthasar Burkhard / Urs Dickerhof, Biel; D: Estate Balthasar Burkhard / Kunsthalle Bern; E: Estate Balthasar Burkhard / Urs Dickerhof, Biel; F: Estate Balthasar Burkhard; G: Jacques D. Rouiller, Vaux-sur-Morges; H/J: Estate Balthasar Burkhard; L: Walter Binder, Zurich (Exhibition documentation, Archiv Fotostiftung Schweiz, Winterthur)

Documenting the Art Scene

The young photographer becomes part of the extremely vibrant Swiss art scene of the 1960s. He documents Bohemian lifestyles and a number of important exhibitions curated by Harald Szeemann, the colorful director of the Kunsthalle Bern. Burkhard's pictures record new forms of art, and the fleeting installations, performances, and happenings of the Fluxus artists, which would otherwise have left no material traces. These pictures fulfil the role that Charles Baudelaire once assigned to photography: to be at the service of art. For Burkhard, these images constitute documents and memories that he compiled into "diaries." Some of them were taken by other photographers and Burkhard is seen on them as a protagonist.

Swiss artists in the painting *Kranenburg* by Franz Gertsch, 1970, including Balthasar Burkhard, who is carrying the camera

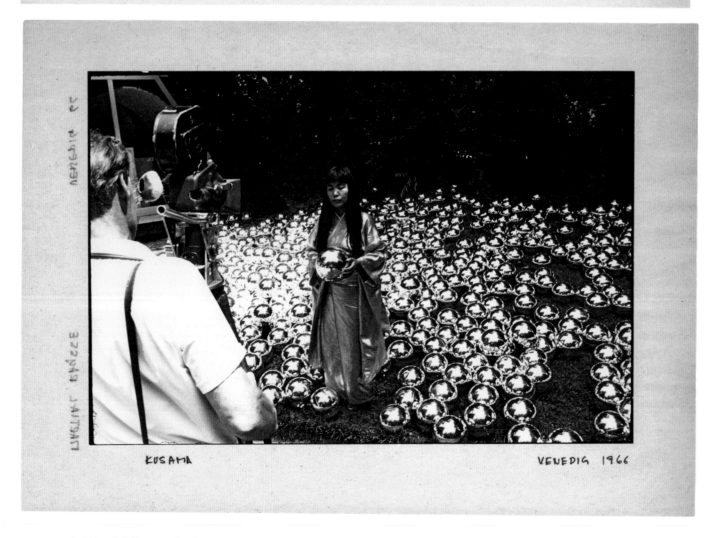

BIENNALE 66 VENEDIG FRANZ. PAVILLON
MARTIAL RAYSSE

KUSAMA VENEDIG 1966

▲ **Martial Raysse in the French Pavilion, Venice Biennale, 1966**
▲ **Yayoi Kusama in her installation *Narcissus Garden*, Venice Biennale, 1966**

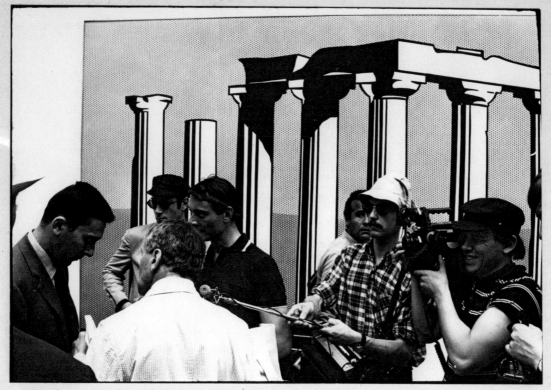

BIENNALE VENEDIG 1966
ROY LICHTENSTEIN (4.V.L) UND M. SONNABEND (2.V.L) INTERVIEW VOR DEM BILD
"TEMPEL OF APOLLO" (L4) IN AMERIKANISCHEN PAVILLON

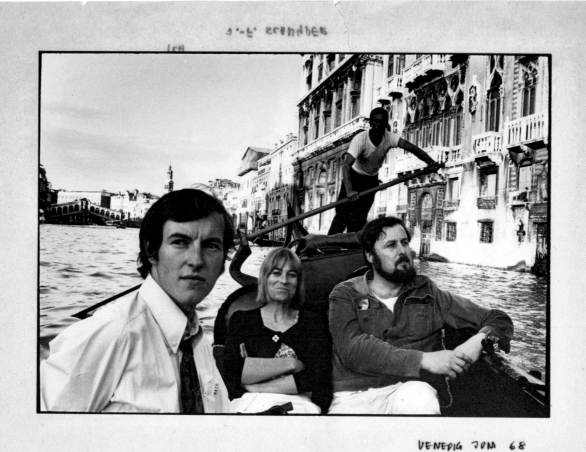

VENEDIG JUN 68
JEAN-FRÉDÉRIC SCHNYDER FRANCOISE & HARRY SZEEMAN

▲ Roy Lichtenstein in front of *Temple of Apollo*, American Pavilion, Venice Biennale, 1966
▴ Jean-Frédéric Schnyder, Françoise and Harald Szeemann, Venice, 1968

MARKUS RAETZ BEI FERNSEHAUFNAHMEN IM KUNSTHAVS ZÜRICH ZÜRICH 1968
(3.v.L) AUSSTELLUN WEGE & EXPERIMENTE
HINTERGRUND RAER «SCHEMA» H 479, B CA. 1000 cm, T 500 cm.

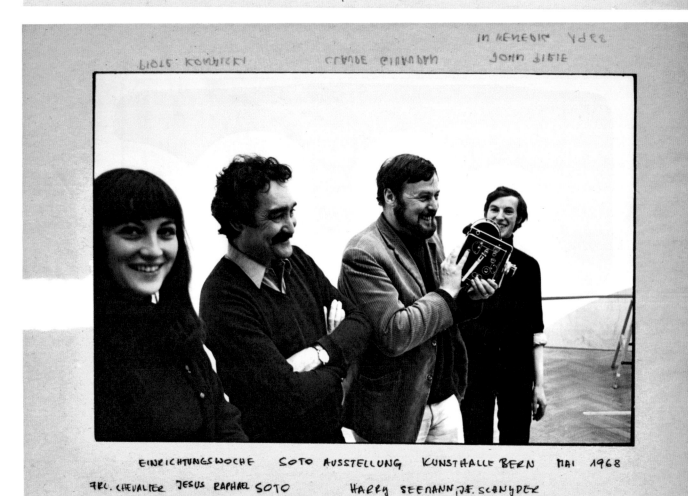

EINRICHTUNGSWOCHE SOTO AUSSTELLUNG KUNSTHALLE BERN MAI 1968
FRL. CHEVALIER JESUS RAPHAEL SOTO HARRY SEEMANN, JF. SCHNYDER

⌃ **Markus Raetz during recordings made for the exhibition** *Wege und Experimente* **in the Kunsthaus Zürich, 1968** ◂ **Installing the exhibition** *Jesús Raphael Soto* **at the Kunsthalle Bern, 1968**

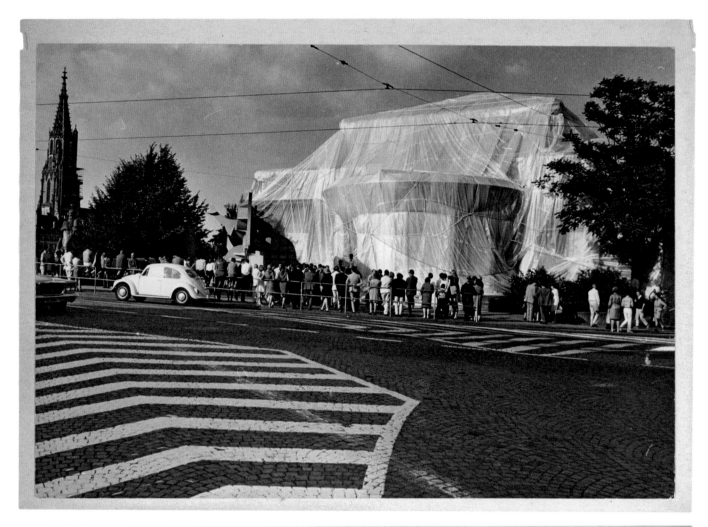

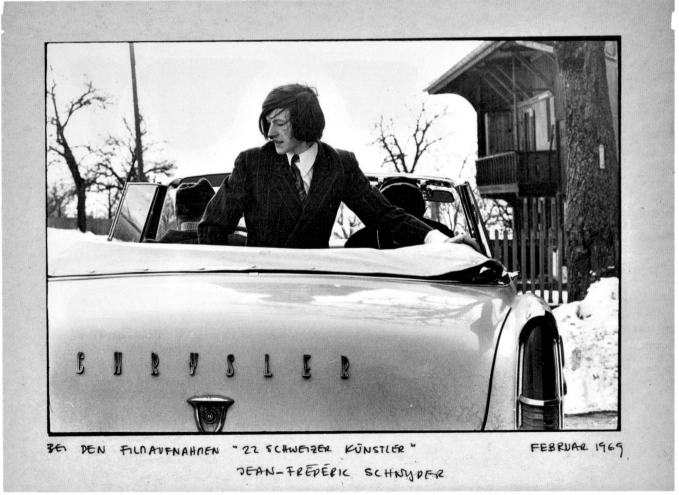

BEI DEN FILMAUFNAHMEN "22 SCHWEIZER KÜNSTLER" FEBRUAR 1969
JEAN-FRÉDÉRIC SCHNYDER

⬍ **Wrapping of the Kunsthalle Bern by Christo and Jeanne Claude, 1968**
▲ **Jean-Frédéric Schnyder during the shoot for the film *22 Schweizer Künstler*, 1969**

49

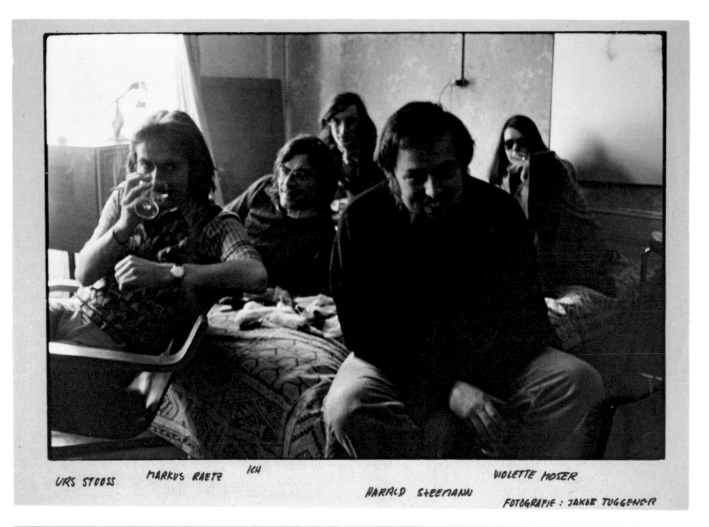

URS STOOSS MARKUS RAETZ ICH VIOLETTE MOSER

HARALD SZEEMANN

FOTOGRAFIE : JAKOB TUGGENER

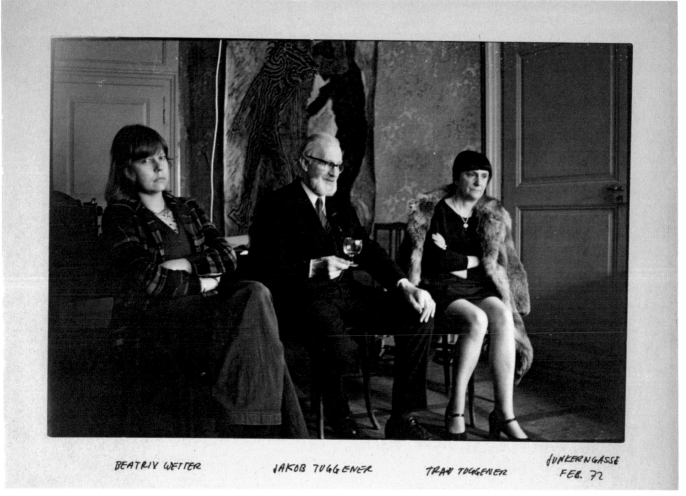

BEATRIX WETTER JAKOB TUGGENER TRAU TUGGENER JUNKERNGASSE FEB. 72

50 **Bern art scene at a film matinée at Jakob Tuggener's home, February 1972**

FOTOPAUSE KLÖSTERLISTUTZ Sonner 67

ICH MARKUS + MONIKA ESTHER Peter SAAM

ELISABETA Hoffmann

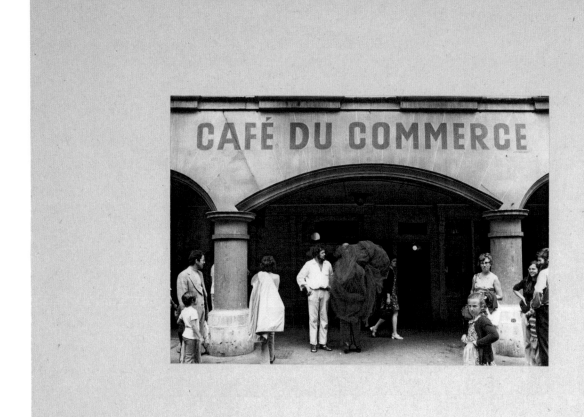

CAFÉ DU COMMERCE

▲ **Excursion to Klösterlistutz, summer 1967** ▲ **Harald Szeemann and James Lee Byars in front of the Café du Commerce, Bern, 1972**

ATELIER FRANZ GERTSCH 73/74 ?

FRANZ GERTSCH
JEAN-CHRISTOPHE 71

⬆ **In Franz Gertsch's studio, 1973/74** ▲ **Franz Gertsch and Jean-Christophe Ammann, 1971**

Urs Lüthi, Balthasar Burkhard, and Jean-Frédéric Schnyder on a trip to Amsterdam, 1969 53

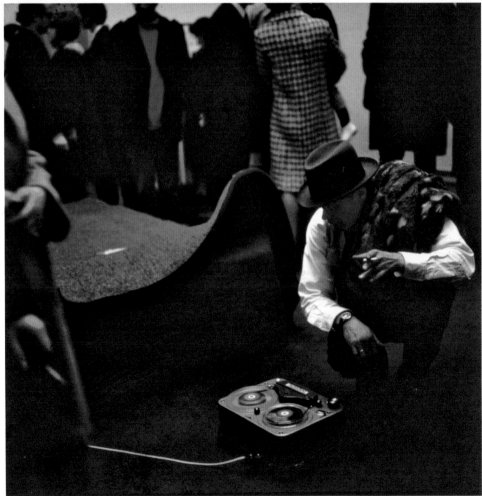

➥ **Pages 54–57:** *When Attitudes Become Form,* **Kunsthalle Bern, 1969**
⬆ **Alighiero Boetti,** *Io che prendo il sole a Torino il 24–2–1969* ▲ **Joseph Beuys at the opening**

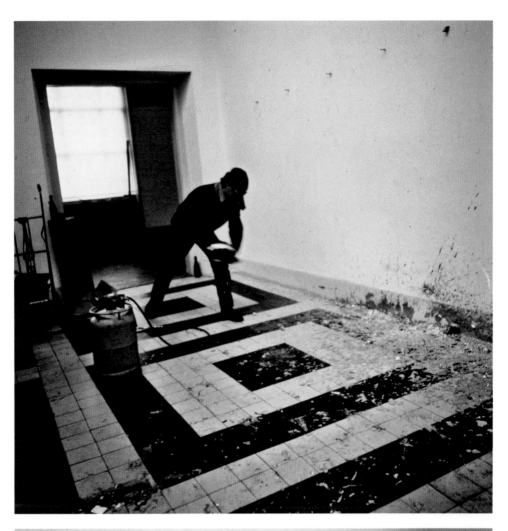

▲ Installing Richard Serra's *Splash Piece*
▲ Richard Serra, *Close Pin Prop, Shovel Plate Prop,* and *Sign Board Prop*

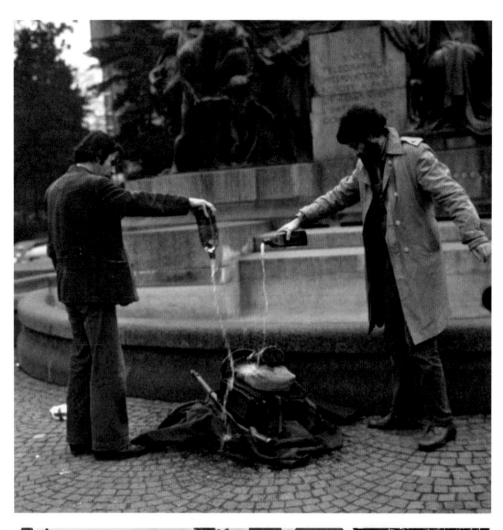

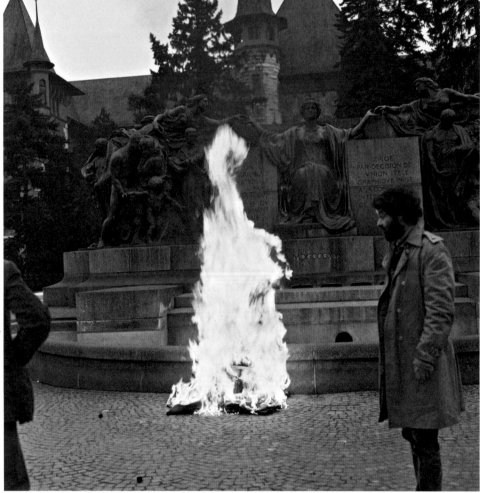

Peter Saam burning his army uniform in front of the Kunsthalle with the help of Michael Heizer (left)

Constructing Michael Heizer's installation *Cement Slot* **in the park behind the Kunsthalle**

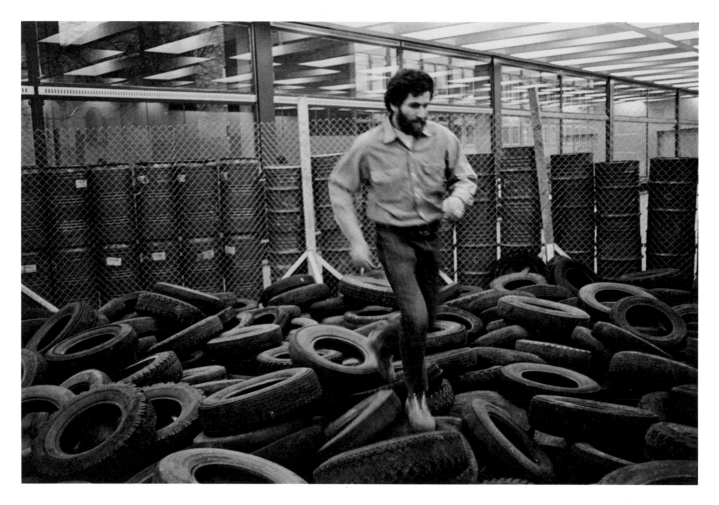

↠ **Pages 58/59:** *Happening & Fluxus,* Kölnischer Kunstverein 1970
↟ **At the opening** ⬥ **Allan Kaprow in the installation** *Yard*

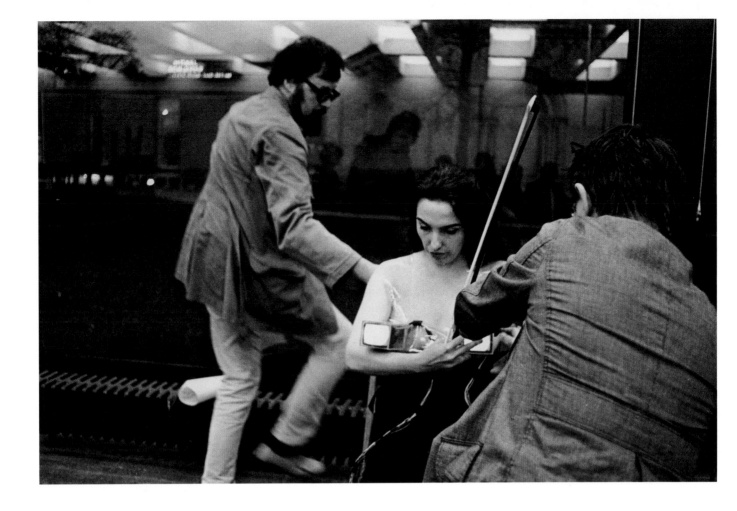

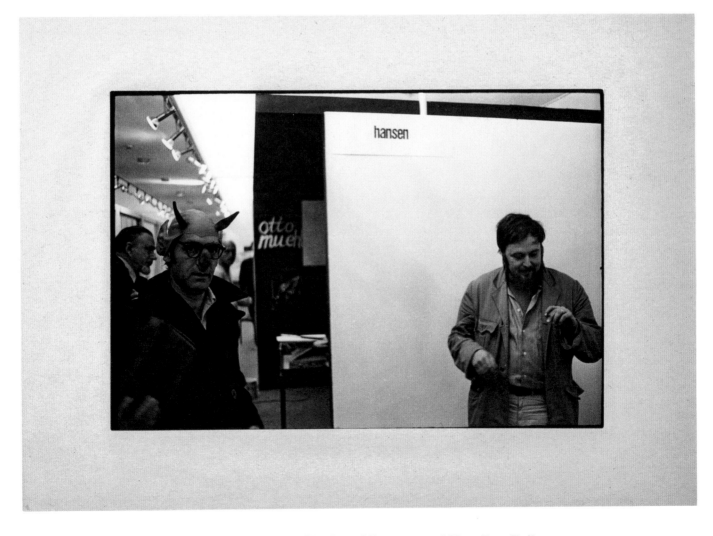

▲ **Harald Szeemann (left) at a performance by Charlotte Moorman and Nam June Paik**
▲ **Al Hansen and Harald Szeemann**

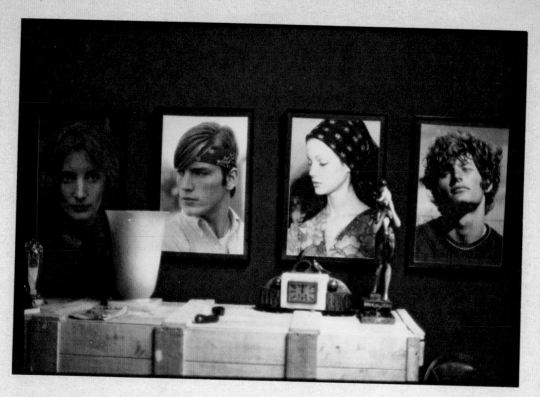

UNION SQUARE 33 WARHOL NEW YORK 72

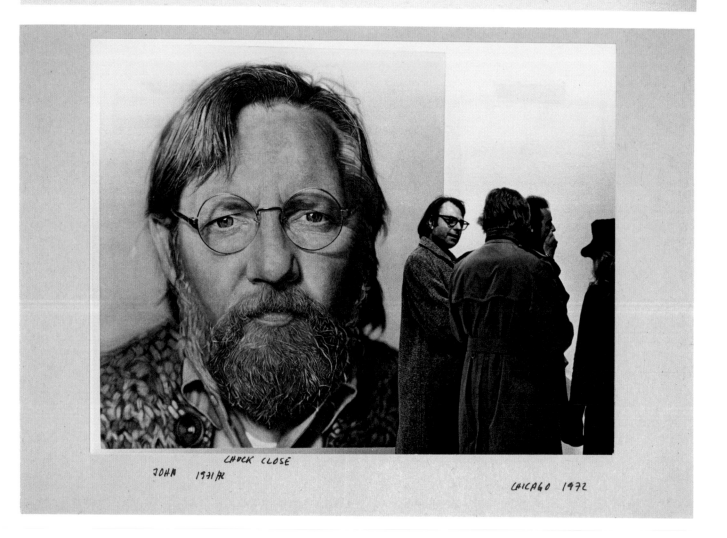

JOHN CHUCK CLOSE
 1971/72 CHICAGO 1972

▸▸ **Pages 60–65: Trip to America, 1972—research for documenta 5**
↥ **Andy Warhol's Factory, New York** ▴ *Chuck Close* **exhibition, Museum of Contemporary Art, Chicago**

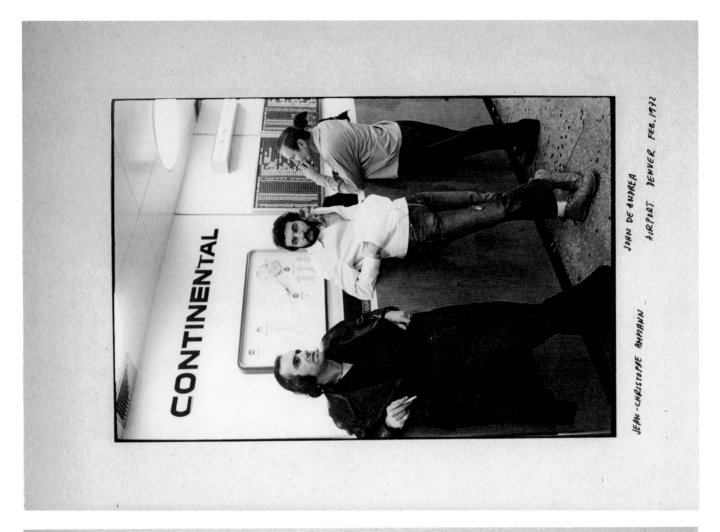

↥ **Jean-Christophe Ammann and John DeAndrea at Denver airport** ⬥ **Jean-Christophe Ammann** 61

LUCAS SAMARAS

NEW YORK FEB. 72

JOHN C. FERNIE

SAN FRANCISCO FEB. 1972

⬆ **Sculptor Lucas Samaras, New York** ▲ **Artist John C. Fernie, San Francisco**

Artist John DeAndrea in his studio in front of the unfinished sculpture *Sitting Woman*　　63

64 **Ed Ruscha with the poster he designed for documenta 5**

UNION SQUARE 33 JEAN-CHRISTOPHE NEW YORK 72

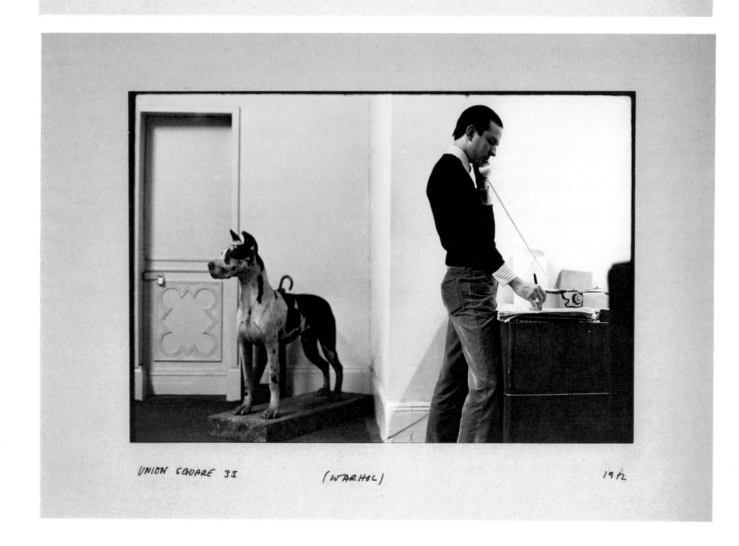

UNION SQUARE 33 (WARHOL) 1972

⤒ **Jean-Christophe Ammann in Andy Warhol's Factory, 33 Union Square, New York**
▲ **In Andy Warhol's Factory**

Jennifer Gough-Cooper

Nature Is Dark and in Twilight

Balthasar believed that something magical works on the film from the time it is exposed to the light until the moment it is plunged into chemicals for its development. As good wine matures in the barrel, during this period of rest photographic alchemy takes place in the sealed cassette. For all that—or because of it—Balthasar was a photographic wizard.

Conjured from black-and-white negatives, Balthasar printed his images into an extreme density of black velvet darkness, from which the form and a degree of light emerge. His early images of the nude are a refined example of his vision, where the superfluous has been pared down, as a sculptor whittles away his material to create a three-dimensional object of light and shade. At the Kunsthalle Basel, in 1983, I found the monumental *Grand Nu I* astonishing in its power and purity of form. The picture of a reclining nude stretched out on the ground had been captured in a series of four separate frontal shots—in order to avoid any perspective in the image—enlarged to 1,320 cm in length, and then "stitched" together seamlessly. In repose, on this scale, the body becomes a timeless, rolling landscape, but the gentle sleeping nude had been lit to resemble an exquisitely designed machine, honed for subtle movement and sculpted for speed. On March 13, 1988, Balthasar showed me the set-up of his darkroom beyond his studio at the Rief Fabrik, Sandrainstrasse, Bern, where he and his team printed on a large scale. The room seemed to be the size of a tennis court; the exposed paper was rolled and unrolled successively into a series of big, rectangular trays standing on the floor, each filled with a chemical: developer three minutes, stop bath one minute, and fixer for three minutes. On the same day, he made the portraits of Jacques Caumont and myself.

I first met Balthasar in May 1972, as a member of Harry Szeemann's team at documenta 5 in Kassel. In the weeks prior to its opening, his small Leica in hand, Balthasar quietly prowled round the vast exhibition site, recording for Harry the hive of activity taking place both out of doors and inside the two large galleries: the Museum Fridericianum and the Neue Galerie. In this most famous of documentas, many of the artists created their work in situ, supervised the installation, or wandered about like strolling players. The atmosphere was rarefied. For this assignment, Balthasar must have used hundreds of rolls of 35 mm black-and-white film. He captured some wonderful moments: Szeemann kissing the wall where the first work of the exhibition had just been ceremoniously hung; Richard Serra supervising four huge sheets of steel as they were maneuvered into place, bisecting the room; James Lee Byars being raised by fireman's ladder to the pediment of the Fridericianum where he stood motionless like a statue; Mario Merz watching his motorbike being secured at right angles to the curved stairwell of the Fridericianum, transforming the space into a silent wall of death; Paul Thek requesting a moment's silence before a young birch tree was cut down to use as an element in his *Arc, Pyramid*. Balthasar did use some color film in Kassel: he gave me a color print that was taken during lunch in a restaurant, when James Lee Byars asked me to try on his wide-brimmed straw hat!

With Jacques Caumont, I had other opportunities to watch Balthasar at work. In May 1988, he came to Normandy to stay with us for a few days. He was amused by the magnificence of our billy goat, Gaspard, the tiny toads in the garden, as well as Jacques's splendidly springy beard. The main reason for this visit, however, was to see and photograph an unusual version of one of Gustave Courbet's subjects: the wellspring or source. On the Channel coast at Grainval, close to Fécamp, is a spring that cascades over the top of a chalk cliff onto the pebble beach below. Into his open-top gray-blue Citroën 2CV, Balthasar secured a wooden ladder of ours and proceeded to follow us along the country roads to this rarely frequented spot by the sea. The ladder was long enough for him to climb high enough to reach the height he needed for his shot. The angle to the cliff and the waterfall was also critical: with Jacques's help, Balthasar moved the ladder and his slender tripod—adjusting his position several times and shooting plenty of film—until he was satisfied he had the shot in the bag (p. 227).

Balthasar returned to Normandy in February 1995 in pursuit of another of Courbet's subjects: waves breaking onto the shore at Étretat (pp. 223, 225). As I recall, Balthasar was in close communication with us to fix the most suitable date for his visit, when huge waves could be expected on the coast. Jacques recommended the few days around the spring tides (which that year fell the week beginning February 13) when the weather and exceptional high tides would be most likely to whip up the sea sweeping ashore. Several days running we

went to Étretat, Balthasar armed with his Leica, Rolleiflex, and Linhof 4 × 5. At the end of the week, close to high tide one morning, waves came to the party in spectacular fashion—the sun and the wind as well. In the teeth of the gale, Balthasar found that he could not keep the Linhof steady without support from Adrian Scheidegger and Guy Jost, his friends from Bern. The three of them would move forward as one body, as far as they dared, but then, unexpectedly, a bigger wave came further up the beach, crashed onto the pebbles and drenched them all.

In June 2004, I found Balthasar standing with Vida on the top of the steps at the entrance to the Kunstmuseum, Bern, welcoming his friends. It was the opening of his *Omnia* exhibition, which drew crowds of visitors. I wrote in my diary, "The exhibition is big, and the big enlargements seem the best to me … I was struck by how the smaller prints have little light, they are so somber. Mostly an atmosphere of *pénombre*. Little or no contrast … Nature is dark and in twilight." This magical shadow play often within a register from gloaming to darkness is a unique mood found only in Balthasar's work: a mysterious world that is often dark, rich in patterns and exquisite textures, from which the subject emerges sublimely.

Jennifer Gough-Cooper is a British artist and former curator now living in Cape Town. As a member of Harald Szeemann's team, she worked together with Jacques Caumont to help install documenta 5 in 1972. This was also how she first came into contact with Balthasar Burkhard.

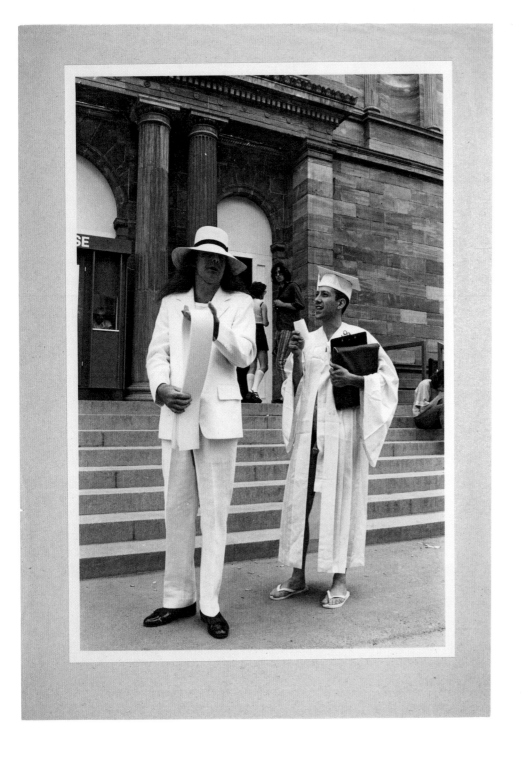

➻ **Pages 68–85: documenta 5, 1972** ▲ **James Lee Byars and Paul Cotton in front of the Fridericianum**

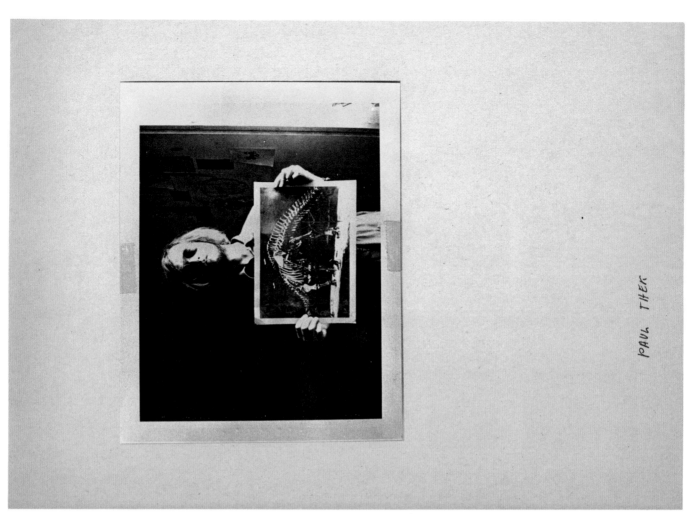

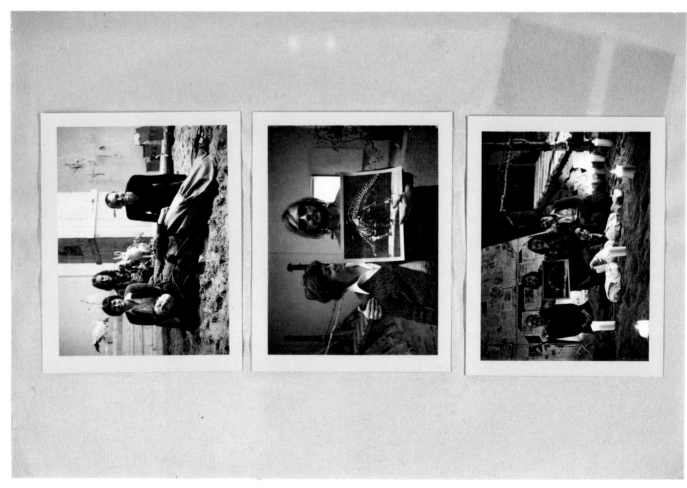

‣ **Paul Thek** ▴ **Paul Thek and artist friends in his installation** *Ark, Pyramid* 69

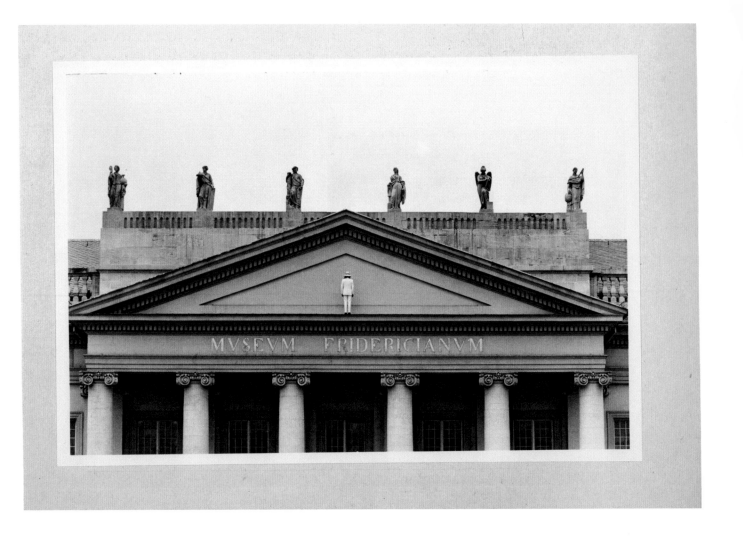

James Lee Byars on the pediment of the Fridericianum

⬆ **Paul Thek's installation** *Ark, Pyramid* ▲ **Paul Thek in his installation** 71

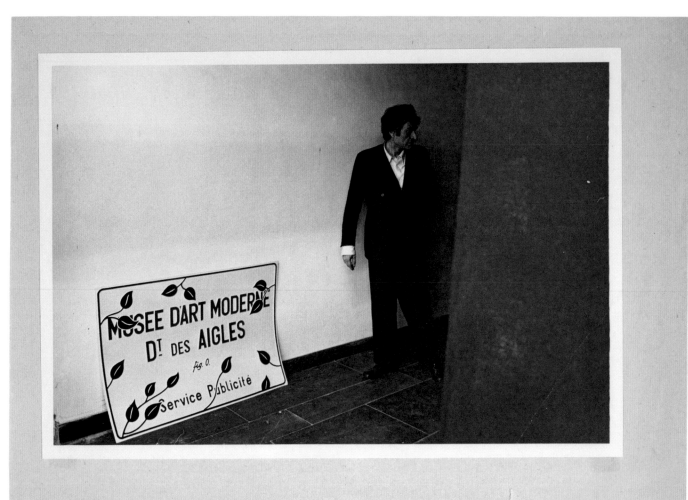

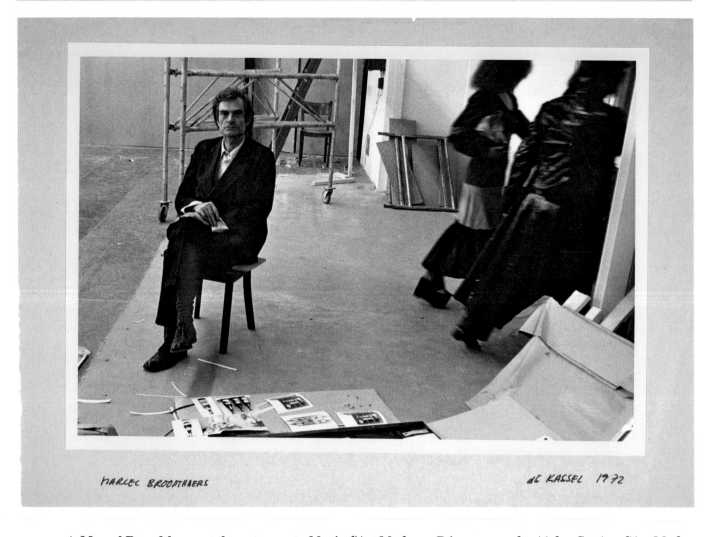

⤒ **Marcel Broodthaers at the entrance to** *Musée d'Art Moderne, Département des Aigles, Section d'Art Moderne*
▲ **Marcel Broodthaers at the exhibition setup**

Panamarenko in front of *Aeromodeller*

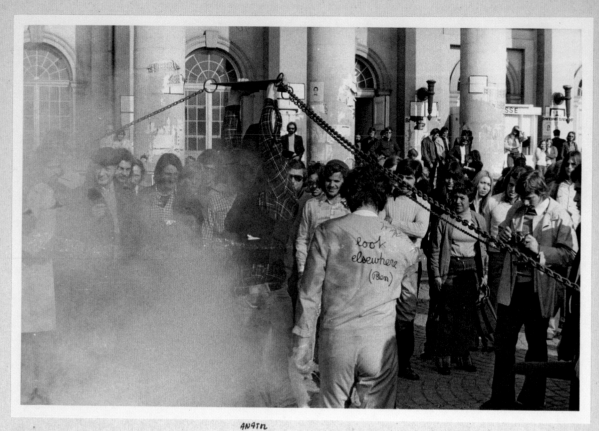

AKTION ANATOL – ARBEITSZEIT ANGTN WILP d5 KASSEL 1972

⬆ **Anatol Herzfeld during his performance** *Arbeitszeit* ▲ **Ben Vautier in his** *Thinking Room*

▲ Harald Szeemann, Balthasar Burkhard, Claes Oldenburg, and Kasper König
▲ Harald Szeemann on the final day of documenta 5, October 8

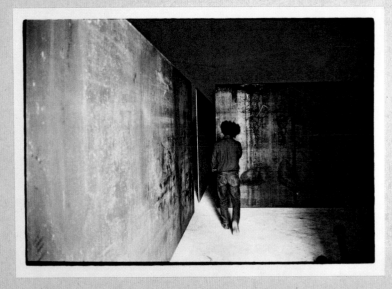

RICHARD SERRA d5 KASSEL 1972

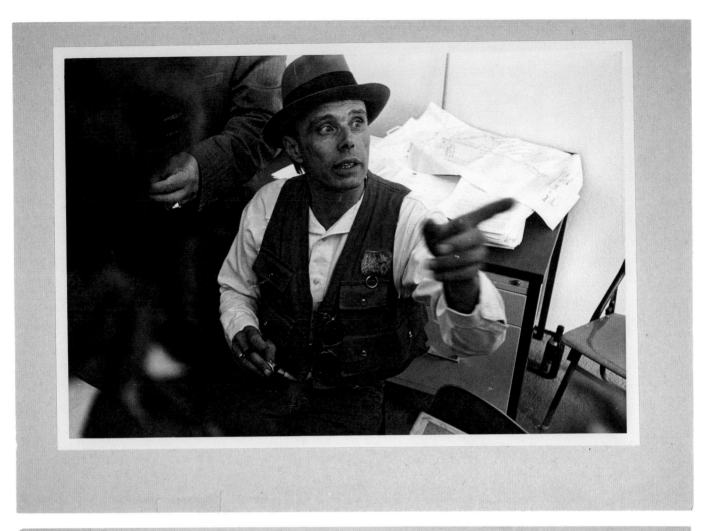

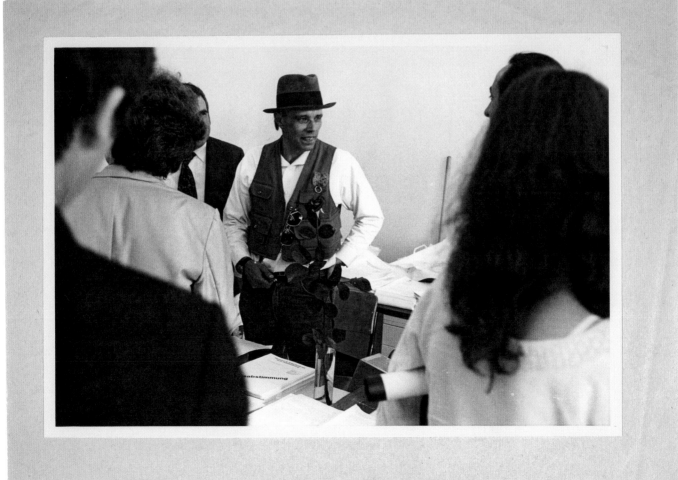

Joseph Beuys

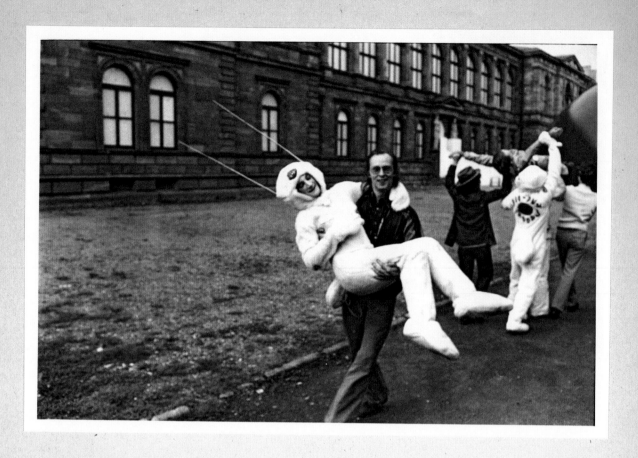

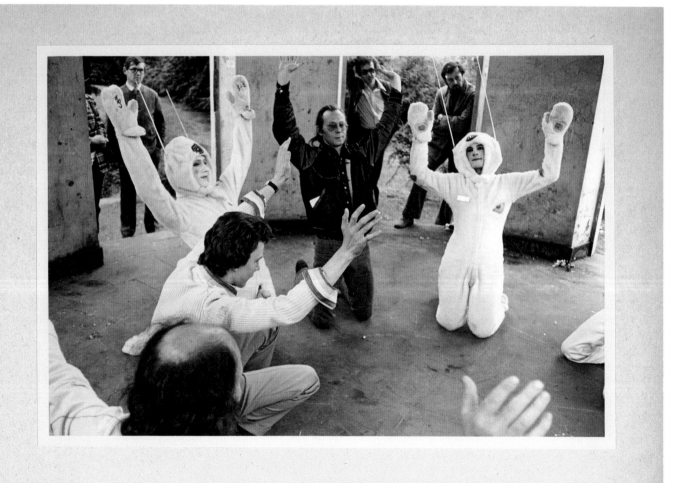

Performance *Prince of Peace* by Paul Cotton and Eugenia Butler:
⭱ Paul Cotton, carried by Sigmar Polke ▴ Sigmar Polke as part of the performance

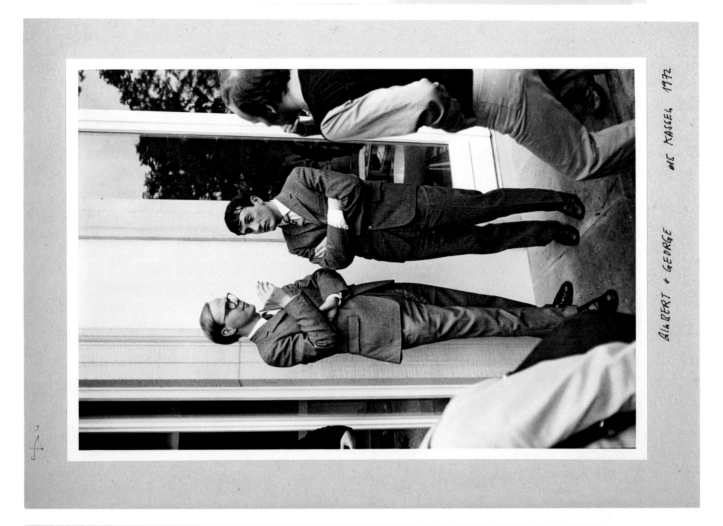

Gilbert & George ▲ **Performance by a naked Paul Cotton**

BEATRICE & MARIO MERZ FIBONACCI 1.1.2.3.5.8.13.21.34.55..

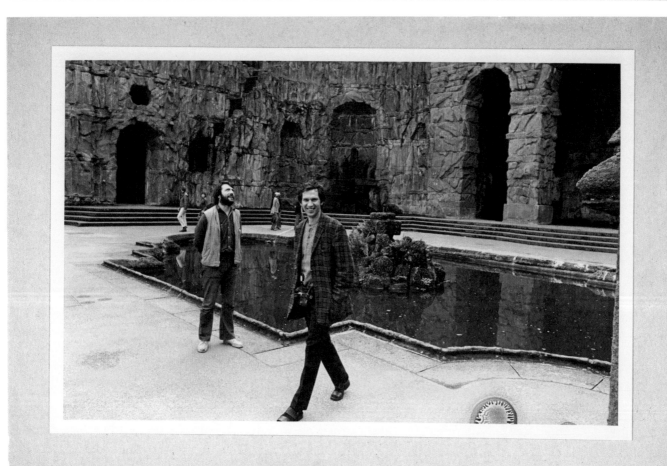

BEN VAUTIER d5 KASSEL 1972

 ⬆ **Beatrice and Mario Merz in the Fridericianum**
 ▲ **Ben Vautier at the Hercules monument in Kassel's Bergpark**

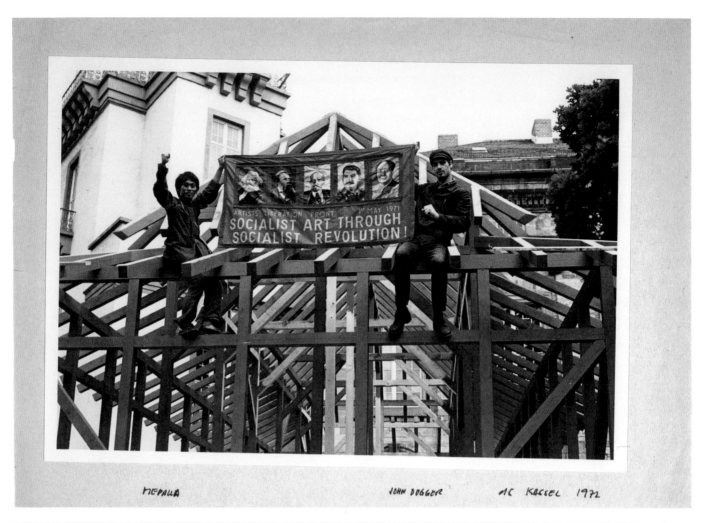

MEDALLA JOHN DUGGER MC KASSEL 1972

⬍ **David Medalla and John Dugger at Dugger's** *People's Participation Pavilion* ▲ **Ingeborg Lüscher** 81

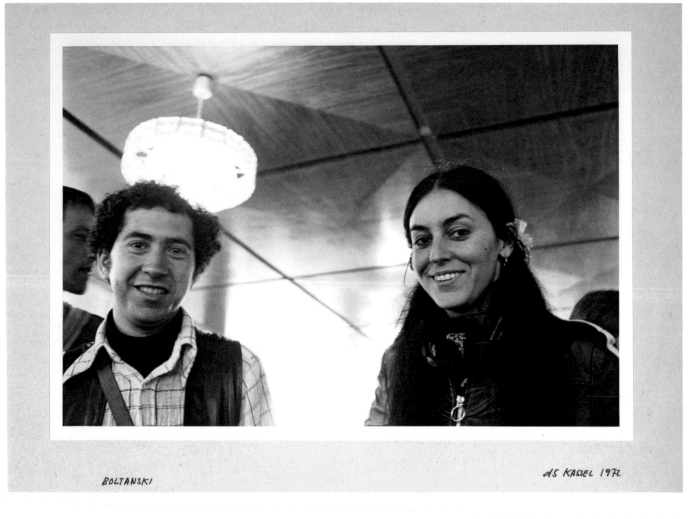

⬆ **Sarah and Piotr Kowalski in the installation** *Mesure à prendre*
▲ **Christian Boltanski and Annette Messager**

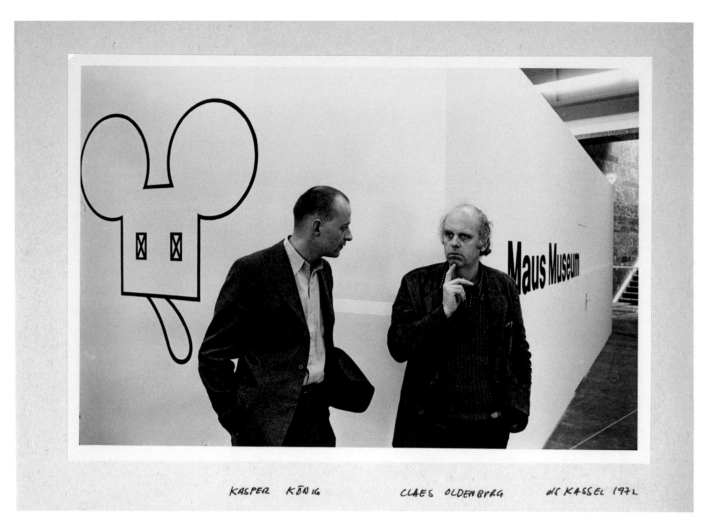

KASPER KÖNIG CLAES OLDENBURG alf KASSEL 1972

CLAES OLDENBURG MAUSMUSEUM alf KASSEL 1972

⬆ **Kasper König and Claes Oldenburg in front of the** *Maus Museum* ▲ **Claes Oldenburg in the** *Maus Museum* 83

84 **Staff passes for Violette Moser and Balthasar Burkhard**

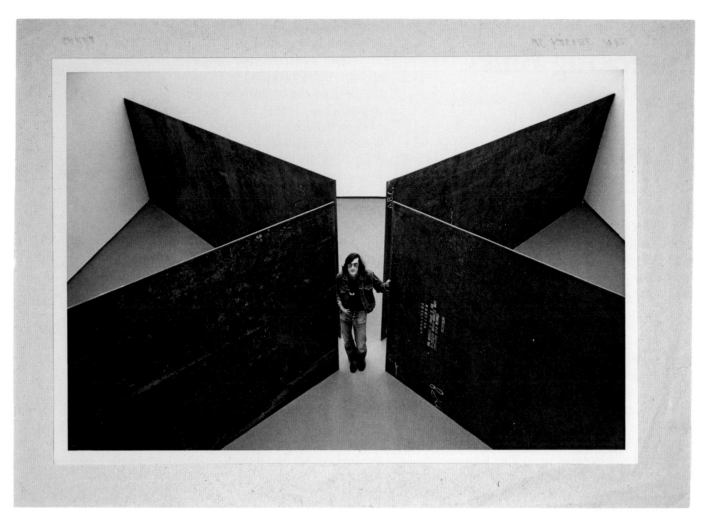

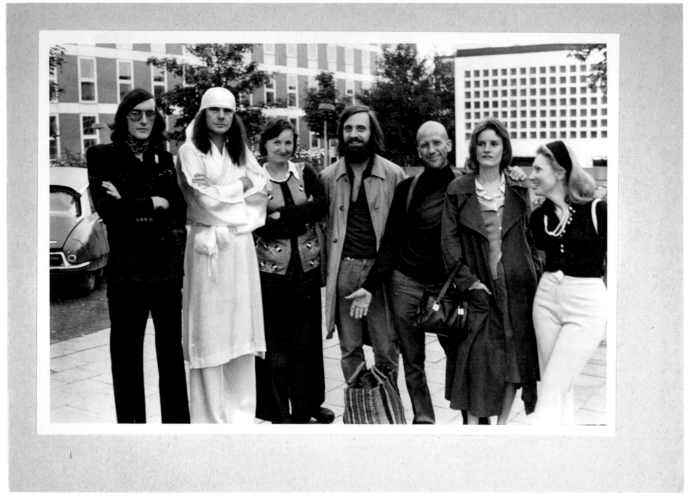

⬆ **Balthasar Burkhard in Richard Serra's *Circuit***
▲ **Balthasar Burkhard, James Lee Byars, Jennifer Gough-Cooper, and artist friends**

Tom Holert

Wrecking Ball

When Attitudes Become Form and documenta 5
—the exhibitions that Balthasar Burkhard docu-
mented with his camera in Bern (in 1969) and
Kassel (in 1972) respectively—offered new motifs
to a visual chronicler of the art world, while also
presenting fresh possibilities for getting involved
in the scene. The motifs were new because
the two exhibitions marked a crucial change in
the physical and social spaces occupied by
visual art.

The curator Harald Szeemann was largely
responsible for these changes. Starting out in
Bern and the city's Kunsthalle (and a former
school building across from it that was used as
an additional exhibition space), Szeemann pur-
sued his idea of opening up the closed gallery
space, a project that had always had a trans-
national scope. In the white cube, artworks are
systematically isolated from the processes of
their production. The setting up of a supposedly
neutral environment designed to ensure that
the art object receives the viewer's undivided
attention was one of the most influential steps
taken by the modernist art movement.

The artists, the vast majority of them men,
that Szeemann (the "exhibition maker") thought
were worth considering for this project—and
with whom he had been working since the late
1960s, inviting them to stretch the limits of the
white cube with their aesthetic practice—would
move through the spaces where they set up
their presentations with a nonchalance that was
at times provocative and that certainly repre-
sented a challenge to the authority of the mu-
seum. With their gestures and physical presence,
they performatively took over the galleries of
the Kunsthalle in Bern and the various venues in
Kassel, even as their site-specific and process-
oriented installations, environments, and sculp-
tural objects were being created. The resem-
blance the process of exhibition assembly bore
to a construction site was inherent to the tem-
porary experimental setup of the exhibitions
themselves, which were intended for just a few
weeks. This setting of assembly, production,
and experimentation with materials, light, and
other physical laws did not end when the exhi-
bitions opened but rather continued, in theory
at least, as a provisional situation, albeit now in
the artists' absence.

Burkhard seemed particularly fascinated
by the way the spaces were transformed by the

artists' physical actions and behavior. He ob-
served their work in the way one might watch
an artisan, lab technician, engineer, dancer, bill
sticker, or graffiti sprayer. These photos seem
to efface all the customary deference and cultur-
ally ordained respect for the museum as a place
of contemplation, and all the authority of the
white cube. Burkhard used his camera to docu-
ment how the artists, working together and
in parallel, literally made the exhibitions, and
many of his images convincingly capture the
intensity, contingency, and physicality of this
"making."

Here we will focus on one of these photo-
graphs. The picture was taken in the area in
front of the Kunsthalle shortly before the open-
ing of When Attitudes Become Form. Almost
half of the image is occupied by an inspection
of the asphalt, where four round indentations
indicate the action of a wrecking ball. The color
scheme of the photo is dominated by different
shades of gray: cement, asphalt, stone. The
slightly pinkish orb of the wrecking ball is still
lying in the place where it has left its last dent,
almost exactly in the geometrical center of
the image. The steel cable with the rig to which
the ball is attached describes an arc that con-
nects the right edge of the frame with its upper
border.

Above the dented asphalt and the rock-
like wrecking ball (in the upper left quadrant of
the photo) there are two men in motion. The
younger of the two, dressed in a brown leather
jacket, jeans, and black cowboy boots, seems to
be walking up to the indentations in the asphalt
and is pointing with his right hand. The older
man, who is wearing a hat and a dark-green ano-
rak tightly belted at the waist, is looking down
as he follows the explanations and gestures
of his interlocutor. Although it is clear here who
is giving directions to whom, there is some
question as to who has ultimate responsibility.
For this is a work of destruction that is being
examined, and we cannot be sure whether the
job is finished.

In the background of this scene, in the en-
trance area of the Kunsthalle, we can see five
people. They are the "audience" or something
like the chorus of the stage-like setting. On the
right edge, in the upper third of the image, stand
a young man and a young woman, who seem
to be watching the action. The man is leaning
against one of the pillars of the round portico
and is looking toward the camera, while the
woman's attention is fixed on a two-person film
crew positioned to the left of the pillar, who
have a 16 mm camera on a wooden tripod
pointed at the asphalt. The light-colored wood
of the tripod and the bright-red pullover of
one of the two camera operators are the two

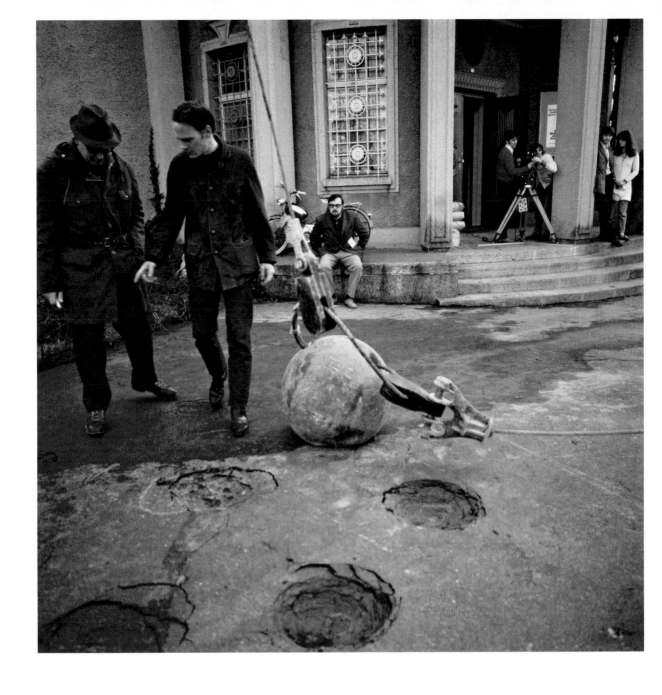

Michael Heizer, *Bern Depression*, **which featured in** *When Attitudes Become Form*, **Bern, 1969**

elements in the picture that contrast most strikingly with the otherwise predominantly stone-gray coloring.

Between these two pairs of people in the background and the two men in the middle ground, we see a person sitting on the plinth section of the entrance. His jacket is buttoned and his hands are buried in his trouser pockets—a piece of white paper is sticking out of his jacket pocket. You might expect to see a cigarette in the mouth of his bearded, bespectacled face, but there is no one smoking here at this particular moment. We may infer the importance of the seated figure from its central placement in the composition, directly above the wrecking ball. In actual fact, this figure is Szeemann himself, the artistic director, producer, orchestrator, and, some would claim, author of *When Attitudes Become Form*. Poised to jump up at any moment (or is his crouched posture due to the cold?), he is present at the creation of *Bern Depression*, a work by the US American earth artist Michael Heizer. The artist is the man in the leather jacket who is gesticulating; the man in the anorak is part of the construction company that has supplied the wrecking ball.

Here Burkhard clearly selected a composition that is both harmonious and richly evocative, but his photo is also a monument to the complex interplay of local and international actors in the art world around 1970. Moreover, the image conveys an impression of the extent to which the (here rather violent) impact on the institutional and physical space of art also creates an overall shift in the image of artistic practice. The curator invites artists who either make hands-on interventions or become commissioning clients and contractors. One way or another, the work is now realized in situ—the museum is turned into a construction site, workshop, or studio.

That Burkhard is not the only one to recognize this shift in the status quo on that cold March day in 1969, and to see it as something worth chronicling, is corroborated by the presence of the camera team in the background of the picture. It would be interesting to know to what extent Burkhard the observer felt himself observed and possibly curated at this moment by Szeemann, who is also looking in his direction. This photograph embodies a complex series of interactions both in what it shows and also in what it does not show but nonetheless expresses.

Tom Holert is an art historian, critic, and curator. Besides publishing work on contemporary and postmodern art, he also writes on visual culture, the governmentality of the present, and the politics of knowledge in the context of contemporary art.

Daniel Buren, *Affichages sauvages,* **in situ street installation in Bern, 1969** 89

Ralph Gentner

Some Recollections of My Friend Balthasar

We first met in Bern in 1958, just after I had arrived there to work as an architect at Atelier 5. The meeting probably took place in the Café du Commerce, which was then a favorite haunt for Bern's bohemian crowd. He was known as Bauz or Bäutzu (in Bern every name is given a distinctive local twist: Fritz becomes Fridu and Hans becomes Housi—no one is spared). This was also how he was addressed by Kasper, or Chäschpu, his beloved youngest brother who died at an early age. It wasn't that these diminutives of his name would have bothered him, but when he turned his attention to art, his name naturally had to revert to Balthasar. He had after all been christened with this unusual name.

We soon became good friends and got up to everything imaginable, including a lot of pranks, particularly at parties with arty types; strangely enough, somersaults on the carpet were a favorite trick. Archery was also assiduously practiced in a quarry near Bern. In the twenty years that followed, Balthasar Burkhard regularly took photographs for Atelier 5, which made our relationship even closer. After some "test shots" he replaced Leonardo Bezzola as the "court photographer" of our architects' collective in around 1968. Not because we hadn't been happy with Bezzola but because Balthasar had, so to speak, become part of Atelier 5. This was demonstrated, for example, in the international competition for a superstructure in Lima (in Peru), where we planned to present our project in a way that would be completely novel. As usual, Balthasar was fully committed to the idea—he photographed the models, colored in the plans, and did all-nighters with us. In addition to the documentation for the buildings, the best group photo of the partners ever taken was produced in the 1970s (p. 192).

Balthasar probably did not even think of himself as an artist when we got together in around 1970 to hang the series with the photos of barren farmland and fields and the shot of a tiny aircraft circling in the blue sky, mounting them on a high wall at my house (pp. 93, 96). However, this may have been the start of his career in the art world, oddly enough with a

black-and-white image tinted blue. Except for his very last few series, he was the black-and-white photographer par excellence. In Atelier 5, we occasionally tried to get him to photograph our buildings in color; but nothing doing—black and white was his way of seeing things. And that was fine, because a book like *Atelier 5: 26 ausgewählte Bauten fotografiert von Balthasar Burkhard* (Atelier 5: A Selection of 26 Buildings Photographed by Balthasar Burkhard) would never have been as compelling as it was if it had been interspersed with color pictures.

Much to my delight, a helicopter was sometimes hired in those days to take aerial views of our housing estates. Everyone knew Balthasar on the Bern-Belp airfield, not as a photographer but as the brother of Markus Burkhard, who was a well-known helicopter pilot and inspector with the Swiss Federal Office of Civil Aviation—which their father directed. Flying ran in the family.

Through Balthasar I got to know a lot of people in the art world, including Harald Szeemann, whose acquaintance I made in 1972 at documenta 5, where I also met James Lee Byars, who was to become a good friend. Balthasar photographed Byars at one of his performances, standing under the pediment of the Fridericianum (p. 70). Or Niele Toroni, with whom he had a very fine joint exhibition at the Musée Rath in Geneva, which led us at Atelier 5 to suggest the two of them as artists for the new buildings for the teaching seminar in Thun, where they did magnificent work. Incidentally, Niele called him "Balt"—Balthasar was presumably too baroque for him.

In 1975 we drove together from New York to Chicago because Balthasar was taking up a teaching position in the Department of Art at the University of Illinois. In New York we had lived in the loft of Kasper König, with whom we visited On Kawara and played ping pong, although, of course, we lost one game after another hands down.

When Balthasar returned to Europe, he was accompanied by Christina Gartner—the two of them lived together for years in Bern and La-Chaux-de-Fonds. She supported him in his work, and her sister Lucy was the model for the reclining nude (pp. 150–53) I saw at the exhibition in the Kunsthalle Basel in 1983, wonderfully hung by Remy Zaugg. Christina now lives in Berlin, married to the painter Bernd Koberling. Up until his death, Balthasar regularly spoke with her on the telephone, and she is still a good friend of mine too.

During his time in Chicago Balthasar suddenly got the idea of starting a career as an actor. At that time I was back in America on my second visit there, along with the painter Christian Lindow. Balthasar lent us his car for

a trip right across the USA, all the way to the West Coast. In Los Angeles we met Urs Egger, a friend from Bern, who subsequently helped Balthasar to get a part in the film *Eiskalte Vögel* (Icebound), which was to be his only leading role in the movies, albeit not in Hollywood. On the way back to Chicago, we managed somewhere in New Mexico to get hold of the snakeskin that covered his Hollywood application portfolio.

Ralph Gentner joined the aspiring young firm Atelier 5 in Bern after completing his architectural studies in 1958. He later went on to become a partner. Atelier 5 was known for its intimate connection with the Bern art scene. Gentner not only provided Balthasar Burkhard with commissions when he was a young photographer but was also his friend and close associate. Burkhard's photos were instrumental in securing the Pritzker Prize for Atelier 5 in the 1980s.

Emancipation as an Artist

Burkhard takes his first artistic steps in the company of artists who have become his friends, such as Markus Raetz. Besides a series of conceptual landscape photographs, the two friends develop a sequence of large photographs on canvas at the invitation of curator Jean-Christophe Ammann. These works no longer represent a window on reality; instead, they question the reality (and illusion) of the image itself. They presage photography's incipient conquest of the large-scale format and its venturing into a realm where art dominates and fills its surroundings.

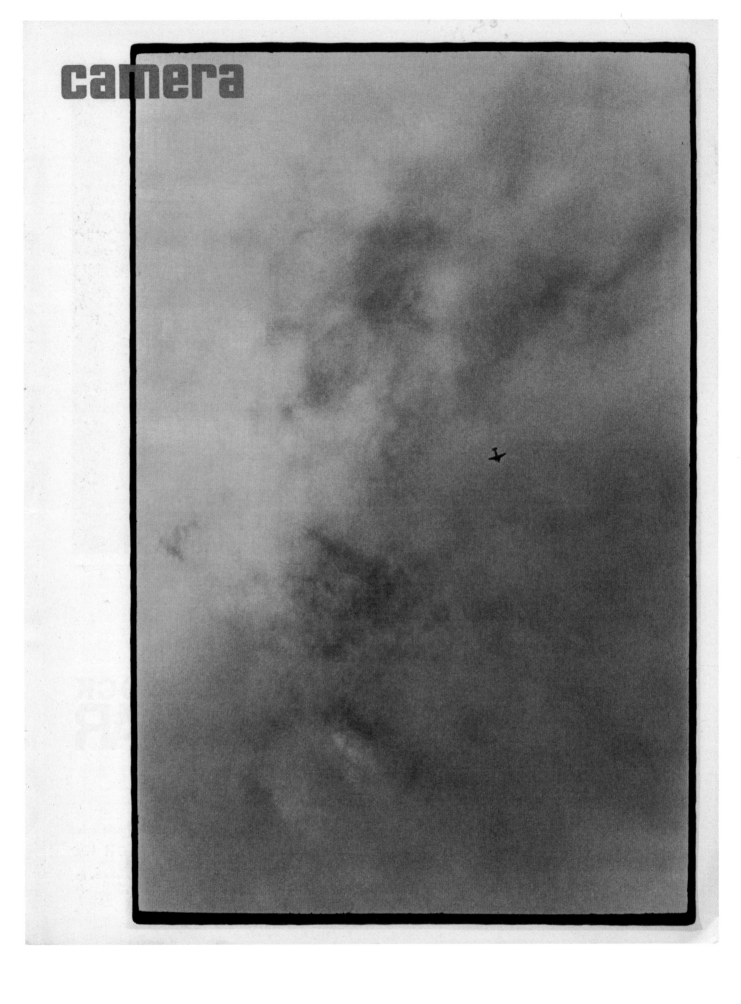

camera

BALTHASAR BURKHARD

'He does not photograph in order to fix emotional motives, to bring portentous elements in contact with one another. It is not his eye which is selective, but the perception which determines the cropping. The phenomenon—its mood and individuality—is captured in such a way that there can only be one way of cropping, one picture section. Thus the photographer is concerned with a category of reality which can be considered as neither expressionistic (the projection of a world of feeling), nor abstract and stylized (reduction to basic design principles), nor engaged (a purely personal statement), but as one which represents an attempt at a sober objectification of reality; i.e., the fundamental elements such as light, emptiness, nearness and distance, earth (its weight as a material phenomenon, its relationship to the texture of the snow) are superimposed as transparent plains. The aesthetic aspect arises from these perspectives, the unity of which—the simultaneous, impartial concern with the individual and the whole—defines the landscape as both sign and object. Thus the brown tone of these pictures is not merely an optional extra but a contributory element in the materialization factor of the total image. The presence of the brown tone in one of the pictures with aeroplanes—the one aeroplane was photographed from another—is due to the fact that the photograph, taken by Burkhard's father, is old. In the other picture, an aeroplane photographed from the ground, the brown tone is absent since it would fulfil no purpose.

'Work by Balthasar Burkhard and Markus Raetz portraying reality as objectified facts were shown in the exhibition "Visualisierte Denkprozesse" (Visualized Thinking Processes) in the Lucerne Art Museum in 1970. Among the works shown were images of a bare studio, a bedroom, a kitchen, and a curtain presented on huge screens. The purely concrete character of the pictures was made relative by the fact that the screens were hung on pegs, and the resulting folds endowed the images with a new dimension with which—as a result of the manner of presentation—they were identified.

'The pictures shown here were made in the winter of 1969. From the thematic point of view, they would appear to be connected with certain contemporary developments in the visual arts. Their poetry stems from the inherent inner laws of both subject and representation using a motive which possesses all the characteristics indicative of a new perception of reality.'

By Dr. Jean-Christophe Ammann, curator of the Lucerne Art Museum.

Balthasar Burkhard was born in 1944 in Berne, where he still lives today. As a freelance photographer and chronicler of the young Bernese avantgarde, he works for the Bernese Museum of arts, the Kunsthalle. He was co-producer of the films *Thirteen Bernese Museums* and *Twenty-two Young Bernese Artists* (1969), and together with Harald Szeemann he made a film about the Münstergasse in Berne entitled *Height × Length × Width × 100 Arcades,* as well as photographic documentations on contemporary artistic creativity.

Burkhard used a Nikon camera with a 35-mm lens and Kodak film (400 ASA). The lighting was available daylight, the film was developed in Microdol-X, and the enlargements were made with a Leitz Focomat enlarger and tinted brown or blue.

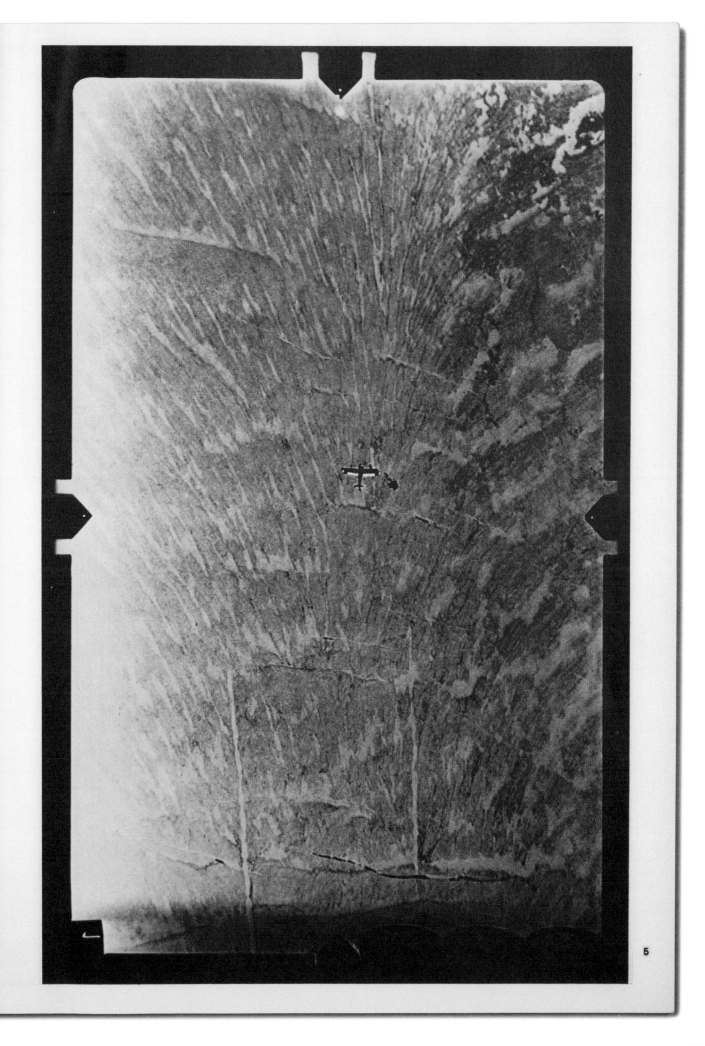

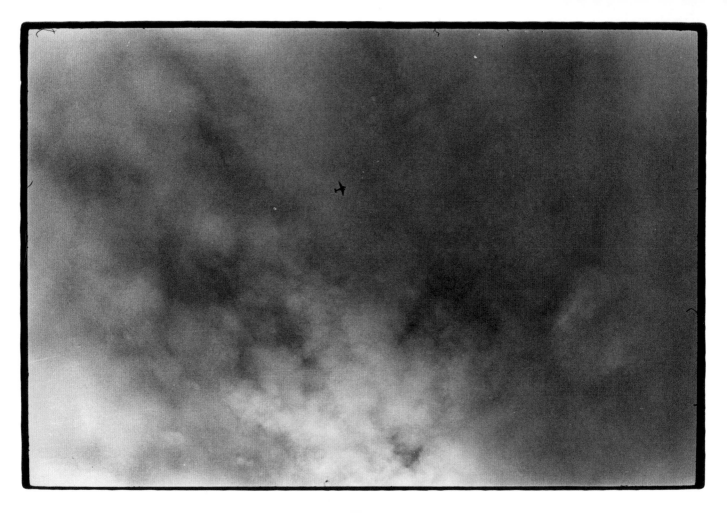

96 *Himmel,* 1969: the original picture used for the cover

⬆ **Picture taken by Balthasar Burkhard's father: photograph of a glacier landing, 1928**
▲ **Burkhard's father taking photographs from an airplane, 1920s**

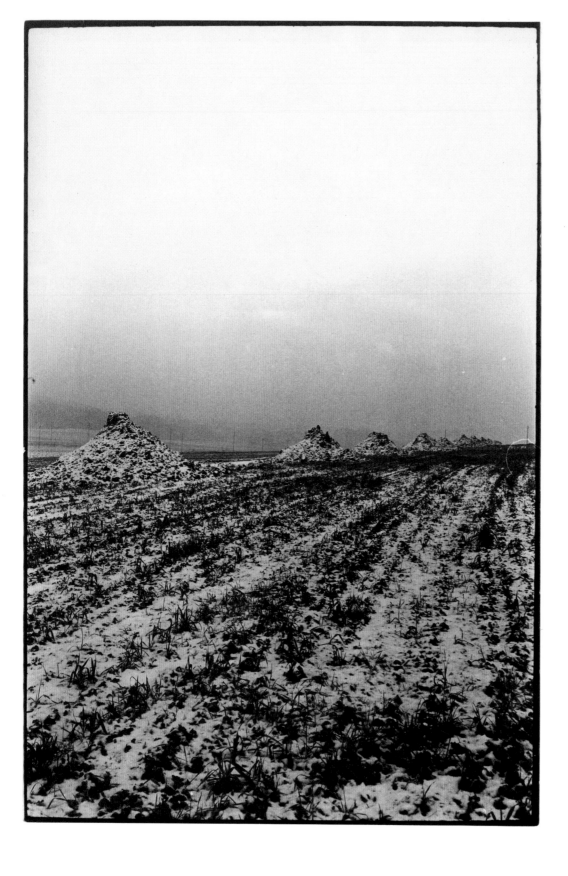

98 **Photographic series showing a designed landscape, 1969**

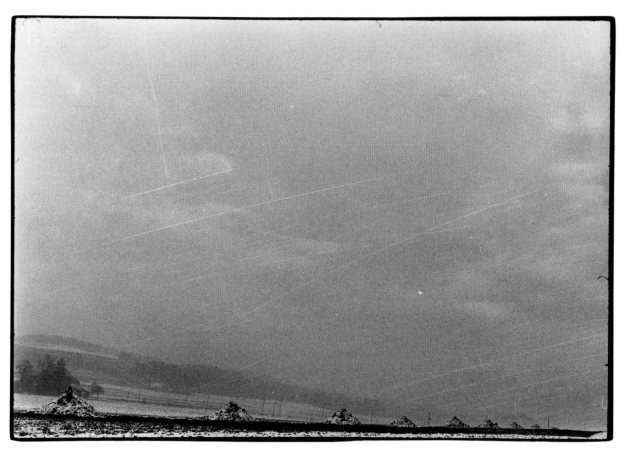

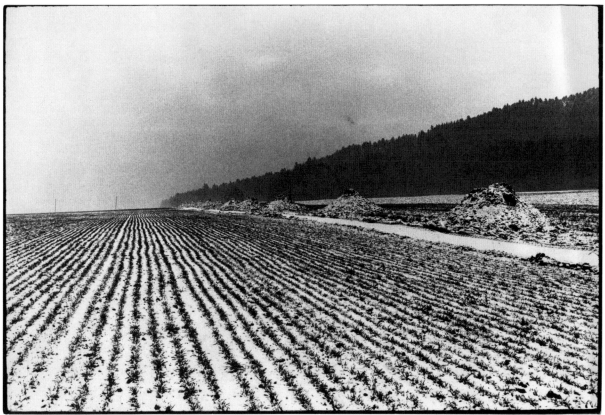

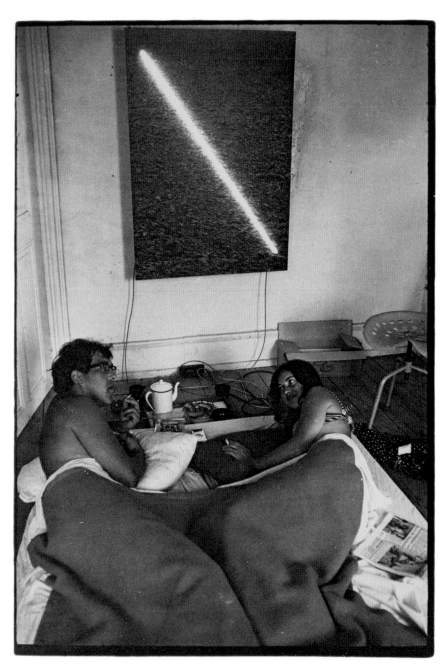

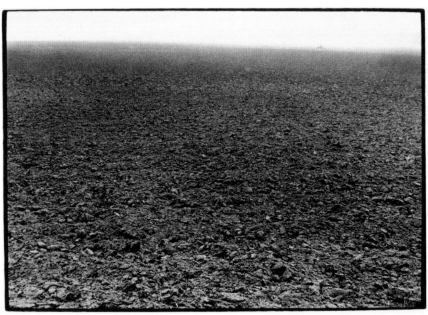

⬆ On the wall: illuminated object *Live in Your Head* (joint work by Burkhard, Schnyder, Raetz, and Szeemann) ▲ *Erde*, 1969

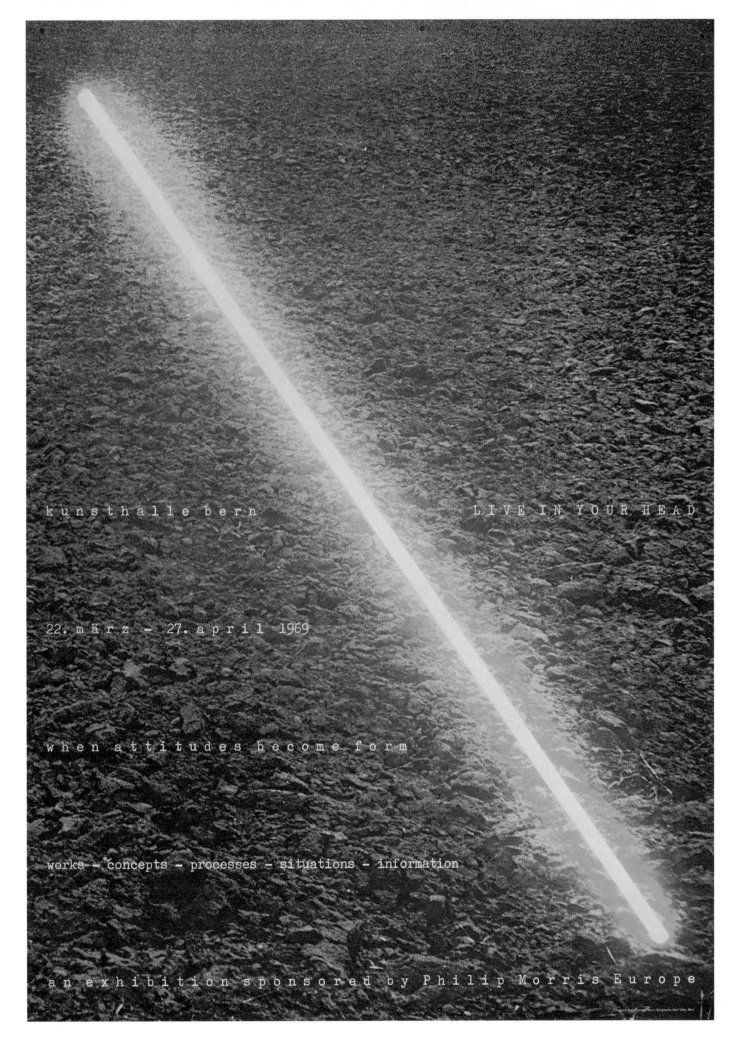

Poster for *When Attitudes Become Form*, 1969

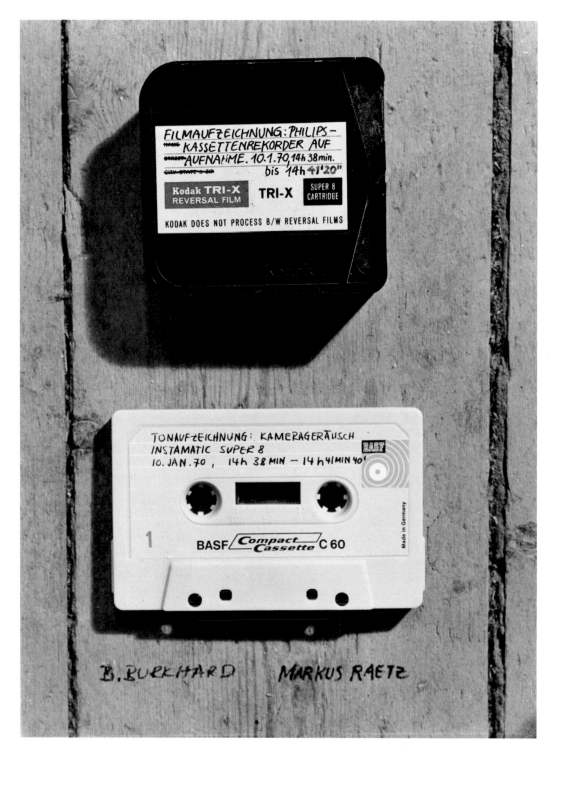

Balthasar Burkhard and Markus Raetz, *Kassetten,* **1970**

```
┌─────────────────────┐
│  MARKUS RAETZ       │          Balthasar Burkhard
│  KOGGESTRAAT 11     │    &     z.Zt. Koggestraat 11
│  AMSTERDAM-C.       │          Amsterdam-C
└─────────────────────┘
```

Herrn
Dr.Jean-Christophe Ammann
Kunstmuseum
CH-6000 L u z e r n

 Amsterdam, den 1.1.7o

Lieber Jean-Christophe,

Es ist 18.22h MEZ und unsere Arbeit für die Luzerner Ausstellung
läuft seit 18 Stunden 27 Minuten.
Den Anfang unserer Arbeit bildet die visuelle (Film, Fotos) und
akustische (Tonbänder) Registrierung des Jahrzehntenwechsels.
Burkhard und Raetz filmten und fotografierten in Amsterdam eine
Leuchtuhr, während Stähli, den wir inzwischen auch eingeladen hat-
ten, in Luzern Tonbandaufnahmen der Kirchenglocken und des telefo-
nischen Zeitdienstes machte.
Dies schreiben wir Dir, dass Du Dir ungefähr vorstellen kannst, wie
wir uns das so denken.
Die Arbeit wird hundert Tage dauern, und in Luzern möchten wir stän-
dig die neusten Ergebnisse unseres Schaffens ausstellen. Das können
Fotos, Filme, Zeichnungen, Texte, Tonbänder, Objekte etc. sein.
Ende Januar werden wir Dir die ersten 31 Tagesarbeiten schicken.
Alles wird in A4-Plasticmäppchen verpackt und im Museum an die Wand
gehängt, so dass die Besucher sich selbst auf dem im selben Raum
stehenden Xerox-Gerät einen Katalog zusammenstellen können. Die Ko-
pien sollten in ein Plasticmäppchen oder in die dafür konzipierte
zweite Umschlagklappe des gedruckten Katalogs gelegt werden können.
(Aufdruck. Burkhard-Raetz-Stähli. Die ersten hundert Tage der Sieb-
ziger Jahre. Dies ist der Titel unserer Arbeit.Arbeitstitel 1./1oo/7o)
Die beigelegten Polaroid-Fotos sind für den gedruckten Katalog gedacht.
Die Raetz-Projekte von der Galerie Mickery könnte man auch zum Kopie-
ren an die Wand hängen oder teilweise im Katalog abdrucken.
Ab jetzt werden wir immer via Stähli, unserem Mann in Luzern, mit Dir
in Verbindung bleiben.

Herzlich grüssen Dich

.RALZ............... RAETZ............

 ┌──────────────────────────┐
 │ MARKUS RAETZ │
 │ DIE ERSTEN HUNDERT TAGE │
 │ DER SIEBZIGER JAHRE │
 └──────────────────────────┘

Beilage. 2 Fotos
```

**Letter from Balthasar Burkhard and Markus Raetz to Jean-Christophe Ammann during the project**
*Die ersten hundert Tage der Siebziger Jahre*, 1970

Bern, den 19. Januar

Lieber Jean-Christophe,

Du hast mich gebeten, Dir einen Katalogbeitrag zu schicken.
Hier einige Photos, die ich heute morgen  - Bern ist im Nebel
und monoton - während ungefähr einer Stunde gemacht habe. Ohne
speziell auszuwählen schicke ich Dir was ich für mitteilungswür-
dig halte. Jeder Alltag ist würdig, mitgeteilt zu werden. Wenn
ich Iseli treffe zum Beispiel, oder Eggetschwiler. Oder wenn
mir das Lifthäuschen auf der Plattform in die Augen springt.
Wenn ich Dir  diese Photos schicke, so möchte ich gleichzeitig
auch wissen, welches Dein Alltag ist, wie Du ihn siehst und
was für Dich würdig ist, festgehalten zu werden.  Mit Deinem
Apparat kannst Du meine Photos ergänzen. Du kannst sie besser
machen oder ihnen andere gegenüberstellen. Meine Photos sollen
Ausgangspunkt für ein Gespräch, für einen Dialog  sein. Was
für mich Ablauf ist, Aufeinanderfolge, kann für Dich Anregung
sein für Gedanken oder Assoziationen. Mit dem Apparat kannst
Du diese festhalten, gleich jetzt,wenn Du willst. Auch der
Besucher der Ausstellung sollte dies tun können. Ich werde zu
diesem Zweck eine Kamera während der Ausstellungsdauer bereit
halten. Das Photo als unumstössliche Feststellung oder Aussage
interessiert mich nicht. Wenn ich einen Augenblick festhalte,
so nur weil ein anderer auf ihn folgt. Für mich ist er anders
beschaffen als für Dich. Beides verdient mitgeteilt und weiter-
gegeben zu werden. Jedes Photo interessiert mich, keines lässt
mich gleichgültig: Dein Photo, das Bild in der Illustrierten
oder das Bild am Fernsehen.

                    Freundlich grüsst Dich  BALTHASAR

Wenn Du willst, kannst     diesen Brief als Textbeitrag be-
trachten. Kannst Du ih                   ihn im Druck über
die Photos hinweglaufe

**Proposal for a contribution to the catalogue for the exhibition** *Visualisierte Denkprozesse,*
**January 1970: letter to Jean-Christophe Ammann and enclosed photos**

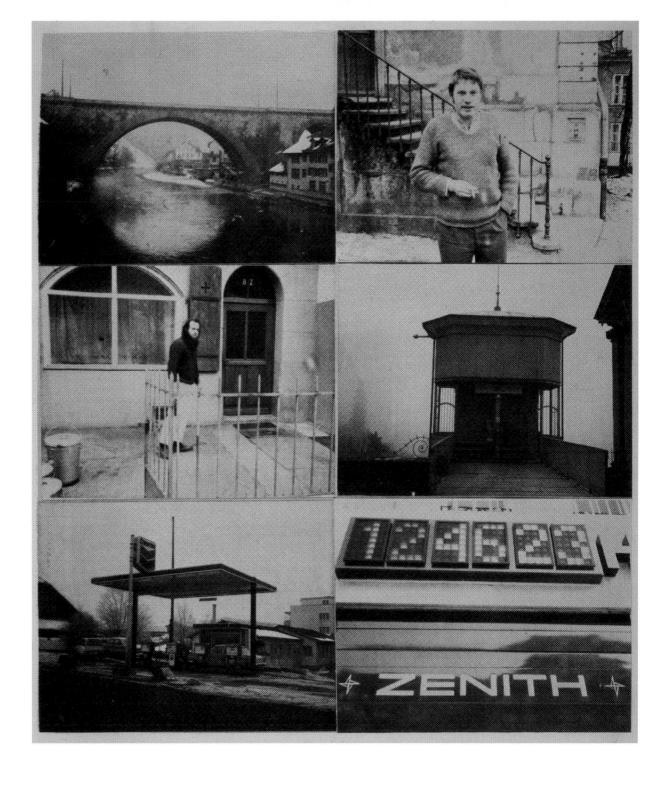

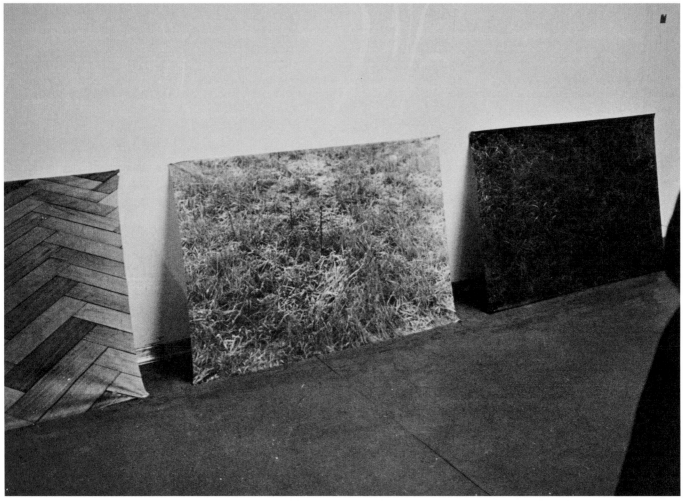

106  ▲ **First exhibition of conceptual photographic works by Balthasar Burkhard and Markus Raetz,**
*Visualisierte Denkprozesse*, **Lucerne, 1970**  ▶ *Das Bett* **(photo canvas with Markus Raetz), 1969/70**

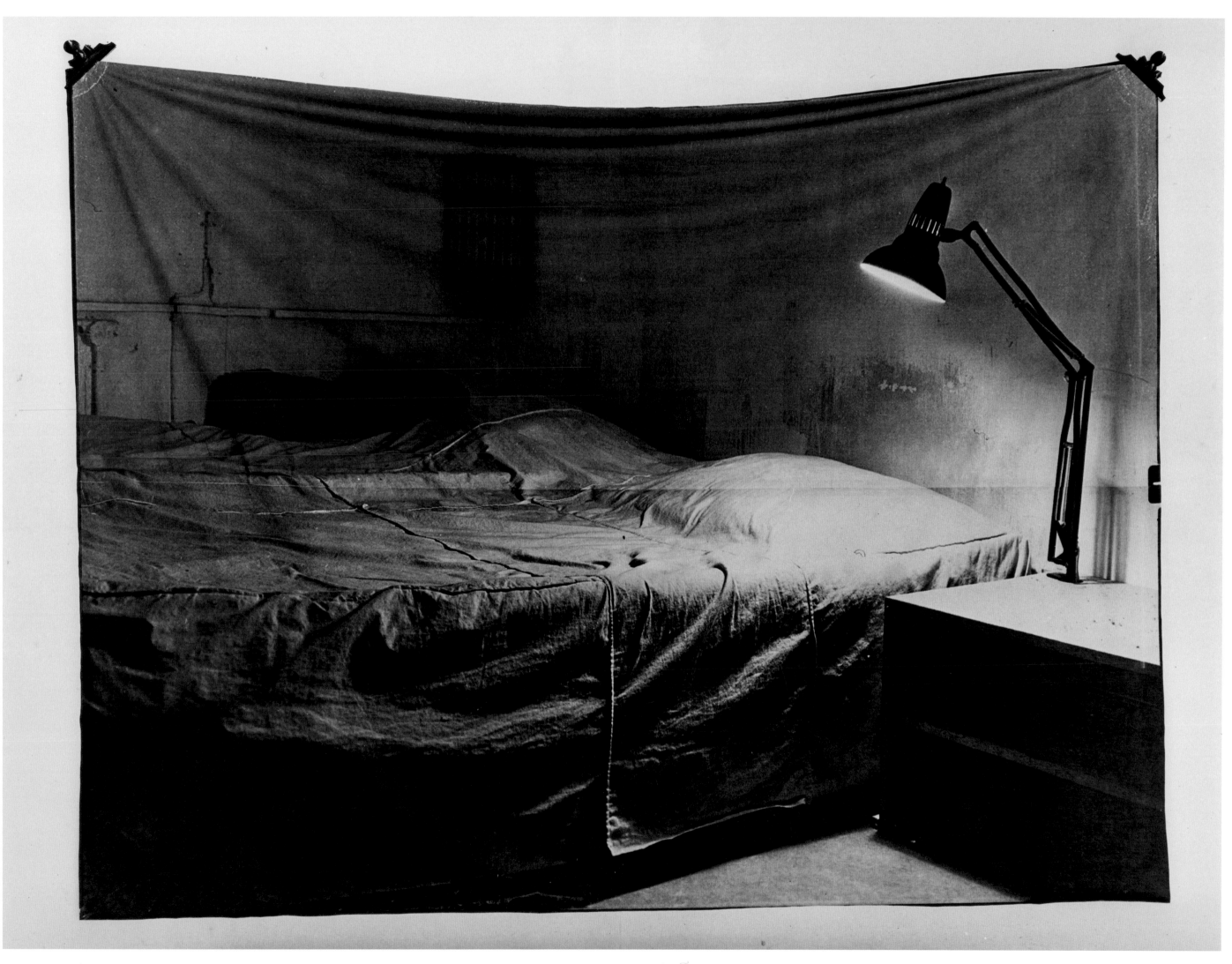

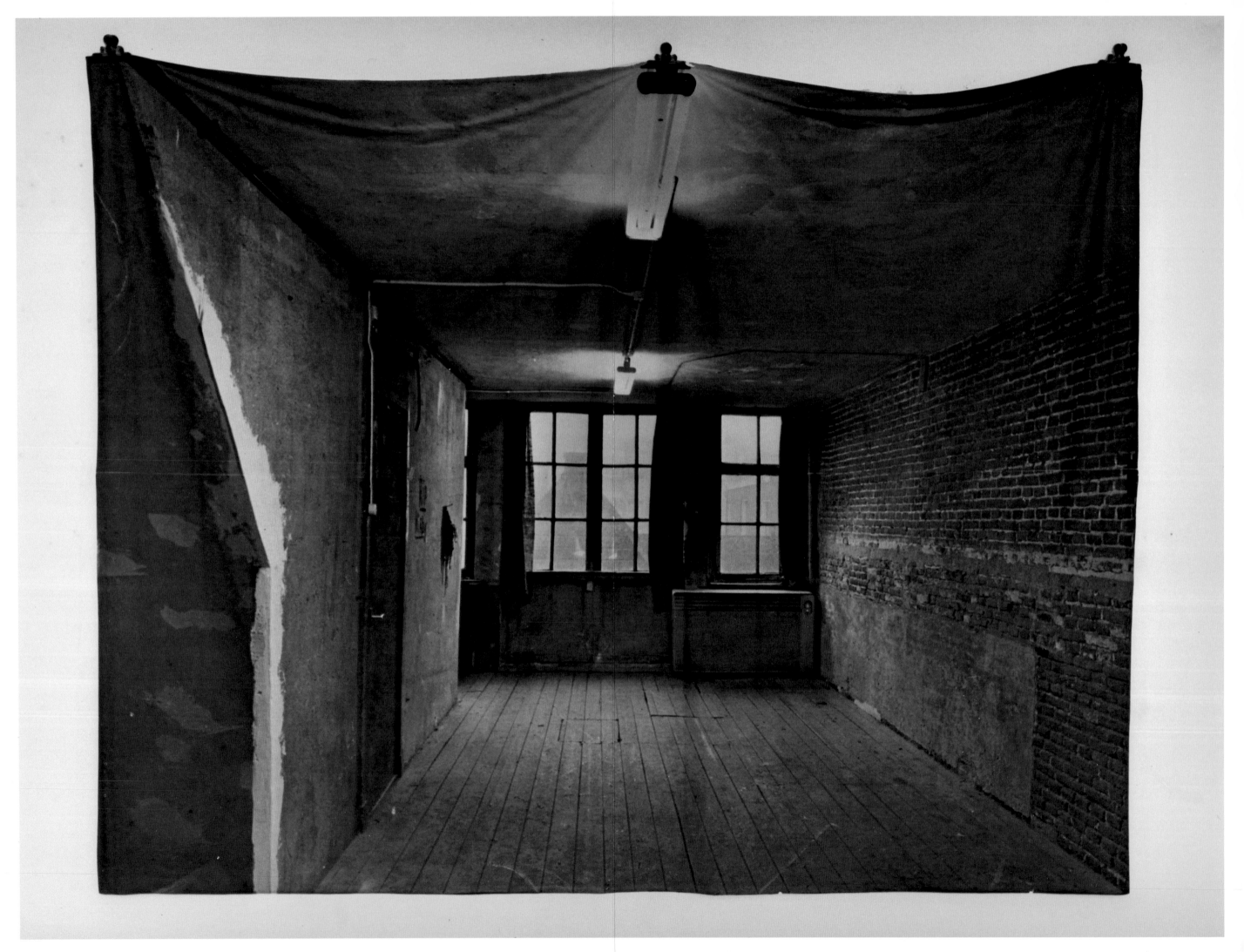

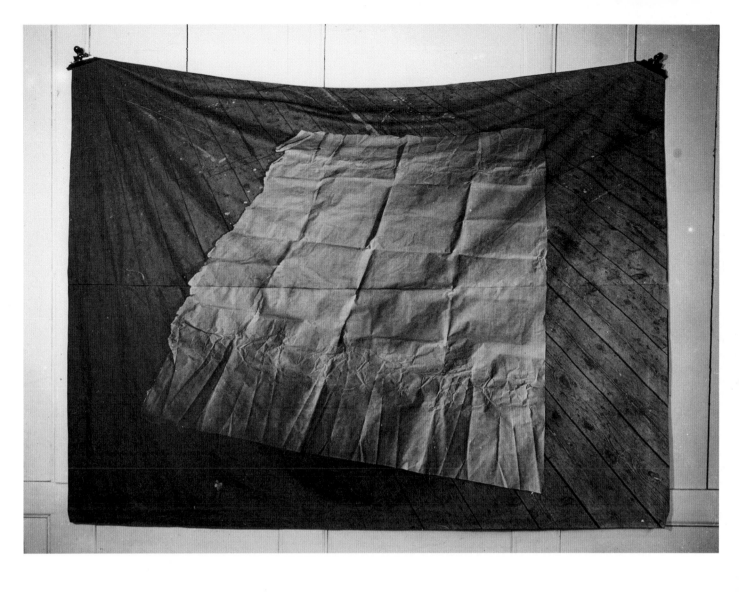

◄ *Das Atelier* ▲ *Das Papier* (photo canvases with Markus Raetz), 1969/70

110    *Der Vorhang* (photo canvas with Markus Raetz), 1969/70

GERRY + ROLF WEBER
MARKUS + MONIKA

FRÜHJAHR 1970
AMSTERDAM

KUNSTMARKT BASEL 1971

DR. MARIA NETTER  TONI GERBER  GISLIND NABAKOWSKI
VOR EINER FOTOLEINWAND (BURKHARD/RAETZ)

⋏ **Markus and Monika Raetz, Gerry and Rolf Weber, Amsterdam 1970**  ⋏ **Maria Netter, Toni Gerber, and Gislind Nabakowski in front of the photo canvas** *Das Bett*, **Kunstmarkt Basel, 1971**

# Chicago

Burkhard's post as a lecturer in photography
at the University of Illinois in Chicago between
1975 and 1978 opens up new horizons for the
young photographer. Both Europe and the
photographic medium itself seem to have be-
come too restrictive for him. He applies for and
tries his hand at acting jobs. He turns himself
into the subject of his own work and finally
succeeds in finding his own way as an artist.

exhibition
ward gallery
650 s. halsted 2nd floor
thru january 16
11-3 daily

BALTHASAR
BURKHARD

lecture
room 3304 a&a
wednesday, january 14-1:30

presented by UICC art dept. and college of architecture and art

**Poster announcing a lecture by Balthasar Burkhard to students in Chicago, 1976**

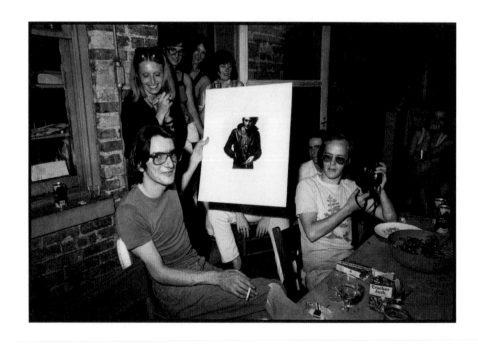

114

⭸ **Selection of slide transparencies for Burkhard's Chicago lecture**
⭯ **Balthasar Burkhard with students in Chicago, 1976**

*7*

Ich rede heute über Fotografie. Ich tue dies auf Grund meiner

eigenen Erfahrungen mit diesem Medium und anhand meiner Werke.

Sie werden aber dabei *auch Arbeiten* andere Personen sehen. Sie werden

Postkarten und Fotos sehen, die nicht von mir sind. Meine

Fotos sind ein kleiner Anteil an der Gesamtheit der Fotos.

Was im folgenden auf meinen Fotos geschieht, ist privat.

Trotzdem ist es stellvertretend für die 60ger Jahre:

Wir leben mit neuen Ideen. Heute leben Sie mit neuen

Ideen. An Ihnen liegt es, die Parallele zu Ihrem Leben

herzustellen.

Die Präsentation habe ich nicht allein gemacht. Mein

*weisser Affe X*

Freund Walo hat mir als weiser chinesischer Affe geholfen.

Ich selber fühlte mich während der Arbeit in der Rolle des

*ANUBIS X*

ägyptischen Gottes in Hundegestalt: Anubis. Anubis sitzt,

auf den alten Darstellungen, auf dem Schrein, in dem sich

die Amulette und Juwelen des Königs befinden.

Ich zeige Ihnen im folgenden alles (oder fast alles),

was ich in den letzten 12 Jahren getan habe. Seit meiner

*X SCHULFOTO*

ersten bewussten Begegnung mit Fotografie - also seit ich

im zweiten Schuljahr von xxx einem professionellen Schul-

fotografen mit meinen Schulfreunden abgeknipst wurde -

habe ich natürlich - fasziniert von der Technik, die

manchmal wirklich Wirklichkeit einfängt - verschiedene

Anläufe unternommen, es dem Schulfotografen gleich zu tun.

Im gleichen Jahr - vor 24 Jahren - gab mir mein Vater eine

einfache Kamera mit auf den Schulausflug, mit der gut-

gemeinten Ermahnung, Telefonstangen nach Möglichkeit

nicht prädominieren zu lassen. Resultat: Ich knipste Land-

schaften.

Architektur-Fotos mache ich seit 1968. Damals kam ich in Kontakt mit einer Berner Architektengruppe, dem Atelier 5. Die Fotos waren Aufträge für eine Gruppe von Leuten, die ich gut mag, und deren Arbeit ich sehr schätze. Mein Auftrag, den ich mir selber gestellt habe, war, die Fotos mit dem selben Engagement zu machen, mit dem die Häuser gebaut wurden. Ich habe mit diesen Fotos viel gelernt. Ich habe vor allem eine Haltung kennengelernt, die ich zeitweise auch zu meiner Haltung gemacht habe. Diese Haltung hat ~~der Architekt Niklaus Morgenthaler~~ das Atelier 5 in einer internen Diskussion einmal folgendermassen umschrieben:

Wir haben als Zielsetzung in kurzer Form gesagt: "Das Atelier 5 will nach Möglichkeit Arbeiten realisieren, die geeignet sind, unserer Umwelt als gutes Beispiel der Lösung eines Problems zu dienen. Dies kann in der Regel nur unter gut/en Bedingungen geschehen, gemeint ist damit, dass der Auftraggeber bereit ist, mit uns zusammen sich mit der Aufgabe wirklich zu beschäftigen, d.h. er will selber dazu beitragen, der Umwelt ein gutes Beispiel zu liefern.

Die wirklichen Ziele des Atelier 5 liegen darin, als Architekt und Planer innerhalb der gebauten Umwelt Verhältnisse zu schaffen, die den Menschen dienen und die auch als gute Beispiele erlebt werden können.

"Architecture is the attitude of mind and not a profession".

Le Corbusier

**Typescript page from Chicago lecture**

**Selection of slide transparencies for Burkhard's Chicago lecture**

Stefanie Unternährer

# Profile of a Lost Work

In the early stages of researching this exhibition, two Polaroids came to light in Balthasar Burkhard's estate: mounted on card, they show an installation of three large photographs in vertical format. These works have hitherto not been published in any of the catalogues on Burkhard, nor are they mentioned in any of the texts about him. It would appear that they were made in 1977 for his first solo exhibition, *Photo Canvases*, at the Zolla/Lieberman Gallery in Chicago. Besides well-known works like *Backseat* (p. 121) and *Entwurf* (p. 131), the gallery also presented these three works on canvas. The Polaroids are the only installation shots preserved in the estate—even though Burkhard made a photographic record of all his exhibitions.

However, his estate does contain the 35 mm negatives that were used to produce the canvases as well as a napkin on which Burkhard sketched the idea for his work. The narrow vertical photographic canvases are detail enlargements of horizontal pictures.

In 1975 Burkhard moved to Chicago, where he cultivated a close friendship with artist Thomas Kovachevich. We know from Kovachevich that Burkhard would occasionally wander through parts of the city that were considered dangerous. As disco and club culture flourished, roller-skating came into fashion, especially in areas that were mainly inhabited by Afro-American communities. Burkhard thus discovered a new subject for his work in Chicago's South Side.

One of the Polaroids shows Burkhard's partner at the time, Christina Gartner-Koberling, standing in front of the works. As she recalls, it was unclear at first whether the canvases were actually destined to feature in the exhibition. Burkhard was working on the series until shortly before the opening. He had even driven to New York with two students to photograph the roller-skating culture there as well. As it turned out, though, he ended up using the photographs he'd taken in Chicago for his canvases after all. On the trip to New York, however, he took another picture that is much better known today: the

photo of the back seat of the car Burkhard was traveling in. This motif was the basis for the photo canvas *Backseat*.

Although there is no indication of why the canvases of the roller-skaters no longer exist, there are various stories in circulation. One of them, related by Thomas Kovachevich, is based on Burkhard's own description. The owner of the Zolla/Lieberman Gallery had invited a renowned art critic to a swanky lunch, but the critic had cried off at short notice, whereupon the gallerist replaced the silver cutlery and expensive wine with paper plates and simple food. Burkhard was so annoyed about this that he destroyed the series.

For this exhibition the roller-skater shots have been produced afresh from the scanned negatives in the form of inkjet prints. It was not possible to enlarge the images on light-sensitive canvas, as this kind of material is no longer being manufactured. Moreover, we wanted to avoid giving the impression that we were showing "originals." The framing of the images is modeled on the framing from the Polaroids. All of Burkhard's photo canvases from this period have a width of 102.5 cm. The new prints make use of this format.

*Stefanie Unternährer is a curatorial assistant at the Museum Folkwang; she was co-responsible for producing the exhibition in Essen.*

*Rollerskaters*, 1977 (Reconstruction 2017)

◂ *TV Chicago, 1977* ▴ *Backseat, 1977* 121

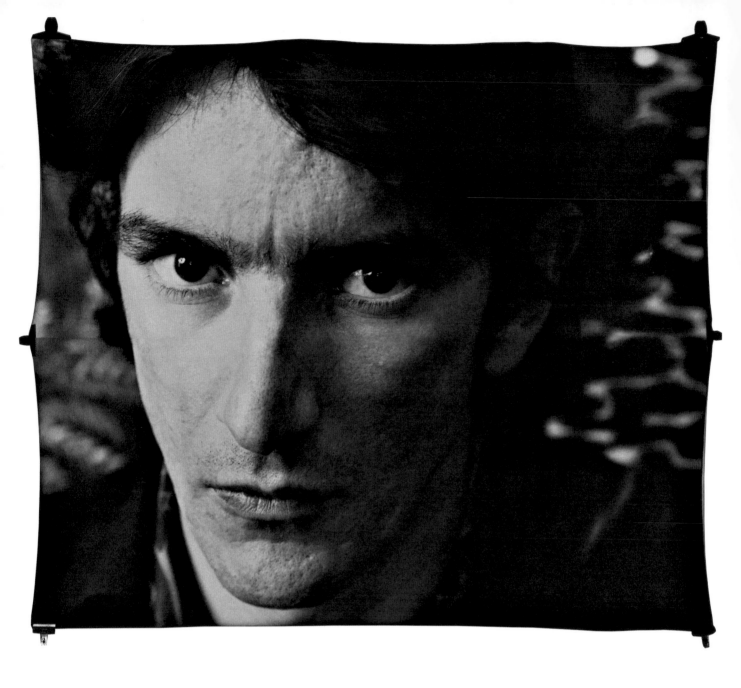

122    *Selbstbildnis*, **1977, as large-format photo canvas**

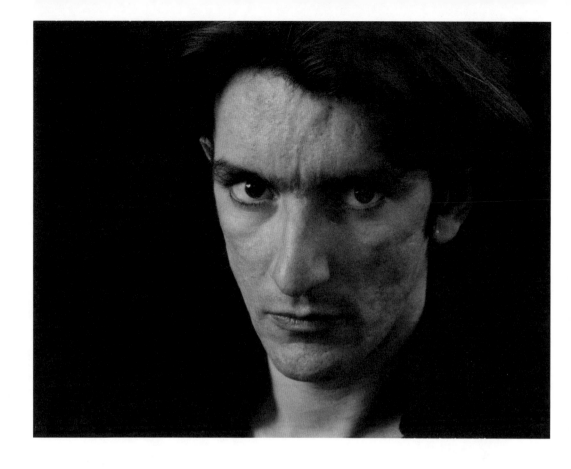

*Selbstbildnis*, 1977, print from Polaroid negative (with Thomas Kovachevich)

124    *Snakeskin Box*, 1976 – Burkhard's Hollywood application material

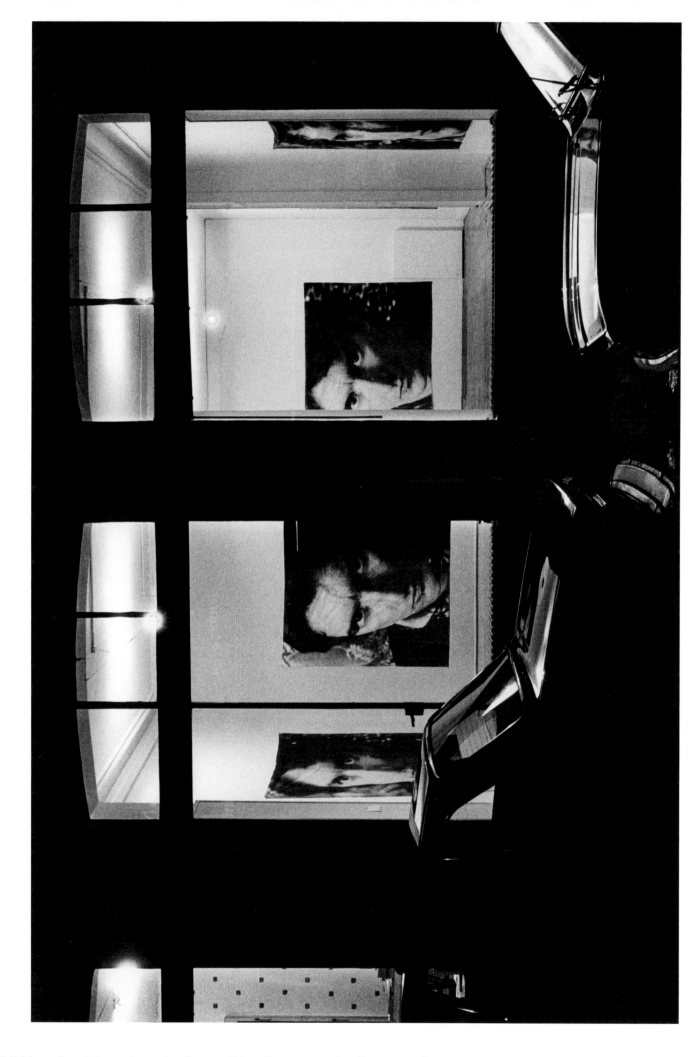

**Exhibition view *6 Portraits* at the Centre d'Art Contemporain, Geneva, 1980**

# Beyond the frame

## Swiss photographer transfers prints to huge hanging canvas

### Donald M. Schwartz

A Swiss photographer exhibiting in Chicago has made a striking breakthrough in the presentation of photo prints.

For a long time photography has been held back as an art form by the standard, rather trivializing presentation of photo prints. Typically, a black-and-white print was stuck on a white mounting board, or perhaps, if one were really getting fancy, the print was framed.

A whole row of prints with white mounting board borders tends to look like so many humdrum postage stamps pasted on a wall. And framing frequently doesn't help much because photographs don't stand up well to framing.

But Balthasar Burkhard has done something quite different, demonstrating that the effect and impact of photos can be transformed.

Burkhard, in an exhibit at Zolla/Lieberman Gallery, 368 W. Huron, has produced a group of photo prints on large pieces of canvas. And he has let the canvas drape and sag on the walls, somewhat like big bed sheets. Moreover, his floppy canvas photographs are without borders or framing—they are simply soft photographic images which have made their own place on the walls without benefit of any irrelevant assistance.

The effect is potent. And it was also pretty unpredictable. Because the prints are far stronger, far more impressive than photographs served up in a more formal, elaborate manner.

A self-described admirer of Roman Polanski's work, the photographer could easily have stepped out of one of Polanski's avant-garde films. In fact, he has a desire to be an actor.

But he also has some of the classical attributes of the true artist—he reserves an area of his work to please only himself (although he has worked as a commercial free-lance photographer); he is a perfectionist and he searches for methods to carry out his artistic desires—not merely to create some kicky new effect, but to express the artistic feelings and values that attract him.

Commenting on how photographs are affected when they're printed on softly draped canvas, he said: "They become something else." Burkhard said that printing on large pieces of canvas (covered with photographic emulsion) appealed to him because of the big scale that was possible.

He knew of 4-foot-wide rolls of photo canvas manufactured by a German firm, and a look at his earlier work showed his propensity for vast scale. Even in some small prints, reproduced in a photo magazine, Burkhard's pictures emphasized huge spaces.

But scale wasn't the only thing that attracted Burkhard.

"The canvas came in also because I was able to create these folds, to create a new reality," he said.

To get the softly draped effect, he treats the finished canvas print with glycerin, or else the canvas would be stiff. As it is, his prints move and float in a breeze like a flag.

"With these folds there's somehow the creation of a new reality," he said, and he added that with large pictures of interiors, viewers feel like they have "the possibility of entering them; the pictures hang just a foot above the floor."

But there is a twist. While his very realistic photo technique gives "the impression of a real situation, on the other hand, these folds take you away from it again."

One of Burkhard's pictures is of a room with a TV set on a rolling cart, and a chair, an empty glass and an ash tray on the floor. The floor boards themselves are quite sharp, clearly depicted. It's all very real and very ordinary; one can visually enter the scene quite easily—it's no remote art. And yet the scene is draped on a wall, presented in soft folds . . . and so, not real after all.

Burkhard's technique has thus set up a tension that often appears in good art.

Four of his soft photos feature the kind of ultra-mundane content that has become a trend in a certain type of contemporary photography—a table top littered with cups, plates, glasses and a beer bottle, following a meal; the back seat of a car with a crushed beer can, newspapers and a jacket dumped in a heap.

But the most effective piece in the exhibit is

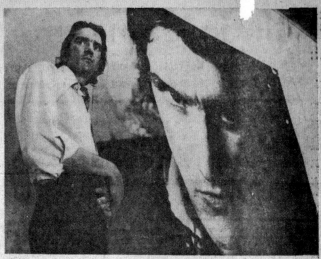

Balthasar Burkhard's canvas displays add a new dimension to photography—the huge self-portrait seems to capture his persona. (Sun-Times Photo by Jim Mescall)

a self-portrait, another staple of the traditional artist.

This self-portrait is huge—about 6 1/2 by 10 feet. It's as though Burkhard's persona has been captured on a bed sheet. With intense eyes and a firmly set mouth, he stares out of the canvas that hangs loosely on the wall and casts a rapidly changing shadow when it blows in a breeze.

Like all the canvas photos in the room, the picture seems especially intimate and engaging.

And one is made to realize that traditional, flat prints leave the photographic image remote and separated from the viewer—out there, somewhere beyond the camera lens. Burkhard's new technique brings the content right up to you and you are put on close terms with it.

The Swiss artist, who started out in photography 16 years ago, has just finished a teaching stint at the University of Illinois at Chicago Circle and plans to go to Los Angeles this summer to pursue some new photo ideas associated with film making.

## Funny things happen to Altman, like...

Continued from Preceding Page

anticipate they will, it will certainly be my funniest film. I mean really funny. But then funny things happen every day. . . ."

The man in white came on quiet shoes, and there was another scotch and soda where the old one had been. Altman obviously had a funny example in mind.

"I had this lady interviewer following me around," he said. "More of that in-depth crap. She was convinced that life with Altman was a

never-ending round of orgies and excess. She was even snooping around in my hotel bathroom, for Christ's sake, and she found this jar of funny white power in the medicine cabinet. Aha! she thinks. Cocaine! So she snorts some. Unfortunately, what she didn't know was that I'm allergic to commercial toothpaste because the dentine in it makes me break out in a rash. So my wife mixes up baking soda and salt for me, and . . . poor girl."

He lifted his glass and mutely toasted her, and Cannes, and whatever.

# 5 years memorable

A doctor by profession, Kovachevich had been observing the permeability of a range of fibrous materials for several years. He noticed how water vapor was diffused at different rates and how subtle environmental variations also contributed to the fibers' expansion or contraction. All of this led to "Paper Comes Alive," the poetic blend of science and art that is Kovachevich's most important achievement.

When first shown before a large audience in Chicago — at the Museum of Contemporary Art, in January, 1977 — "Paper Comes Alive" was a series of performances in which precut papers danced on permeable membranes draped over pans of water. Not long after, Kovachevich patented the idea, issuing a book with everything required for performances at home. Called "K-Motion: Paper Comes Alive," the book now is available in several stores, and the artist thinks of it as his contribution to "public art."

Kovachevich's own performances continue to get richer and more allusive, while remaining completely abstract. Their genius lies in that duality, for no one can come away from them without having certain artistic preconceptions challenged and the emotions stirred. Sculpture, drawing, painting, and dance all were involved in the performances at New York's Droll/Kolbert Gallery last April; the artist continues to redefine and bring into play whatever he can.

Of all the artists working in Chicago, Kovachevich alone has created an art so radical that there exists no basis for direct comparison. We do, however, get the sense that, because of this work, important changes in the way we perceive things one day will be made. And that is as close to greatness as any artist can come.

Since he began to paint in 1972, Dan Ramirez has been pursuing the most elusive of goals — the spiritual sublime. Every abstract work he does presses more closely upon it seeking to raise the quality of art and life. He searches for a language that will take his art beyond formalism, beyond man.

Ramirez's early visual inspiration came from Piet Mondrian and Barnett

Continued on page 13

Balthasar Burkhard and one of his 1977 photocanvases: A most impressive photographer.

CHICAGO TRIBUNE Arts & Fun—June 11, 1978 Section 6 Page 3

Continued from page 3

Newman, artists whose writings he also admired. But always he felt the need to develop his own method of inquiry, a tightly enclosed system of only the most essential pictorial elements. His art needed to be held in thrall to be free.

Ramirez's study of the music of Arnold Schoenberg and the philosophical writings of Ludwig Wittgenstein reinforced the value of such a method. His own work pays tribute to their struggle by exalting in a great tradition and attempting to extend it through ascetic means.

Only his large scale, primary emphasis on rectangular form and surface luminosity have remained constant. Color gradually has been drained. Laminated paper has replaced canvas. Paint has given way to pencil.

But still the goal is the same: to express the self through the Other. And in the 8-foot-high, all-black drawing that will be Ramirez's entry to the Art Institute's Chicago and Vicinity Exhibition he succeeds in making his strongest statement. It is far beyond anything in last year's show at the Marianne Deson Gallery, and it unmistakably announces that this former truck driver has become one of the most compelling artists in town.

The Swiss-born Balthasar Burkhard already had established himself as a respected documentary photographer before he began to do the large photocanvases that were shown for the first time in America at the Zolla-Lieberman Gallery last year. Claes Oldenburg and Tom Kovachevich are among the artists whose work Burkhard has documented, and he continues to record the visions of others even today.

Yet his own two series of photocanvases, respectively completed in Amsterdam in 1970 and in Chicago last year, make up a body of work so refined that Burkhard easily enters into the company of the most impressive photographers on today's scene.

The early series puts us in contact with objects and interiors viewed through the eyes of a European solitary. Their emptiness and quiet carry an unspoken threat. It is as if they are stills from an imaginary film by Alain Robbe-Grillet.

But by 1977 Burkhard's sensibility had changed, and we read the influence of America in his sharpened vision. There is a glitter to the work, a more conscious artifice that is derived from the visual romance of American movies. Burkhard's love for them extends even to Hollywood stardom, perhaps a problematical notion for a serious American artist to entertain, but one that can come quite naturally to a European.

After his return to Switzerland last year, he did indeed star in a half-hour television film by Urs Egger. The experience undoubtedly will have an effect on the photographs Burkhard plans to do here beginning next month, though his projected series of photocanvases also will include a "pure" response to urban isolation. Whatever he does is sure to be marked by elegance, poetry, and winning restraint.

Unlike Burkhard, who has chosen to stay in Chicago, Andrea Blum, one of the city's best installation artists, is moving to New York.

Since her first showing three years ago at the Museum of Contemporary Art, Blum's work has deepened and matured to a point where one no longer has to fear the flirtation with sterility that so often can accompany her materials and methods. Ultimately, Blum's pieces stand apart because she has not done them as a kind of compensation for inadequate sculptural or painterly skills, but because she already has moved through the other media, finding installation the only one suited to her needs.

It is important, too, that Blum never has lost sight of an expressive purpose. She still strives for a combination of materials potent enough to provide an intense optical experience free from conceptual alibi.

The most recent pieces — seen at the Marianne Deson Gallery and in a film made by WTTW-Ch. 11 — are less transformation of the environment than visual notations about it; they are no longer objects, but essays in response. More difficult than any works the artist has done, they move into a rich new direction, and the opportunity to trace it is something I sadly will miss.

Each of the artists mentioned thus far is of the "younger" generation, in his or her 20s and 30s. Miyoko Ito, on the other hand, is entering her 61st year, having painted longer than most of the others have been alive.

That would not be important except that her first solo exhibition in New York took place but three years ago, as did her first inclusion in a Whitney Biennial. Phyllis Kind again gave Ito a New York show this April, and one hopes it will be a regular occurrence. Hers is a mastery deserving to be shared.

Three wonderful attributes are found in all of Ito's paintings: exquisite balance, luscious color, and an extremely personal handling of space. They combine to create abstract, meditative landscapes that read vertically from top to bottom.

The stillness of Ito's world, so often attributed to her Japanese heritage, is less a function of color than one might have supposed. For years it was pale and delicate, hardly a preparation for her latest work. Now, having resumed painting after an illness, Ito gives her canvases an extraordinary glow. But even when they burn with pearly reds and sun-shot sand, these remarkable compositions are as hushed as they were before. They outwardly go beyond, the better to remain the same.

Do these artists, then, give an idea of Chicago's artistic vitality? I think so. We will be fortunate, indeed, to have such brilliant examples five years hence.

127

Thomas Kovachevich

# Time in Chicago

I met Balthasar in Kassel, Germany, 1972. He was the official photographer for *documenta 5*. I was an artist included in the exhibition. While he was photographing works of mine we started a conversation that lasted until his death.

Even though my time in Kassel was brief we managed to form a binding friendship. I believe a factor that supported this opportunity for friendship was the nature of the work I was doing, which required me to personally show it to him. We spent time together and talked about a variety of things both personal and aesthetic for several days. Then I left.

A few years later in Chicago one evening my doorbell rang. There appeared Balthasar with Piotr Kowalski, whom I had also met in Kassel. There was no call, no letter, no notice of any kind. The surprise delighted all of us. We acted as though were we old university friends meeting for a reunion. We drank, smoked, ate, laughed, and reminisced about our time together in Kassel. My family joined us and they bonded too.

Balthasar had a teaching job at the University of Illinois. I had a medical practice. Frequently, after our respective days' work, he would join us for dinner. My wife and children adored him. Soon we were spending a lot of time together. As I recall, Balthasar had not made much "artwork" previously. I knew he had done some canvases with Markus Raetz in Amsterdam and a few prints of his own. He was mostly taking photographs of artists and artists' studios.

Shortly after Balthasar's arrival in Chicago he appeared lost and unsure, which seemed natural to me. I encouraged him and introduced him to my friends. We were very sociable and included him in everything. But after a while I felt he had become melancholy and homesick. He was trying to do his own work but was somehow blocked, which was frustrating to him.

We were both infatuated with film and at the same time I was beginning to do performance work. He helped me in the studio and we spoke of theater and its possibilities. My wife and I realized that we were in fact with a "movie star." He had a resemblance to Montgomery Clift, which we told him. He would discount this. One day I did a "makeover" with him. I cut his hair, dressed him, powdered his nose, and

began taking pictures of him. We had a blast and he looked great. Suddenly he was a star, the star. He bloomed, he laughed, engaged with people in conversation, and most importantly began doing his own work.

I think that this was the moment he found himself as a person and an artist. He became productive and did an amazing body of work on emulsified canvas such as the roller skaters (p. 119), the supper club table, the back seat of a car (p. 121), and some nudes.

We naturally became supporters of each other and tried to promote each other's work. I was his promoter in the USA, he was mine in Europe. I was able to place his work with a few Chicago collectors and get an exhibition for him at the Zolla/Lieberman gallery. Once, at a small dinner party, I told Dieter Roth that I was Balthasar's theatrical agent and we were looking for finance for a movie starring Balthasar. At first Dieter was put off, even angry, but after seeing Balthasar's head shots that I had brought along and shoved in front of his face, he offered to give us 60,000 Swiss francs! Wow. We agreed to meet in the morning. However, I could not attend because I had appointments with patients. Instead I sent Balthasar to meet him, which was a mistake. Never send the star to collect the money! We never got it. No matter. We were happy making work, talking art, laughing, having fun, and plotting our futures as artists.

On one occasion, Balthasar, acting as my agent, organized a tour of my performance work in the Kunstmuseum Bern, Kunsthalle Basel, and Herman Daled's Hotel Wolfers in Brussels. We toured like a theater troupe would. We brought lights, stages, and all the necessary equipment to put on the show. As we used to say, "it was a gas."

Over the years I realize how important the time in Chicago was to Balthasar and to me. I think I witnessed his transition from photographer to artist. He became very strong yet did not lose his vulnerability, which kept him open and receptive to new ideas. He went on to create many wonderful works which we all know, appreciate, and celebrate.

He taught me so many things about art and life. I can see him in my mind's eye, hear his voice. I miss him.

*Thomas Kovachevich is a US American performance and object artist. He met Balthasar Burkhard through his involvement with the 1972 documenta. The "star" portraits mentioned by Kovachevich were put in the snakeskin box that Burkhard used as a kind of application portfolio during his attempts to forge a career in the film industry.*

**Thomas and Elenor Kovachevich with Balthasar Burkhard by Lake Michigan, 1976**

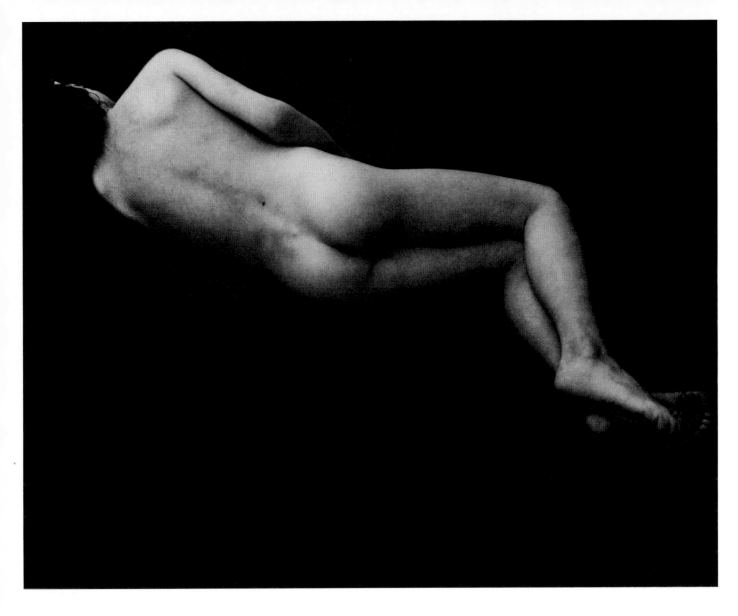

*Entwurf,* **photo canvas from 1977**

Markus Jakob

# Balthasar, the Movie Star— Rediscovering *Eiskalte Vögel* (*Icebound*, 1978)

We were whelps, young whippersnappers, inspired by aesthetic ideals that now seem to me at once distant and as familiar as a trusty old companion. We weren't completely clueless though. When, in 1978, my friend Urs Egger, newly returned from his training at the American Film Institute in Los Angeles, cranked out—as the film's handcrafted solidity tempts me to say—his first half-hour feature, starring Balthasar Burkhard (who, at thirty-three, was somewhat older than us), I worked as script assistant and helped out in various other capacities too. The title of the film (which literally means "freezing birds") refers to a scene in which the two protagonists, in an attempt to get their hands on something to eat, try to cut up a deep-frozen duck using a saw in the lonely chalet in which the second half of the 16 mm film takes place. We weren't short of a sense of humor or an appreciation of multiple levels of meaning.

Still, I thought I remembered—before I saw the film again almost forty years later—that the iconic black-and-white images (in snow-covered alpine landscapes) had taken precedence over the weak plot, which now and then had us blushing as we tried to write the dialogue. But in fact that's not the case. The script also has some rather elegant, laconic brushes with the road movie and horror film genres, before it leads into its heart-rending finale, which gives you a real in-depth understanding of the two men, who are at first mysterious, then sinister, and finally pitiful. A minor masterpiece, as planned by the young director Egger.

Two guys of different ages wind their way in a sculpturally contoured BMW through mountain scenery. At a gas station they pick up a young blonde who has just fallen out with her boyfriend there (a lovely touch: the surfboard fin against the snowy background—the young couple were on their way to the Camargue) and finally head for an abandoned chalet, where the young woman gradually becomes increasingly anxious; this is followed by a weird evening meal (snails, but sadly no fowl as the duck sawing fails), and after her nightmare the blonde runs away in the middle of the night. The next morning the two men finally turn out to be harmless reps, washed-up traveling salesmen of the most pitiful kind, who can't understand why the blonde has taken fright.

In the film Balthasar Burkhard is called Heinz. He constantly complains about having a cold and about always having to do "the dirty work" (in the very first scene he has to push the BMW out of the snow)—a perennially surly loser, an image that does not altogether correspond with the notion that Burkhard had of himself at the time.

The "odd couple" are two quirky guys, who were also two truly oddball performers. On the one hand, the professional actor Eduard Linkers, a smooth operator who knew all the tricks of his trade, born in the Habsburg Empire and banned by the Nazis from practicing his art on account of his half-Jewish ancestry; on the other, the greenhorn debutant Balthasar Burkhard, who struggles to mumble his way through his scanty, constantly kvetching lines with his Bern lilt. But that is just the ticket for this film.

Burkhard prided himself more on his looks than on his German, so much so that in those years he even gave Roman Polanski his snake-skin box, which contained documentation of the stuttering start to his film career (that BMW stuck in the snow!), no doubt in the hope—one that he himself considered ridiculous—of launching a career in Hollywood. The irony whose distant glimmers can be seen in some of his photographs may be at its most obvious here.

And here, en passant, is a dream that I had while committing this text to writing: a film set—an enormous, Japanese-looking boulder made of papier-mâché—is being brought in on rails. Urs, the director, is standing by. Balthasar is apparently supposed to take the still photo. But from the aperture of his dazzlingly white equipment, a huge camera obscura, emerges an equally white bullet of the appropriate caliber, and instead of shooting a picture, Balthasar fires his splendid shot at either the director or the set or both at once. At that moment I woke up.

Fortunately nothing came of this—either of the shot or of his film career. Burkhard shuffled his way through *Eiskalte Vögel* because the aesthetic sensibility of the young director, who was a good friend of his, was close to his own. They shared a taste for, among other things, black-and-white images. (Egger's next film, *Go West, Young Man*, was a color picture—a Hollywood comedy with an element of Frank Tashlin). We may assume that Burkhard saw his film role at the time as part of his own nascent work. Which brings up another question.

There is quite a strong narrative element in his early *Photographien*—he stuck to this way of spelling the German word (with "ph" rather than "f") out of high-mindedness, of course, but also with a certain rationale: for otherwise you would logically have to write *Fysik* ("fysics") in German. In images like *Backseat* (1977; p. 121) he had displayed his interest in the narrative power of the medium. The narcissistic self-image that he flirts with in *Eiskalte Vögel*, where he emerges as a rather poor actor, even if perfectly serviceable in the role of Heinz, fades beside the artisanal precision that characterizes both Egger's film and Burkhard's early work. However, I should add, by way of a postscript, that the best thing is the wonderful film music by Uli Sacchet.

*Markus Jakob is a Swiss critic, translator, and journalist. His writings include texts for the children's book "Click!" Said the Camera, which he produced together with Balthasar Burkhard and which contained Burkhard's animal portraits.*

134    **Balthasar Burkhard as actor on the set of Urs Egger's film *Eiskalte Vögel* (*Icebound*), 1978**

# Body and Sculpture

The 1980s mark the beginning of an extremely productive period for Burkhard, in which his photographs move toward a sculptural understanding of the image, with the print understood as an element in exhibition architecture. The photographer had seen how the previous generation of artists challenged the classical exhibition space, and now his own works take possession of this very space. Burkhard becomes one of the most important exponents of the art of the large-format photographic tableau, which he showcases in a number of radical exhibitions.

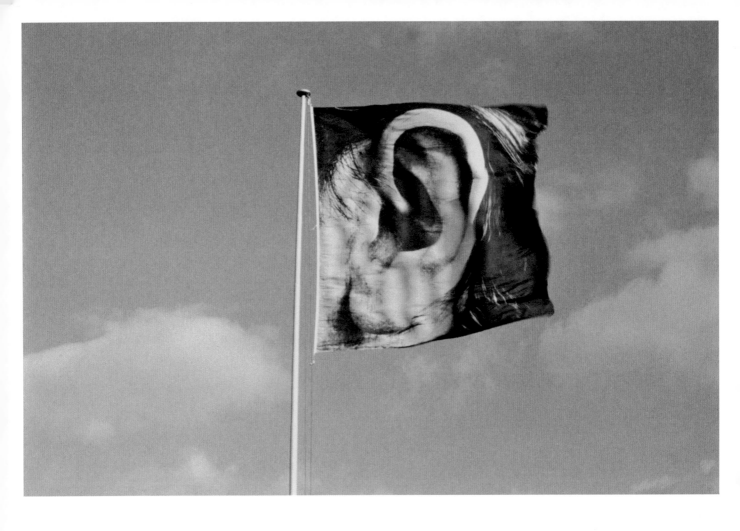

**Edition of a flag for the Musée d'art et d'histoire de Genève, 1986**

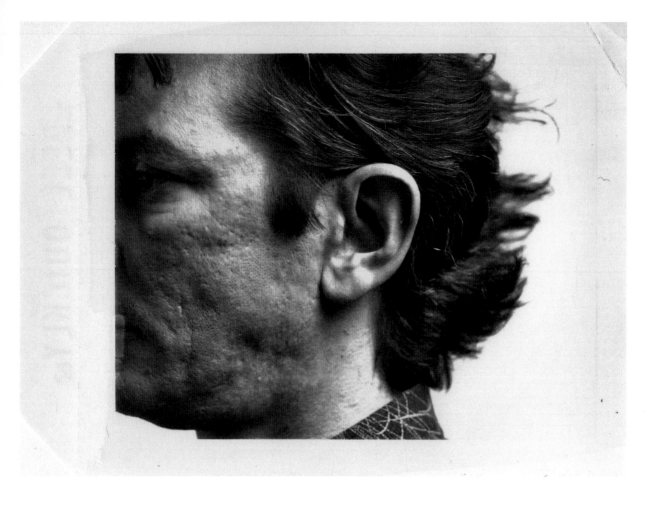

138    **Preliminary study for *Das Ohr*, Polaroid, 1980s**

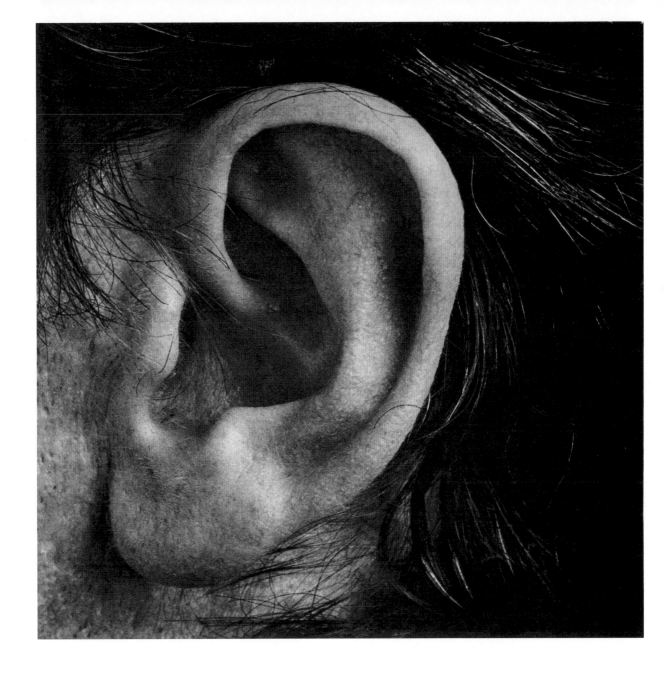

*Das Ohr*, 1986: motif for photo canvas

140    **Different versions of *Der Ellbogen*, Polaroids, ca. 1983**

**Study for** *Der Ellbogen*

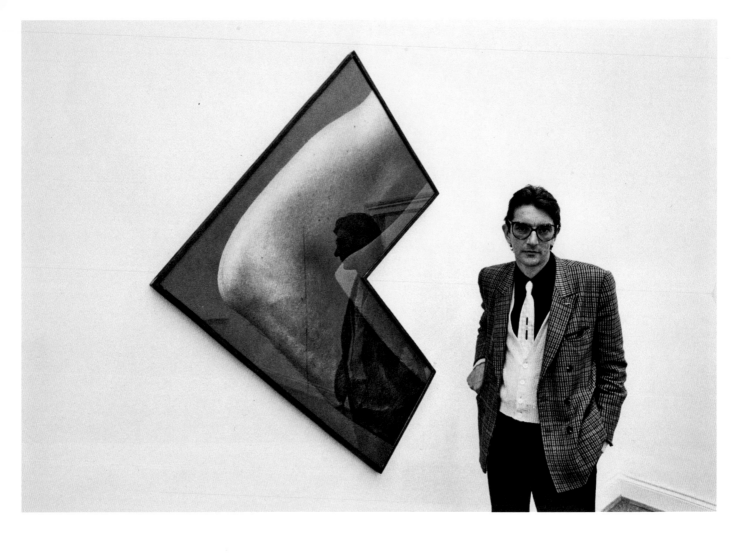

142     **Balthasar Burkhard in front of** *Der Ellbogen,* **Kunsthalle Basel, 1983**

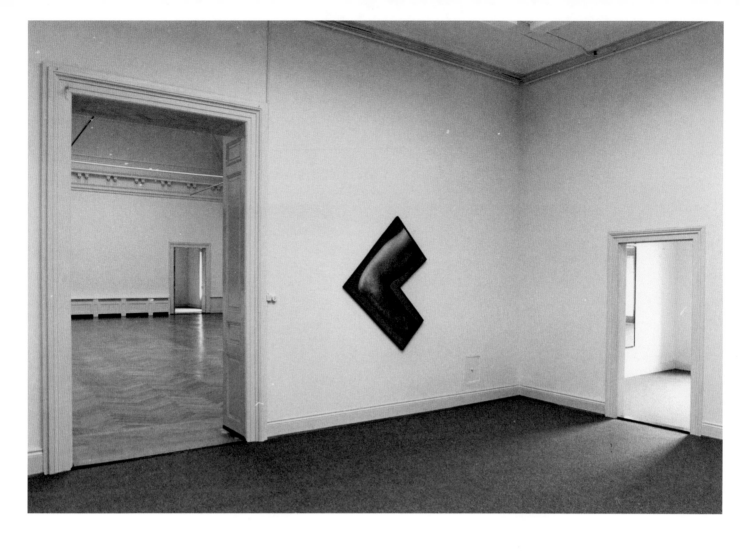

**Installation *Der Ellbogen*, Kunsthalle Basel, 1983**                                      143

144  *Das Knie*, test prints for the exhibition in the Kunsthalle Basel, 1983

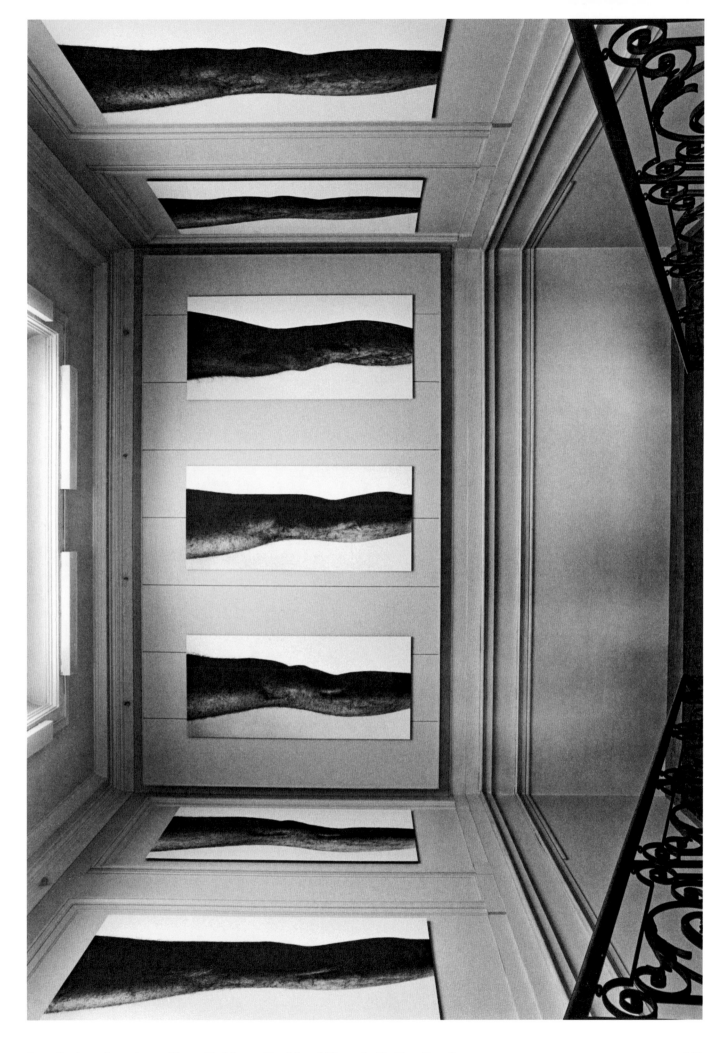

**Installation view,** *Ausstellung: Balthasar Burkhard***, Kunsthalle Basel, 1983**

148    *Füße 1*, 1980

*Füße 2*, 1980

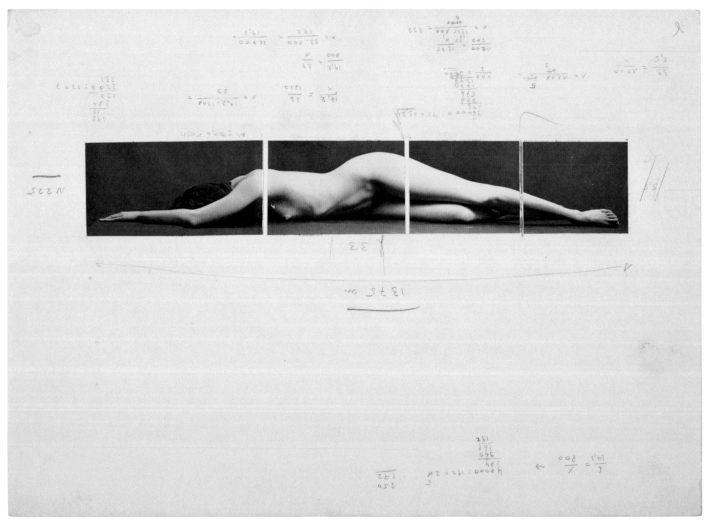

**Draft sketches and installation plans for ⬧ *Der Körper II* and ▲ *Der Körper I***

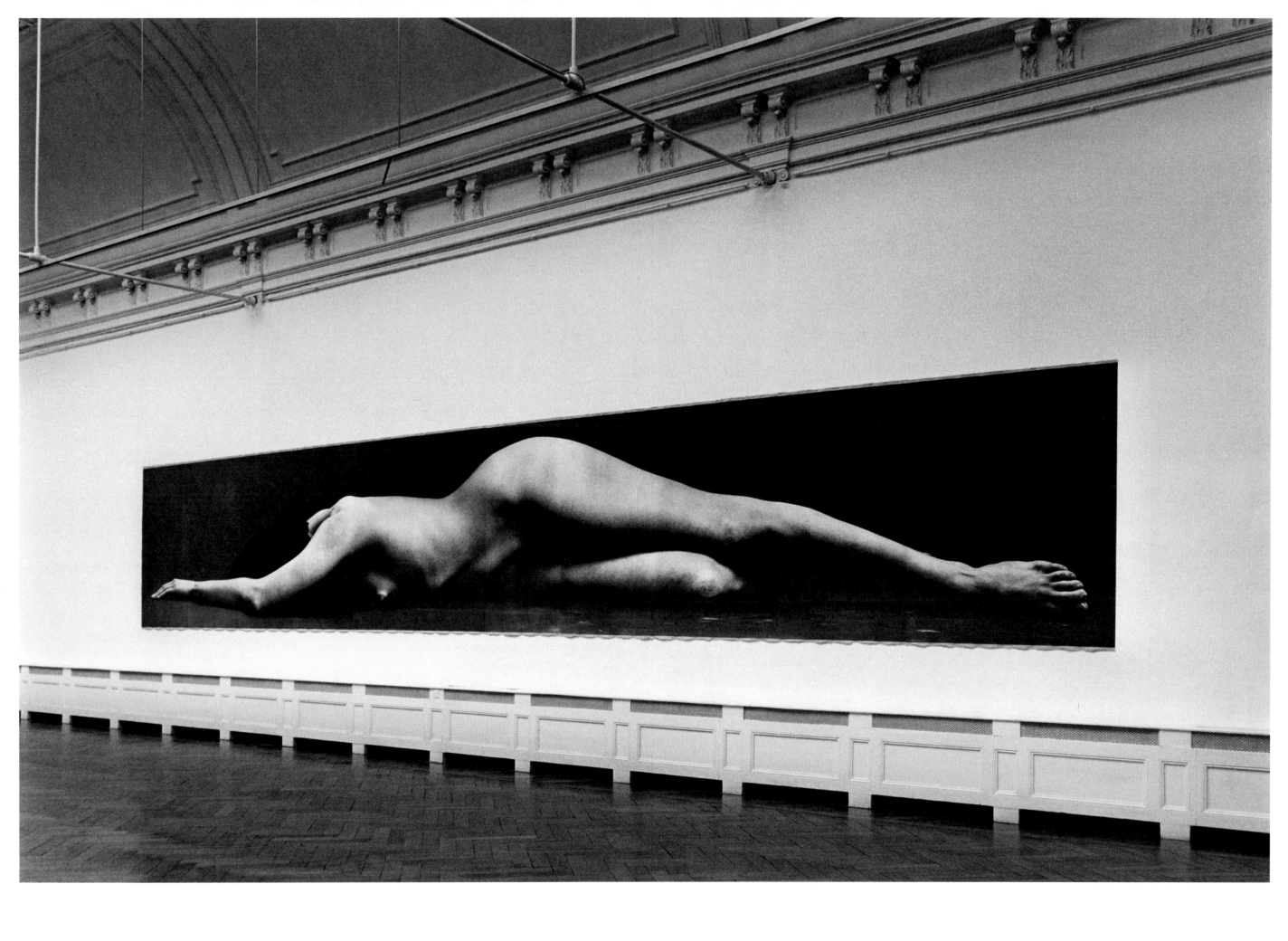

*Der Körper I*, installation view, *Ausstellung: Balthasar Burkhard*, Kunsthalle Basel, 1983

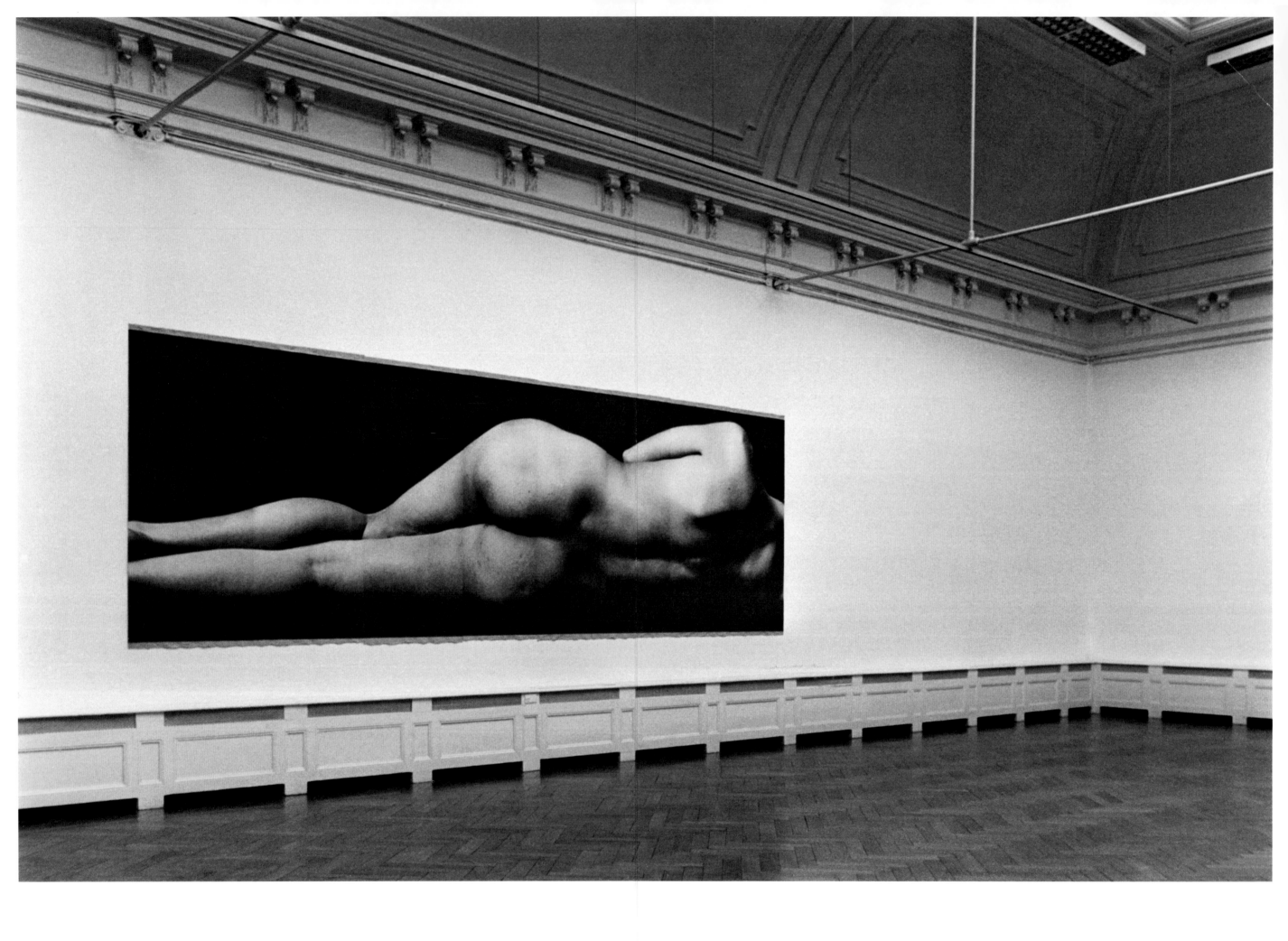

*Der Körper II*, installation view, *Ausstellung: Balthasar Burkhard*, Kunsthalle Basel, 1983

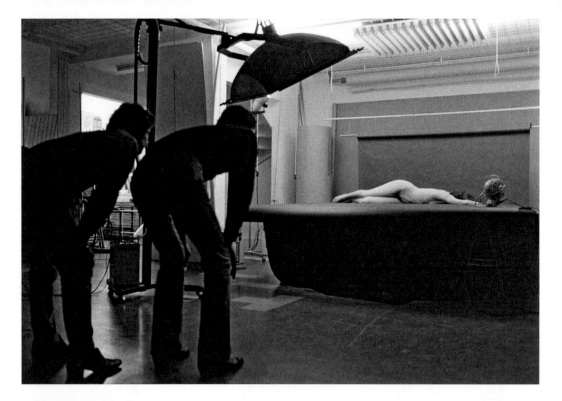

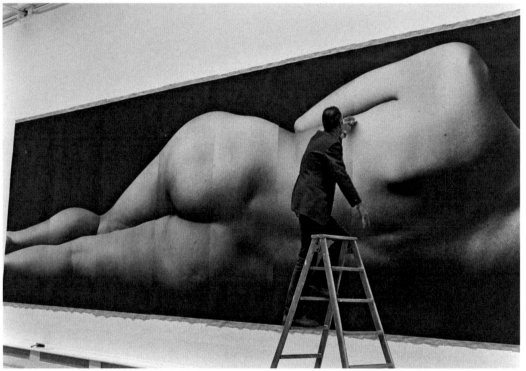

▲ Creating the large-format images of the body in the studio ▲ Installation in the exhibition, 1983　　　153

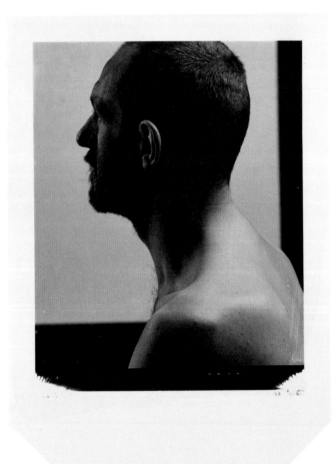

154    **Variant shots of** *Der Kopf*, **ca. 1983**

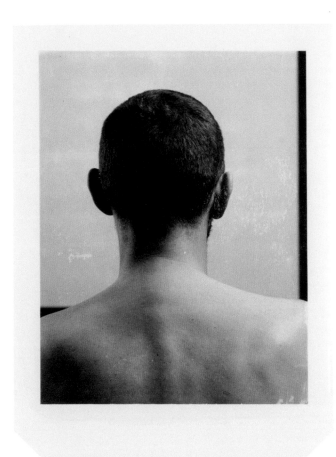
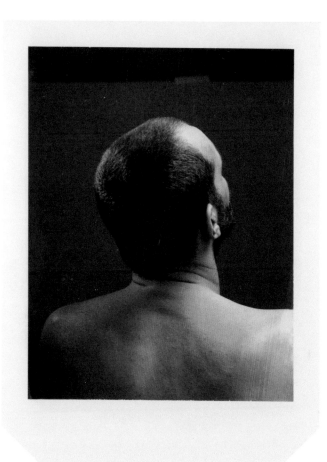
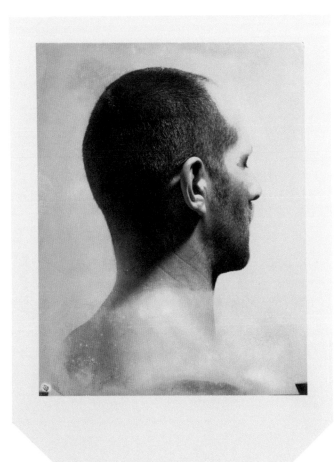
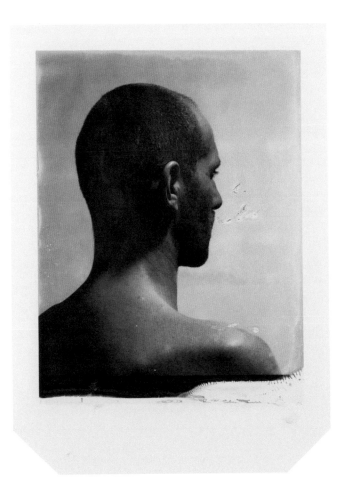

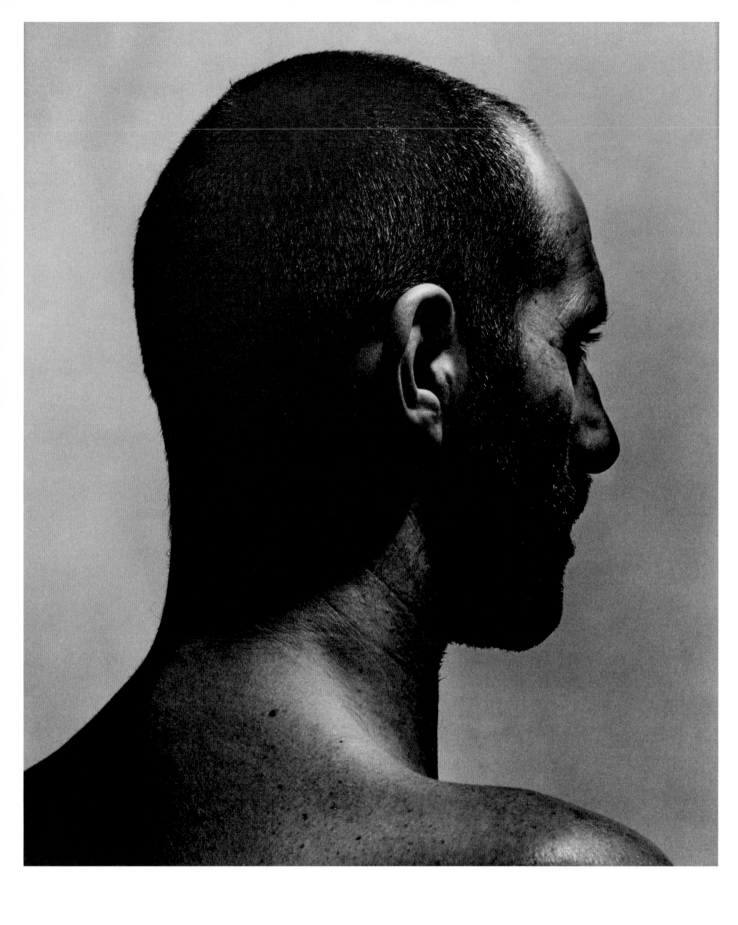

*Der Kopf,* 1983 – **The model is the artist Rémy Zaugg**

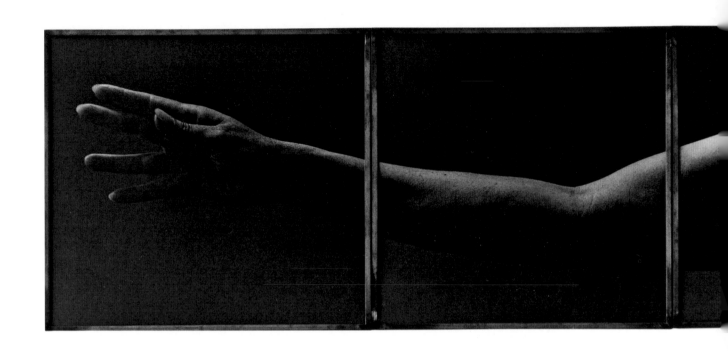

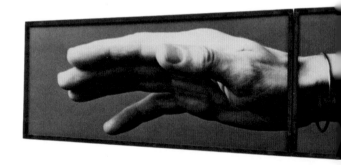

158    **Two versions of an idea – *Der Arm*, 1983**

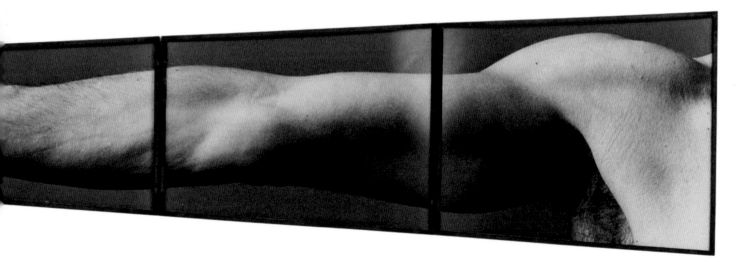

MUSÉE RATH GENÈVE
18. FEV. – 25. MARS 1984

BALTHASAR BURKHARD

NIELE TORONI

160     **Poster for the exhibition with Niele Toroni at the Musée Rath, Geneva, 1984**

**Installation view, Musée Rath, 1984**

Hendel Teicher

# Structure and Memory

My first encounter with the work of Balthasar Burkhard was his exhibition at the Basel Kunsthalle in May 1983. His photographs were intriguing: monumental, static images combined within a cinematic installation. Burkhard's work utilized a singular motif—black-and-white images of human bodies and body parts. Large scale, close-up examinations were presented as formal structures. Pushed forward to occupy the flat surface of the picture plane, they expose skin, veins, and hair—animating a familiar, yet unknown landscape. In Basel I was also taken by his engagement with the specific architectural spaces of the Kunsthalle itself. The abstract aspects of his constructed images and the art-historical references gave me a way into his work. Strikingly new, they also felt part of a modernist continuum. I wondered how Burkhard might further extend and explore that investigation. With this in mind, I soon contacted him to ask if he would consider an exhibition in Geneva. I was then a curator at the Musée d'art et d'histoire, to which Musée Rath belongs.

Our first meeting took place later that same year. I drove with my friend Anne Béguin—a German professor and art historian—to La Chaux-de-Fonds, where Burkhard was living and working. Our studio visit was largely about getting acquainted and discussing the possibility of presenting his work. Arrangements were made for him to see the exhibition space.

On our way back to Geneva, Anne and I asked ourselves why Burkhard would choose to live in a provincial Swiss city after having lived in Chicago and New York. Anne pointed out that both his industrial living and working space and the unique grid street plan of the city reminded her of America, where she had also lived. La Chaux-de-Fonds is the center of the watchmaking industry, and the hometown of the architect Le Corbusier—Burkhard mentioned him often during our meeting. A common technical thread runs through photography, watchmaking, and architecture. All demand a high degree of precision and specialized knowledge. Likewise, Burkhard projected an exacting intensity onto his projects—an almost scientific approach.

My proposal for an exhibition came with some major constraints, a very tight schedule, a

very small budget, and the goal of showing new work—all this within a year's time! Burkhard had in principle agreed, but again wanted to see the exhibition space. So, our second meeting took place as planned in the Musée Rath in Geneva. The history of the museum itself is worth mentioning. Inaugurated in July 1826, it was the first art museum built in Switzerland. The main floor functioned as a traditional exhibition space for paintings, sculptures, and decorative objects. And the lower level, the proposed exhibition space, was originally an art academy, a school that taught technical drawing for the manufacture of watches, jewelry, enameled objects, and textiles. This space was complicated given its previous use and was a major challenge. It is a large, awkward, asymmetrical room, with a low dominant ceiling. After much consideration we decided to use the building's structure as the organizing principle. The only symmetrical elements of the entire space were the four arching flat columns located in the center of the museum. These columns became the redeeming feature, and Burkhard envisioned them as the optimum surfaces on which to hang his work.

Effectively, by leaving three quarters of the lower level space empty, and only hanging artwork on the two sides of the four columns, that central area was transformed into the focal point of the exhibition. This also changed the longitudinal orientation of the exhibition space. The shorter axis created an active new area, which became the visual and physical center—a point of entry. The viewer could approach the columns, moving through them to reach the far wall of the building. This passageway design was reminiscent of the classical setting for sculptures, a situation that encourages both close-up and distanced viewing.

Burkhard was the driving force behind this radical transformation. He had an intuitive intelligence and could expertly assess each exhibition space. He loved architecture and never stopped photographing buildings. Burkhard's deep knowledge of the built environment guided him to determine the most effective placement for his own works. He understood how to animate and maximize their impact. And ultimately to produce the best installation photographs of his own exhibitions. They are, in fact, works in themselves.

During our preparatory discussions we adopted the idea of a two-person exhibition. This helped to mitigate the pressing time issue, since less work would be needed from each artist. It also had an added benefit—another visual layer and potential dialogue. Burkhard was familiar with the collaborative process and when he suggested Niele Toroni I immediately agreed. Having a painter and a photographer

was a unique opportunity to investigate the interaction of the two disciplines. Or, at least to explore the differences and similarities between the mediums.

The Balthasar Burkhard and Niele Toroni exhibition ran in the Musée Rath in Geneva from February 19 to March 25, 1984. An artist's book was published to mark the occasion. Severe and playful, it provides another view of the collaboration. The design places Burkhard's images on the pages on the left, and the images progress from large to small. On the opposite side Toroni's images run from small to large. Meeting in the middle of the book are two images of identical dimensions. Also, the book is dedicated to "Max and Moritz"—two comic-book characters created by Wilhelm Busch, a nineteenth-century illustrator and author. A dark humor runs through Busch's cautionary tales, which recount the numerous tricks and pranks of two friends. Obviously, Burkhard and Toroni identified, at least in this instance, with those characters.

The exhibition itself comprised ten unframed works: five photographs by Balthasar, and five paintings by Niele. All the works were on paper and had the same dimensions, 200 × 100 cm. The size was determined by the width of the columns where eight of the works were fixed, one on each side. In addition, two works, in alignment, were installed on the far wall. Each artist had a dedicated row. The long view showed three pictures for each, and the short view had two visible works. Niele's paintings presented imprints of the number 50 paintbrush repeated at regular intervals of 30 cm. His square painted marks occupied the entire sheet of paper. Balthasar's works presented a series of five black-and-white photographs. Each depicted a torso seen from the back.

Expressing their own concerns with making site-specific works, both artists engaged with that unique place. They believed that interaction between art and architecture can allow for an unfolding experience with a direct and sometimes dramatic effect on the viewer. At a one-to-one scale, Niele's painted brushstrokes manifest a continuous and measured action. A repeated activity that holds the potential to extend beyond the paper's edge. The repetition and endurance of that process, in its limitations and its implied continuity, is the very subject of his paintings. The work's insistent flatness is a stark contrast to the volumetric forms of Balthasar's depicted images. His photographic torsos were created for the specific dimensions of the columns, and enlarged to fit their proportions. The image is contained and complete within the parameters of the paper.

In some sense, Balthasar's essential subject is addressed in this exhibition—the body as structure. Indeed, each torso is centered along its a spine and as a column—verticality is the focus. This stabilizing element is repeated on each column and introduces a temporal rhythm, as well as a forward motion that amplifies and echoes the images' enigmatic presence. The visual dynamics became a fine balancing act, a back-and-forth viewing, between the rigorous presentation of a repeated motif and the subtle differences between the repetitions. After much attention, the torsos reveal slight variations in their positions and framing. And their complex lighting encourages the viewer's eye to wander, slide, and stop in order to savor the rich color tones.

But beyond the surface of these torsos, and despite their distant coolness, one can feel the depth of Balthasar's emotional world. His concern is precisely this ability to create and maintain intimacy—even in the center of public space. And there is an intangible component or foundation that supports and sustains his fascination for both bodies and buildings. It is a felt architecture, at every scale and distance. Organic or built. Human, animal, or mineral.

We benefit from his sense of empathy and wonder.

*Hendel Teicher is an art historian and curator. Balthasar Burkhard specially dedicated one of his own works to her—Fleurs pour Hendel (1984).*

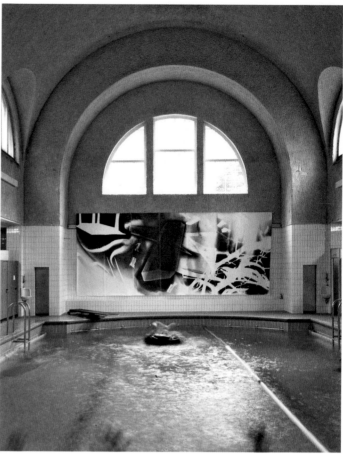

164   ⬆ **Historical photograph, Volksbad St. Gallen**   ⬆ **Photogram, Volksbad St. Gallen, 1985**
  ⬆ **Composition with film strips, photogram on photo canvas**

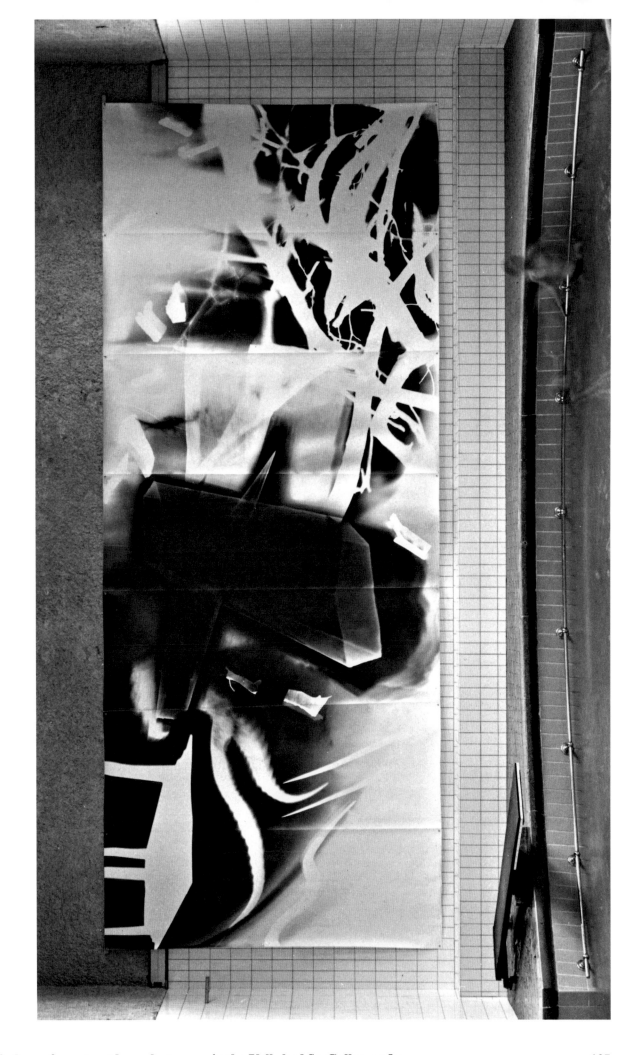

**Installation of a large-format outdoor photogram in the Volksbad St. Gallen, 1985**

Thomas Seelig

# Exhibition: Balthasar Burkhard

In May 1983 the *Ausstellung: Balthasar Burkhard* exhibition opened at the Kunsthalle Basel, whose director at the time was Jean-Christophe Ammann. The publication accompanying this presentation of Burkhard's work prominently names his artist friend Rémy Zaugg as collaborator (along with the photographer himself). Although the exhibition galleries only displayed works by Burkhard, the frame of reference was his work with Zaugg over a period of around six months. The two artists played with ideas about exhibiting work in general and put some thought into how to present the photographs at the Kunsthalle.

The small-format publication, which interestingly cites Zaugg as its author on the cover, is divided into two large chapters. Zaugg completed the first in early January 1983. It made use of theoretical considerations like "select," "define," "question," and "doubt." The second chapter deals specifically with Burkhard's presentation as a discursive whole: the works, their content, and the cross-references between the photographs, with an eye to the architecture and history of the Kunsthalle Basel, etc. Here, Zaugg picked up on ideas from the first chapter, substantiating and documenting them carefully with the exhibition views Burkhard had photographed.

"The work is everything. And whatever is done, is done for the work, for its expressive power, for its sense of meaning. [...] Exhibiting a work thus means presenting it to the senses and the intellect in its fullness [...] on its own terms, so to speak, so as to allow it to present itself, to go out and surrender itself to the body and mind of the subject perceiving it." "The images, which take advantage of the shapes, the walls, and the floor of the halls, present the architecture [...] Every element that is present in the moment is thus fully—by which I mean boundlessly and grandly—represented."

With regard to Burkhard's presentation, Zaugg thus aimed at reception beyond the scope of the individual works. He looked at this in terms of the photographer as auteur, of the contemporary art of the time, of the photographic image, of the inviting institution, and of the works' reception by exhibition visitors.

With nine works varying in size and scope on display on the top floor, the two smaller adjoining rooms, and the staircase of the Kunsthalle Basel, there were only a few photographic exhibits on show. Each work was intended to stand out on its own terms and was placed auratically in an architecturally distinct position, with just one piece per wall or surrounding wall surface. With *Der Körper 1* (Body 1) and *Der Körper 2* (Body 2) (pp. 151/152) Burkhard created two large photographic artworks for the spacious, glass-roofed gallery. These were groundbreaking in their day, outdoing by some distance his photo canvases from 1969/70, which were the product of a collaboration with Markus Raetz. One of the images installed on several rails had a width of 13.2 m, while the other measured 7.9 m. Both are now regarded as lost works. In a review published on May 24, 1983, in the *Tagesanzeiger*, Martin Schaub wrote of the "gigantic dimensions" of the "huge female nude," which one must view "rather like Gulliver on his travels" and which no one had seen in this form before.

Burkhard burst open every form of presentation known to photography at the time. Photographic motifs were usually scaled down to smaller sizes, but Burkhard reversed the polarity, as it were, and applied a scale exceeding that of the subject. The bodies he photographed stretched out and extended themselves, claiming space and meaning on the walls and in the rooms. They made a striking impression when viewed at first hand and were incredibly precise in their technical execution. Yet the other photographic objects also seemed to be the equal of these two images of the body in their visual power and impact. In the smaller cabinet gallery hung a horizontal, four-part, 3.7 m wide photograph of an outstretched, oversized arm, while the spacious staircase displayed the nine parts of *Das Knie* (The Knee), with three room-high prints, measuring 2.7 x 1.25 m apiece, mounted on each of the three walls. The work showed a photographic scroll around a scarred male knee. While the proportions of these works featuring isolated bodies and body parts were larger than much of what had hitherto been familiar in photography, the other single images like *Entwurf* (Draft, p. 131), *Der Kopf* (The Head, pp. 154/55, 157), *Füße 1, Füße 2* (Feet 1, 2, pp. 148/49), and *Der Ellbogen* (The Elbow, pp. 140–43) were also geared to the canvas sizes of Burkhard's painter colleagues.

Jean-Christophe Ammann's invitation to Burkhard to present an exhibition in Basel was predicated on two shows—at the Centre d'Art Contemporain in Geneva in 1980 and at the Galerie Toni Gerber in Bern in 1982, shortly after

# AUSSTELLUNG

## BALTHASAR BURKHARD

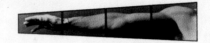

von

REMY ZAUGG

Kunsthalle Basel

Nach der Anstrengung des Aufstiegs, da hängt, in der waagrechten Ruhe der kleinen Vorhalle, die stille Ausgewogenheit eines Bildes, einsam

in der Mitte einer Wand. Die relativ bescheidenen Dimensionen des Kopfs sind intim. Sie laden ein zur Betrachtung der Physiognomie mit dem abgewandten Blick, die der Wahrnehmung des Subjekts, das im Glas sein Spiegelbild entdeckt, Gehör zu schenken scheint. Der durch die Spiegelun-

gen des Glases verborgene Kopf verlangt nach näherem Hinschauen und vergegenwärtigt somit die stoffliche Wirklichkeit.

55

**Rémy Zaugg's publication for the exhibition at the Kunsthalle Basel, 1983** <span>167</span>

Burkhard had returned from the USA. The *Ausstellung* played a key role in shaping the artist's self-image, both retrospectively and proactively, in conceptual, aesthetic, and technical terms. It was based on Burkhard's many years of experience with photography, which had begun with his training under Kurt Blum and then deepened through his proximity to the artists associated with the Kunsthalle Bern and documenta 5, which was curated by Harald Szeemann. From 1964 to 1972 he documented this art scene en route to freeing himself artistically and forging his own path.

During his training period he had learned from Kurt Blum how to make precise enlargements of large-format photos in the darkroom and was not spared his teacher's often finicky criticism at the time. As a consequence, Burkhard was entrusted with the planning and execution of extensive projects, and he was able to feed these technical skills directly into his own productions: from preliminary sketches to the development of scale models in different variants, and the subsequent scaling up of the image from the negative to XL-format photographs, etc.

At the very latest with the large black-and-white photographs that were set behind glass in heavy steel frames and which constituted the most extensive portion of the exhibition, Burkhard had found a formally coherent mode of presentation that would become a kind of trademark in his ensuing work cycles. In the *Starporträts* (Star Portraits) exhibition in Geneva he had entirely dispensed with any borders for his photo canvases; however, in the planning phase for *Körper 1* and *Körper 2*, which he later presented in Basel freely hung on canvas and gauze, he still had steel frames factored into his calculations. The frames absorbed, as it were, the motivic heaviness registered in the primarily dark gray and black tones of his prints and their existential subject matter.

There was another way in which Burkhard profited from his work as a chronicler of the art scene at the Kunsthalle Bern. Both in the seminal exhibition *When Attitudes Become Form* (1969) and later at documenta 5 in Kassel (1972), he benefited from his easy familiarity with the artists involved. Accompanying Szeemann on his visits to the artists' studios and during the important phases of preparing the exhibitions, in this period he consistently witnessed and recorded the moments when loose ideas turned into concrete pieces of work. Whether in the social setting, in the private sphere, or in the concentrated atmosphere generated during the installation process, Burkhard was always present, with his camera ready to hand, and

found himself in the thick of events. The artists that he photographed, among them Richard Serra, James Lee Byars, and Paul Thek, experimented with and extended art forms, and their installations—some of which were produced on-site—and interventionist methods negated the parameters of classical exhibition making and challenged the institutional framework offered by an art gallery or a major show like documenta. Many of the actions and performances only "lived on" in the memory thanks to the photographic documentation that Burkhard carried out at the time.

For Burkhard, Ammann's invitation to Basel was a welcome and indeed overdue opportunity to tie these experiences in with his own creative work. In his extreme openness and curiosity with regard to different forms of artistic and applied collaboration, teaming up with Zaugg to reflect on an exhibition (of his) and explore it dialectically was just one of several collaborative projects. In much the same way as with the photo canvases created together with Markus Raetz in 1969/70, the question about clear-cut authorship and artistic autonomy dissolved into a hazy blur. It seems as though Burkhard spent his whole life seeking out or challenging these discontinuities. Be it the works that he created together with Raetz, the intellectual games he played with Zaugg, the role of service provider he undertook for Szeemann, his "free" attitude as an architectural photographer for Atelier 5 in Bern and the architecture firm Herzog & de Meuron in Basel, the intervention with Niele Toroni at the state training seminar in Thun (commissioned by Atelier 5), or the art-on-a-construction-site project at the commercial high school in Büelrain at the invitation of the Winterthur architect Arnold Amsler: each of these projects took place under different auspices and presented a variety of creative and planning challenges to Burkhard as a "seeing" and "thinking" artist and photographer.

Looking at the exhibition at the Kunsthalle Basel, we may note that Burkhard and Zaugg had carefully studied the architectural parameters, such as the sequence of rooms, volumes, and visual axes, and staged the group of photographic body fragments in *Ausstellung: Balthasar Burkhard* in a minimalist, theatrical way. The contact sheets from his exhibition archive verify that Burkhard never showed the group of images presented in Basel in this configuration again. Individual motifs appear again in other combinations, and there too they clearly make reference to the given spatial settings. In the Basel exhibition, Balthasar Burkhard and Rémy Zaugg may have had a different, more hermetic, and far more radical work in

mind, one that was self-contained and only viewable in this site-specific assembly, and which was only partially recognized and received as such at the time.

*Thomas Seelig has been curator at the Foto-museum Winterthur for many years. The museum not only mounts exhibitions of photo-graphs but is also at the forefront of the dis-course on the current diversity of photographic media.*

1    The exhibition is also known as *Fotowerke* (Photographic Works).
2    Rémy Zaugg, *Ausstellung: Balthasar Burkhard* (Basel: Kunst-halle Basel, 1983), 16.
3    Ibid., 26
4    See the essay by Martin Gasser in this publication.
5    Artist's costs, Ausstellungsarchiv Kunsthalle Basel.
6    "Exhibition views" folder, Estate Balthasar Burkhard, Basel.

# Portraits: Types and Individuals

Burkhard continues his formal concentration on isolated phenomena, which he had developed in his representation of body fragments, now extending it into portraiture. He invites close associates, among them a number of artists who are important to him, to pose in front of the camera. His profile shots of animals against a gray canvas backdrop constitute a very different kind of portraiture. Reminiscent of Renaissance drawings or the animal photography of the nineteenth century, these pictures present animals as ideal representatives of their species, without anthropomorphizing them.

**Christian Boltanski, 1989**

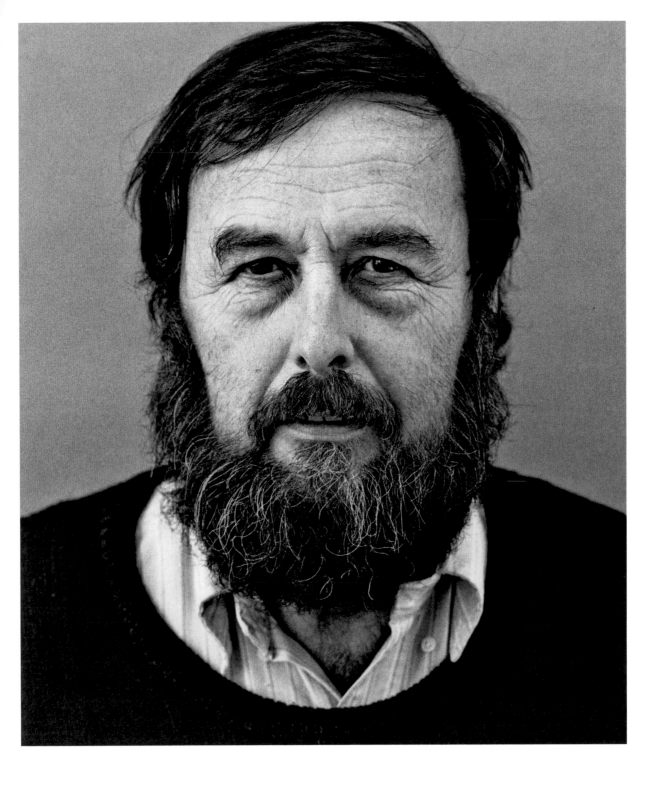

172    **Harald Szeemann, 1989**

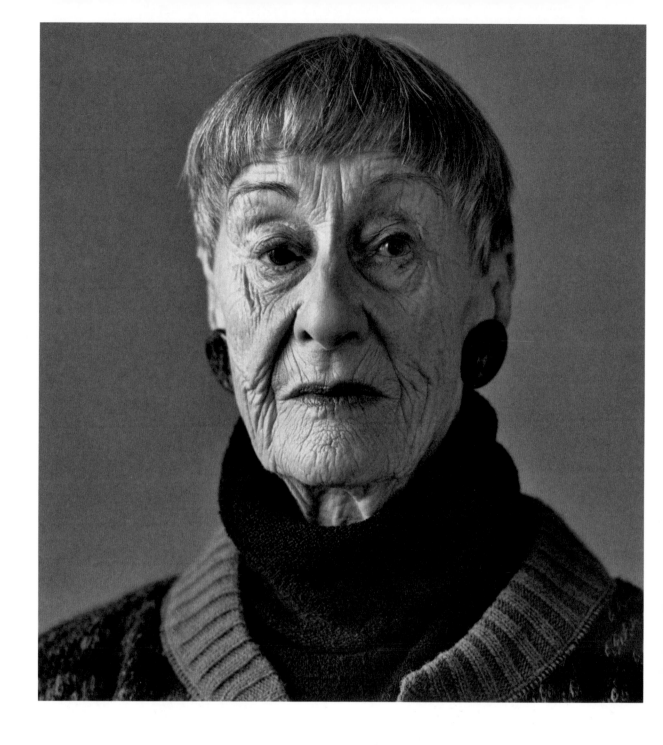

**Beatrice Tschumi, 1989**

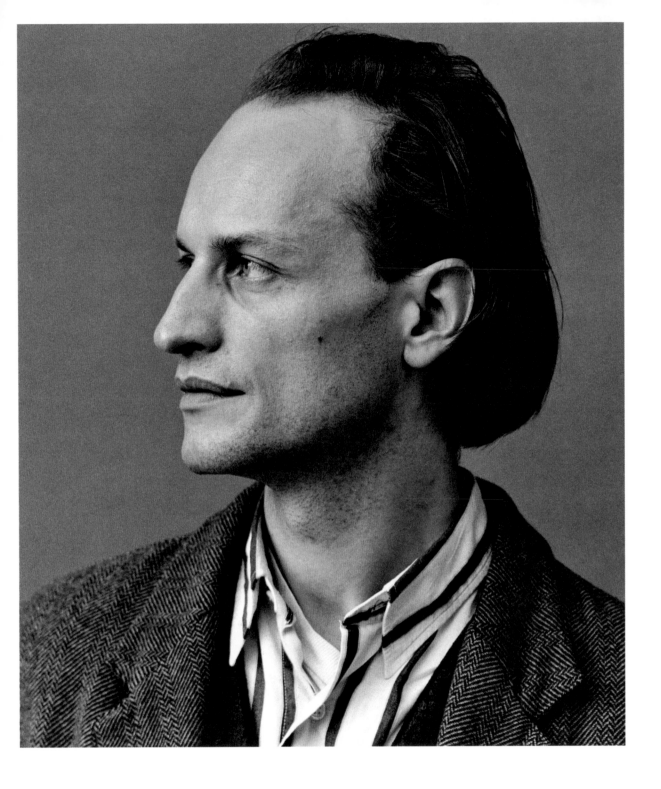

174    **Bernhard Mendes Bürgi, 1989**

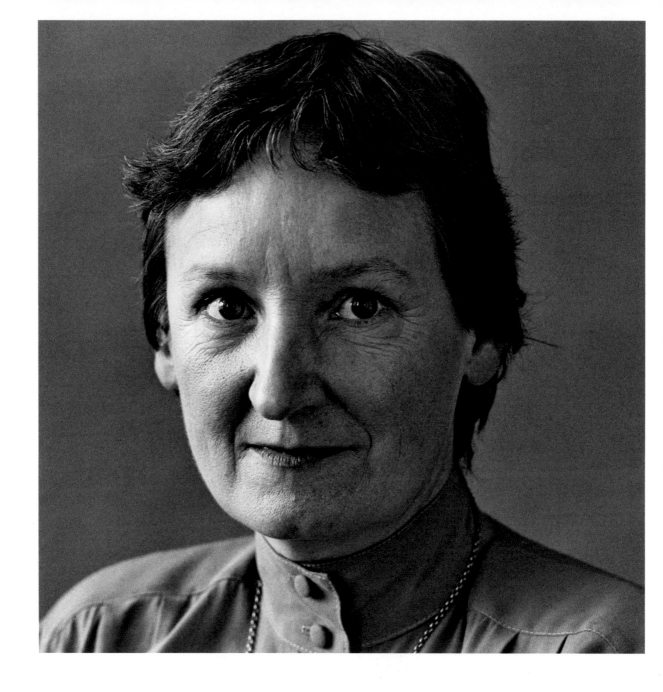

**Jennifer Gough-Cooper, 1988/89**

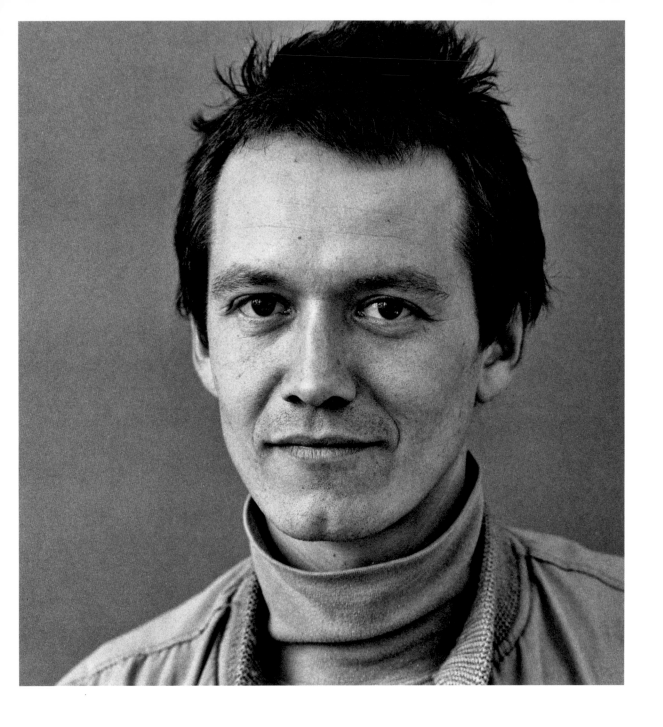

176    **Pidu Russek, 1989**

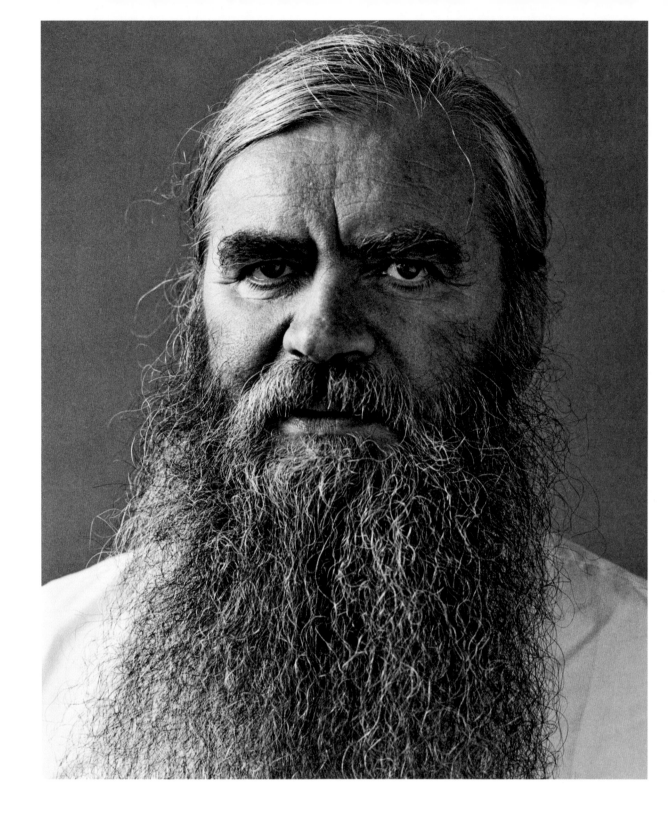

**Jacques Caumont, 1988/89**

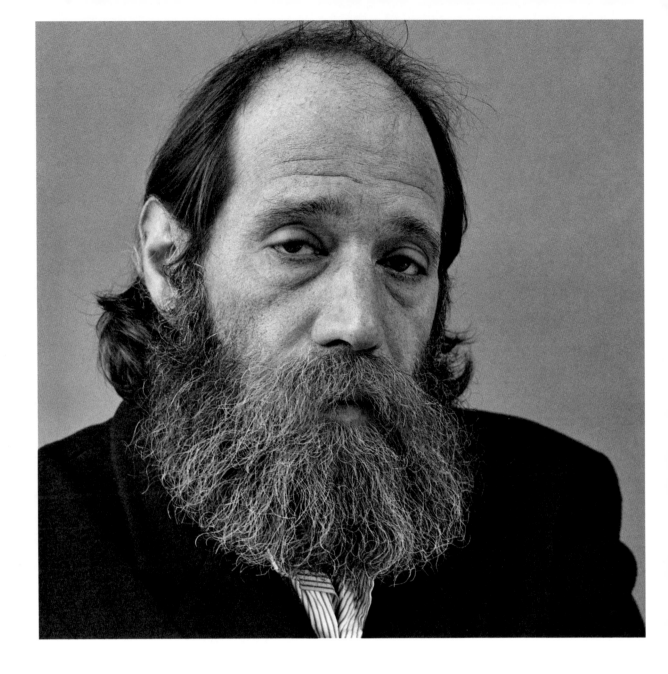

**Lawrence Weiner, 1989**

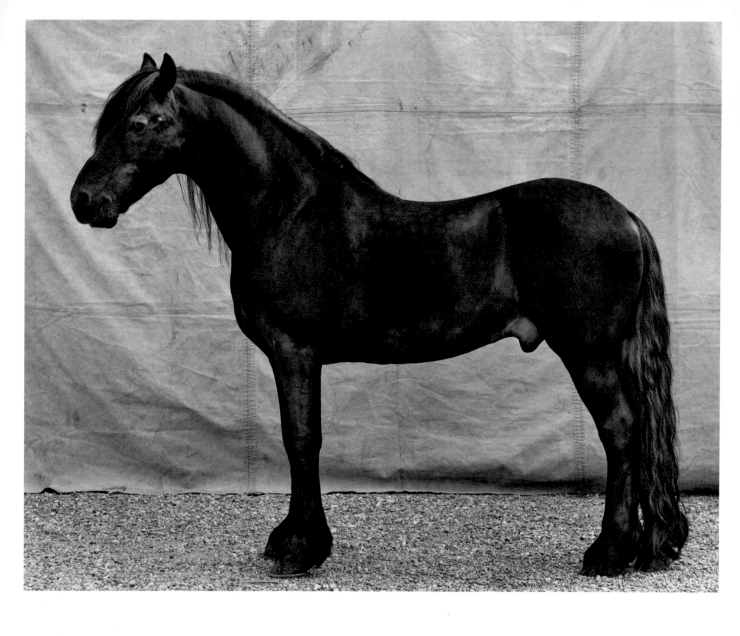

⇻ **Pages 180–87: photographs for the photo book** *"Click!" Said the Camera*
▲ **Black horse, 1996**

**Pig, 1997**

182    **White wolf, 1996**

**Bison, 1996**

184    **Camel, 1997**

**Lion, 1995**

**Donkey, 1996**

**Ostrich, 1996**

188  **Improvised studio for the animal photographs, 1995/96**

▲ Balthasar Burkhard in his studio in Boisset-et-Gaujac, 1995
▲ The children's book was published in 1997 by Lars Müller Publishers in Zurich

# Architecture and Applied Photography

With his increasing success in the art world, Burkhard can afford to be particular about the commissions he accepts. In the 1970s he had taken photographs for the firm Atelier 5 in Bern, with whom he was on friendly terms, and in the 1990s he embarks on a close collaboration with the company USM, whose international advertising campaigns involve considerable traveling, which Burkhard also uses as a way of working on his own projects. His photographic essay on the various buildings designed for Ricola by Herzog & de Meuron illustrates how his own artistic language relating to fragments and materials also influences his architectural photography and commissioned works.

� Pages 191–95: Burkhard's documentation of buildings designed by the Bern architecture firm
Atelier 5, 1970s ▲ *Reihenhäuser Flamatt 1*

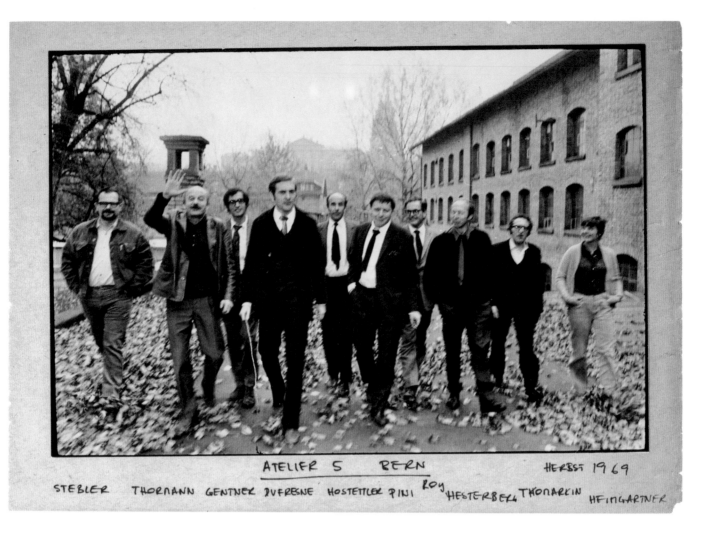

**The Atelier 5 architects, 1969**

*Siedlung Halen*

194    ⬍ *Flamatt 2*   ▲ *Haus Merz*

*Wohnbauten Brunnadern, Bern*

Balthasar Burkhard

# Zofiscope

The idea of taking these photographs was sug-
gested to me by someone else. The underlying
intention was to use photo portraits of members
of the public from different social strata to
provide an insight into the relationships between
an individual's environment and their personality
profile. Is there a connection between a person
and their surroundings? Can you extrapolate
the one from the other? In the course of the
work it turned out that the question was overly
ambitious. Environment, a person's home,
a given set of four walls: you take them for
granted. The personal touches are set in relief,
the domestic shrine where the dreams, yearn-
ings, and memories contained in a wealth
of objects become tangible items that create our
psychic milieu. (What do I mean by "domestic
shrine"? Things like tin pots, postcards, marks-
manship badges, photos of family and friends.
Along with the television, magazine racks, and
plant stands. Add to that a shot of the furniture.
Beds, tables, cabinets—pretty much the same
wherever you go.) My encounters with different
environments happened abruptly, without
any lead-in. The person was always an unknown
quantity for me, the time was too short to get
to know them, and the photographic challenge
was always new and yet always exactly the
same: What to do and where to start? The leit-
motif that connects all these photos with one
another was simply a sense of empathy for all
the people I met during my stay in Zofingen.
This alone was enough to remove the sociolo-
gical aspect from the original question. The
viewer will supply his or her own interpretations.
What I show is an extract from the Zofingen
family album.

*Project text by Balthasar Burkhard on the period
he spent in Zofingen. Zofiscope is a photo-
graphic study of the small Swiss city of Zofingen,
a perspective of a social environment that was
fully in keeping with the spirit of the 1970s.
The work was never published.*

*Zofiscope*, 1974

198  **Installation view of Burkhard's photographs in the Swiss Pavilion, 5th Venice Architecture Biennale, 1991**

**Storage facilities for Ricola AG, Laufen, Switzerland, 1991 – Commissioned work for Herzog & de Meuron** 199

**Storage facilities for Ricola AG, Laufen, Switzerland, 1991 – Commissioned work for Herzog & de Meuron**

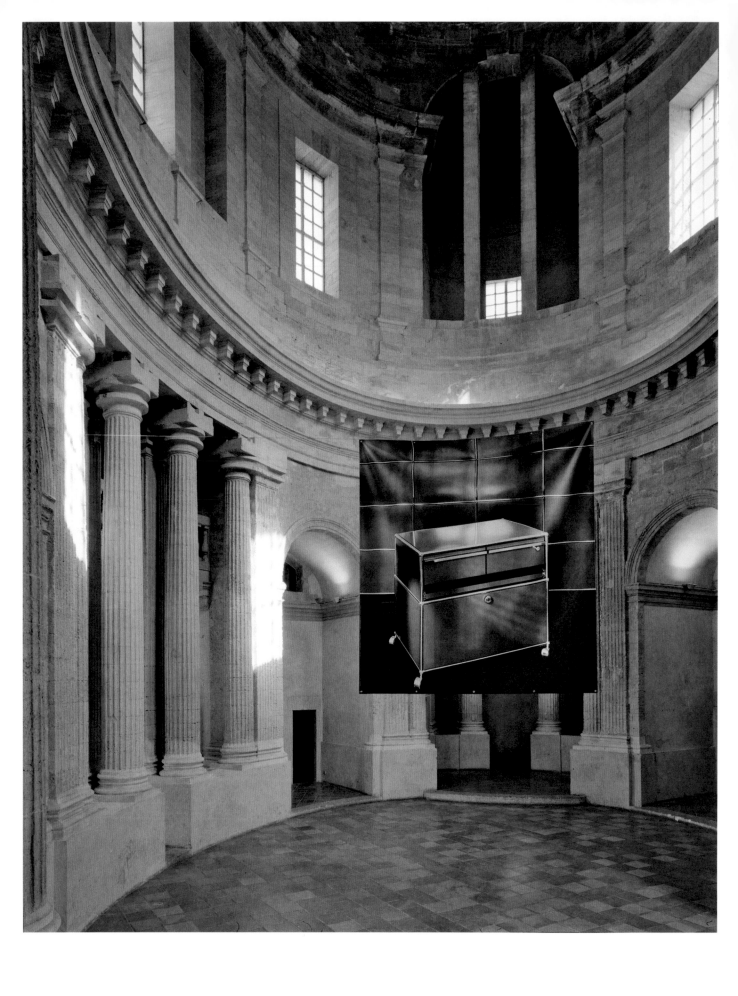

202 ⇥ **Pages 202–5: Product shots for USM on canvas, exhibited and photographed in important works of modern architecture** ▲ **Chapelle du Centre de la Vieille Charité by Pierre Puget, Marseille, 1998**

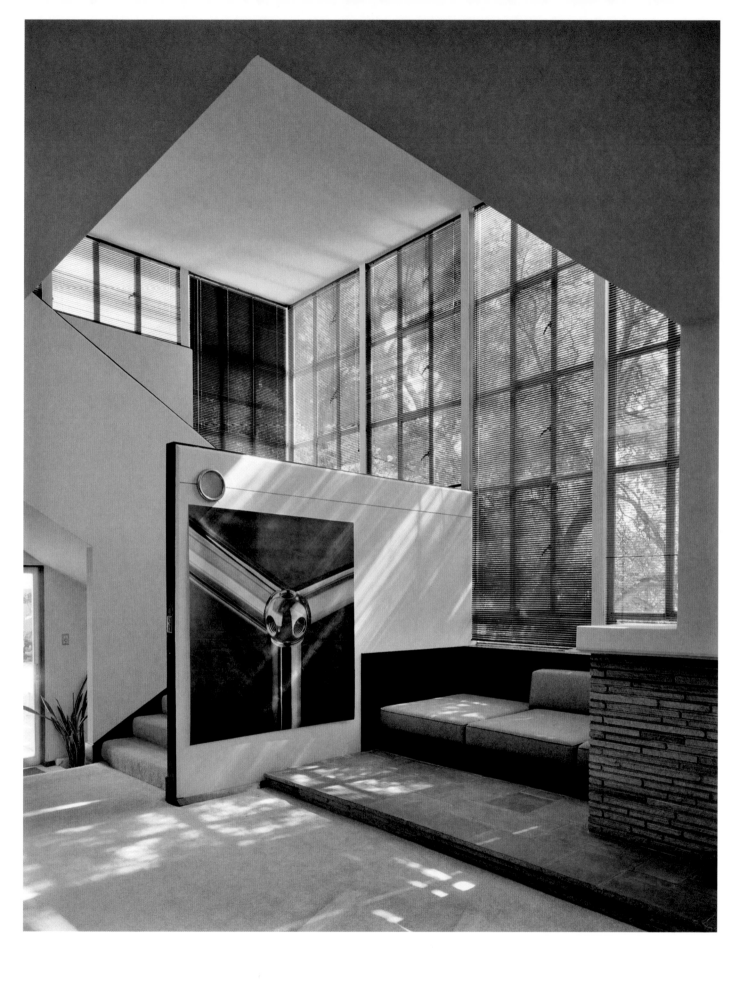

**Building by Richard Neutra, Los Angeles, 1998** <span style="float:right">203</span>

**Barcelona Pavilion by Ludwig Mies van der Rohe, Barcelona, 1998**

# Aerial Photographs

Even before the art world has begun to take an interest in megacities, Burkhard turns his attention in the 1990s to the world's major metropolises. Drawing on the influence of his father, who was a pilot in the Swiss air force, he takes his pictures from an airplane, photographing Mexico City, Los Angeles, Tokyo, London, and Paris from a bird's-eye perspective. This series on urban expanses is followed by desert formations in Namibia.

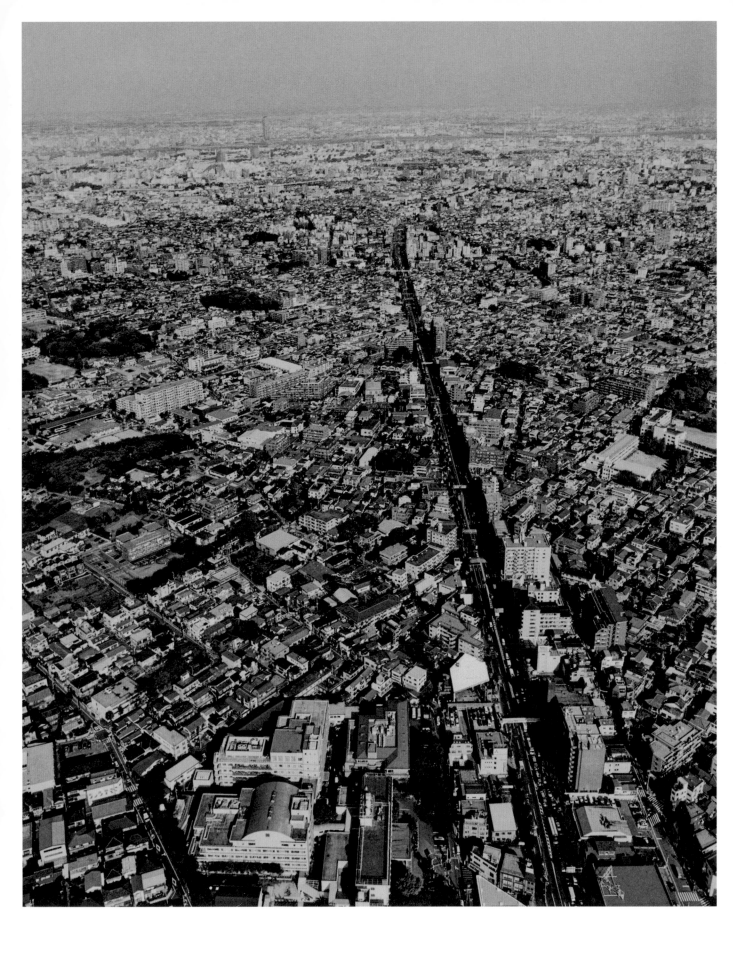

**Tokyo, 2000**

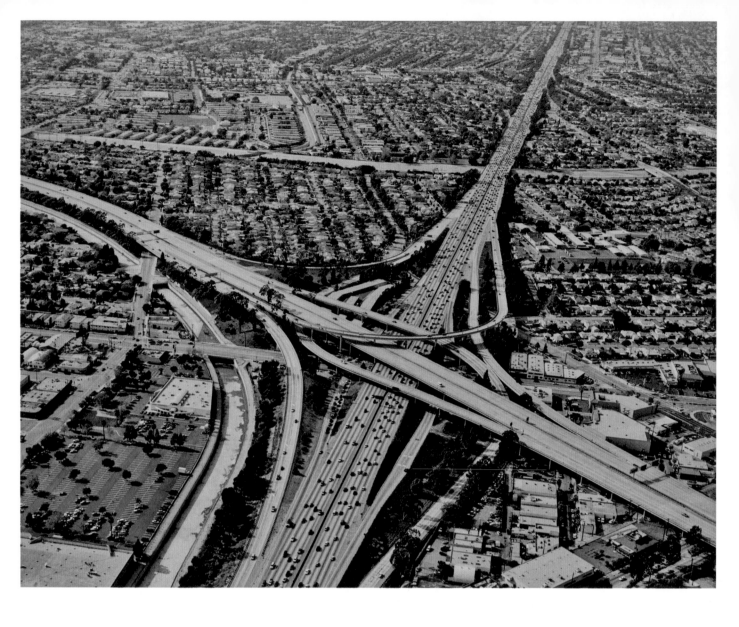

**Los Angeles, 1999**

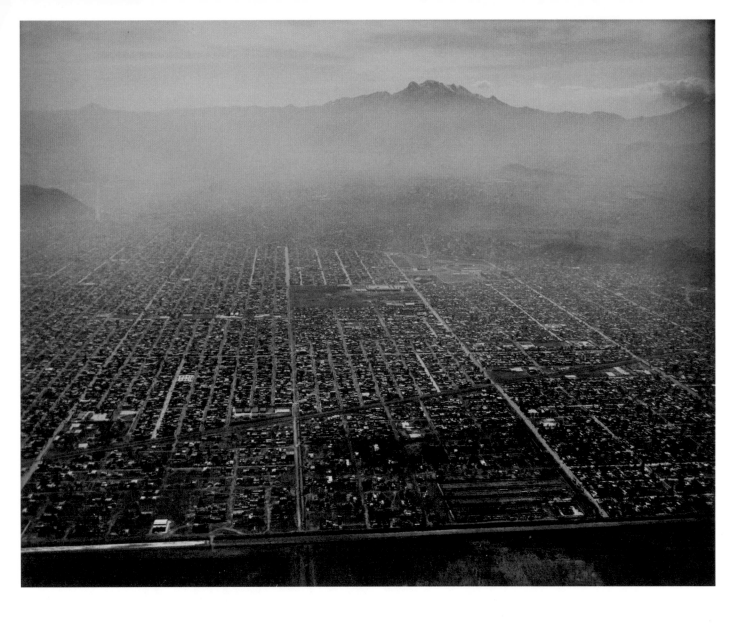

**Mexico City, 1999**

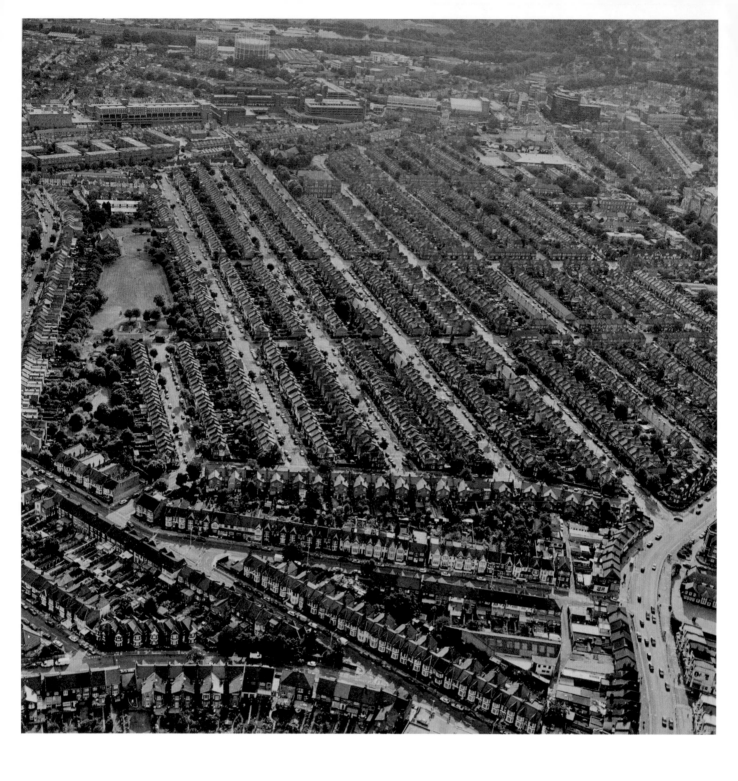

210   **London, 1998 (diptych)**

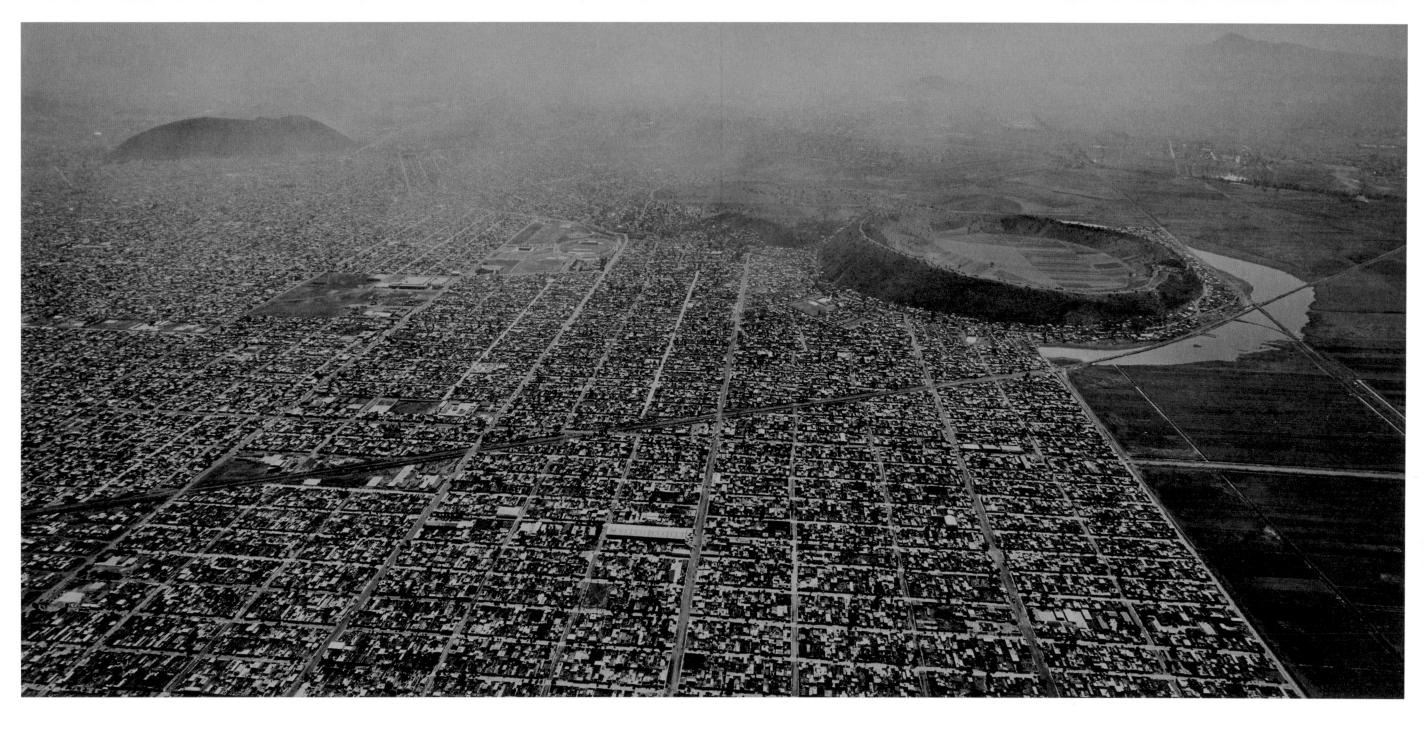

Mexico City, 1999

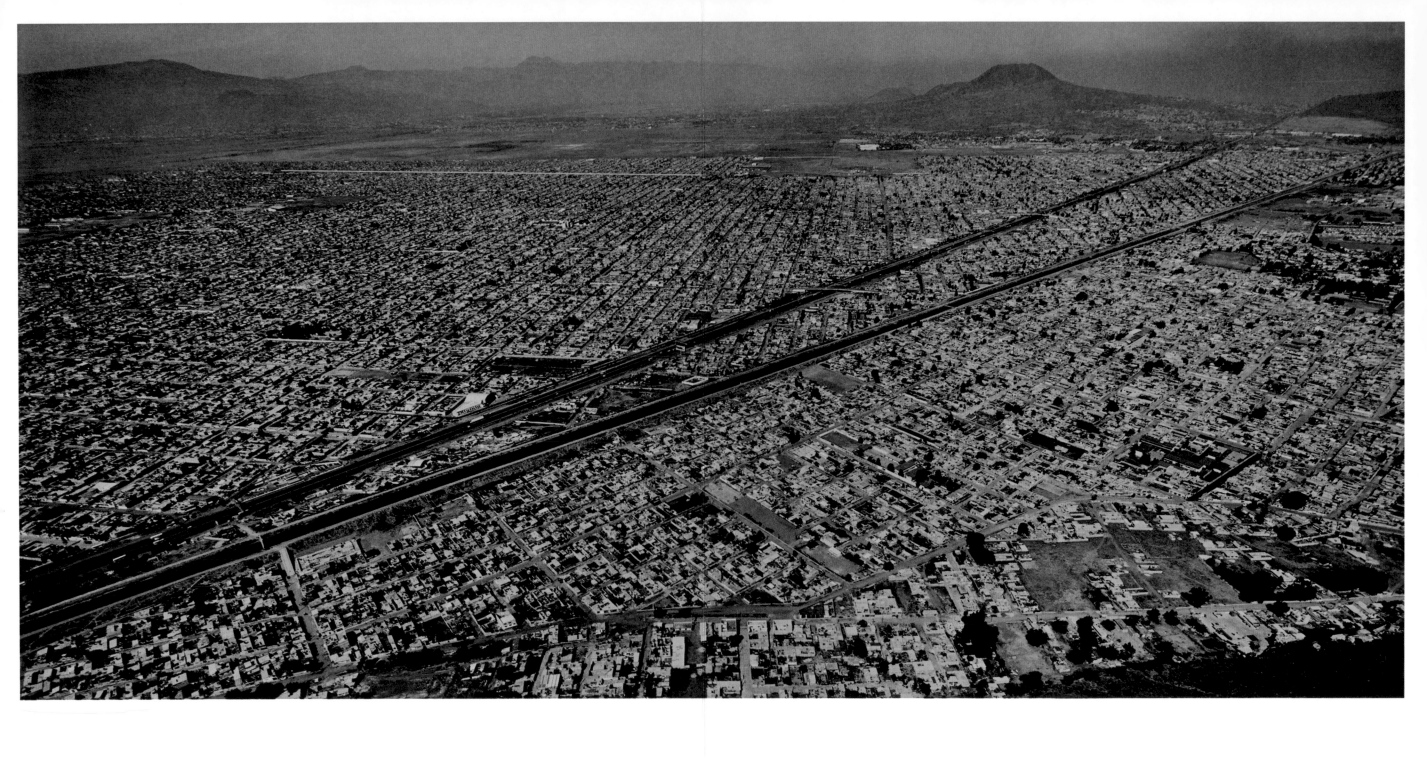

**Mexico City, 1999**

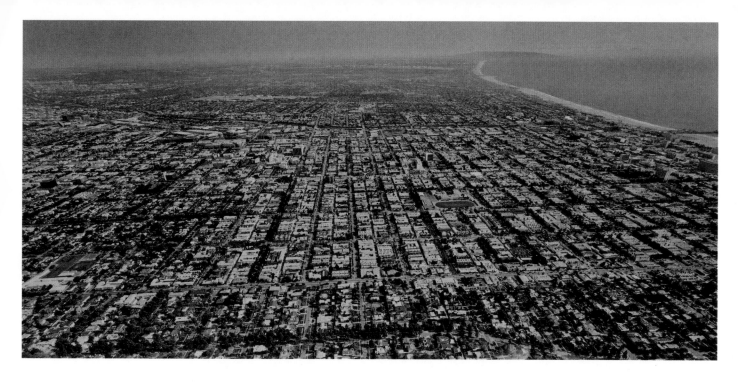

**Los Angeles, 1999**

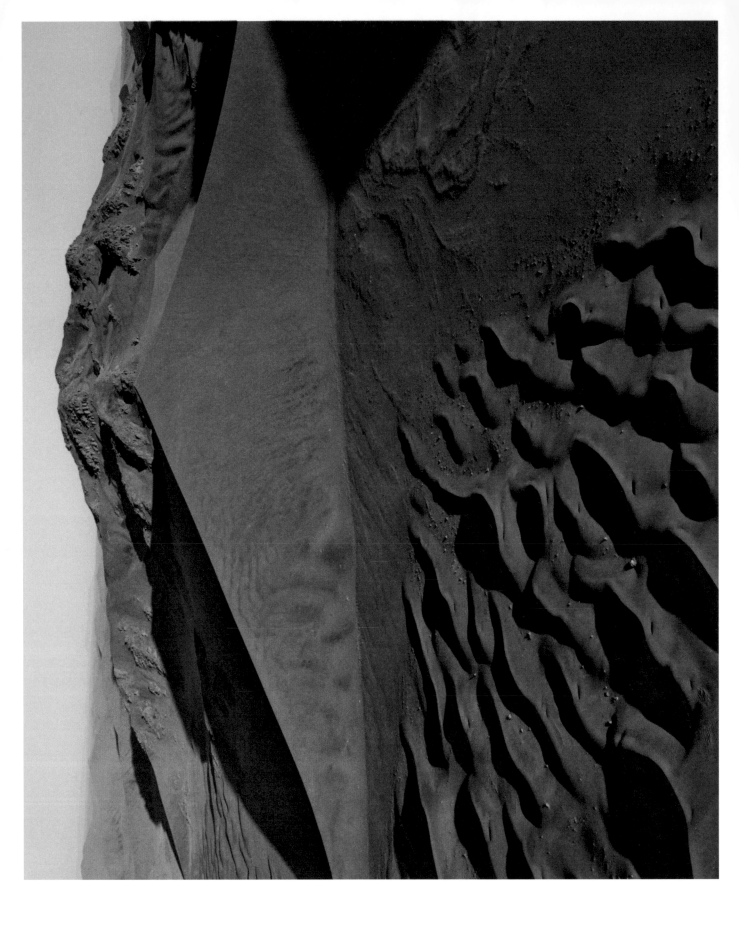

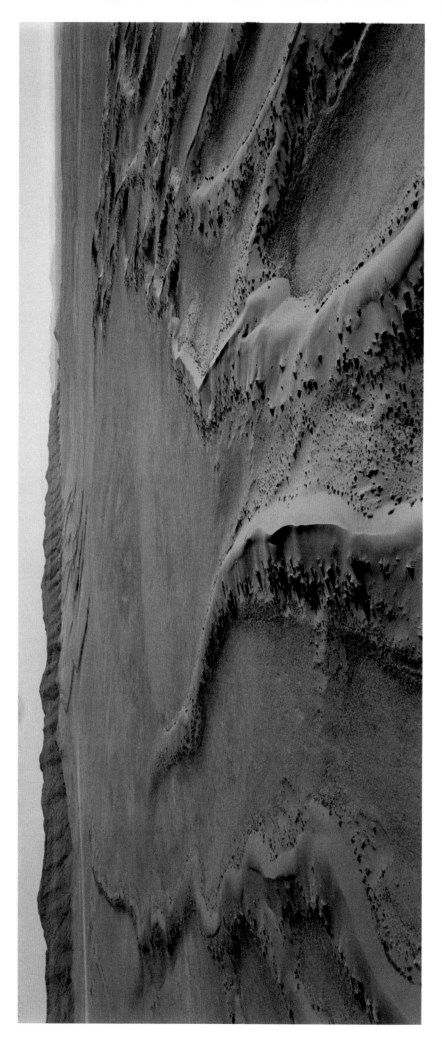

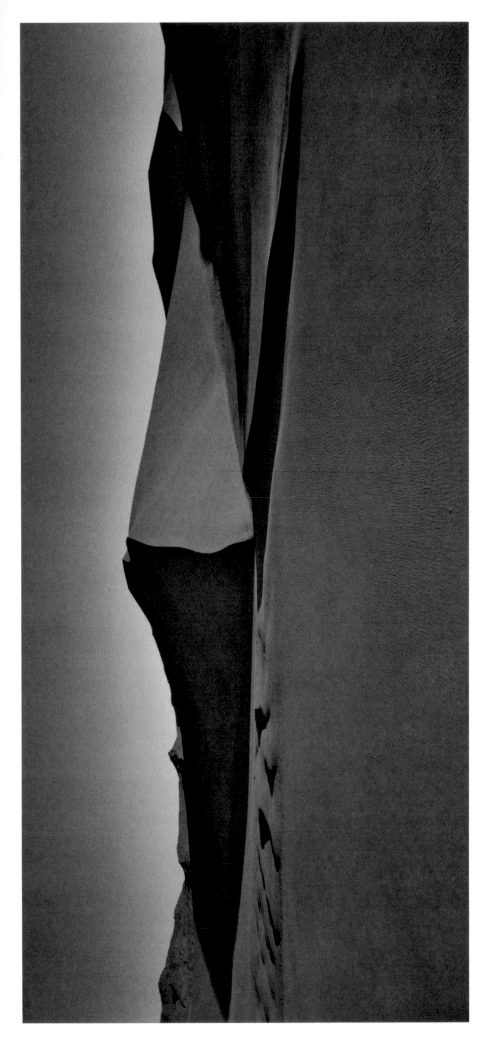

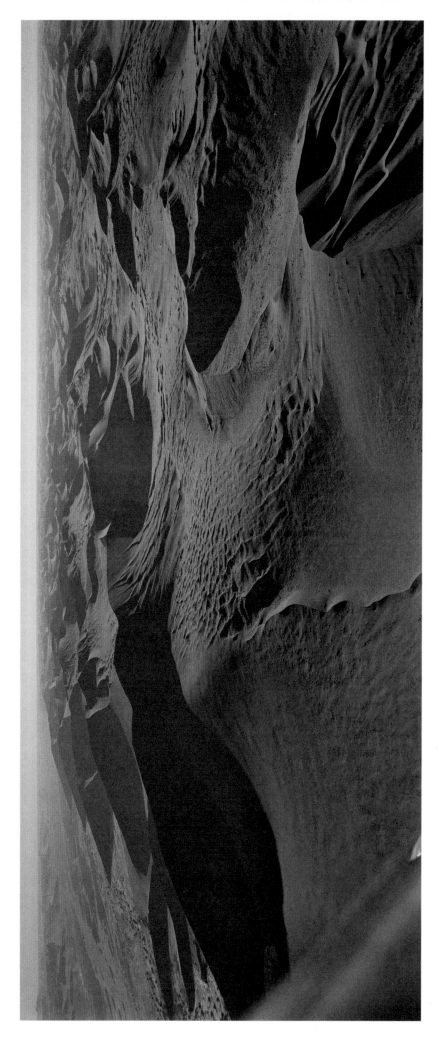

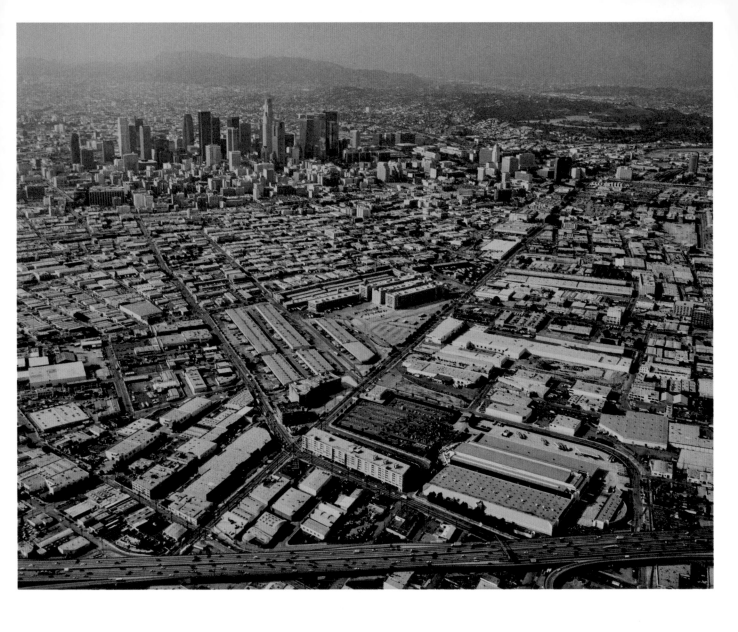

218    **Los Angeles, 1999**

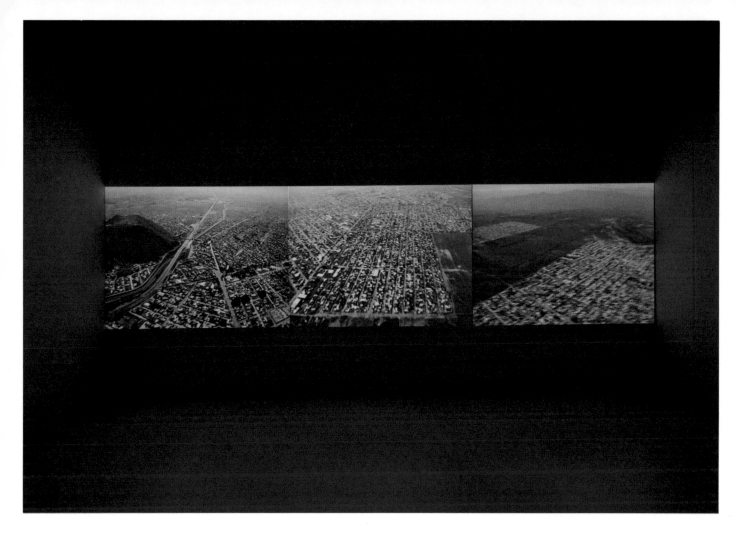

3-channel film installation *La Ciudad*, 1999

Adrian Scheidegger

# The Picture
# Not Taken

"The picture is made; now all I have to do is take it." Balthasar Burkhard often said this or something along these lines, quoting himself. The second part of the statement was always a challenge for his team. It meant planning the relevant journey and assembling the necessary equipment.

Balthasar didn't much care for traveling. He wanted to get to a place and to be on-site. Whether the journey involved was long or short, it was primarily a matter of overcoming the distance in the most comfortable way possible. The journey was not the goal; the goal was the picture. Nevertheless, other pictures regularly presented themselves on these trips—monumental landscapes or spectacular plant life, which could certainly have found a place in Balthasar's oeuvre. So again and again we would stand with the camera set up in front of these potential pictures. After some brief moments of indecision and checking with one another, we knew without a word being spoken: it would be a good photo, but not a good picture. A good melody, but not the right music.

It was never clearer than at moments like these what constituted Burkhard's art. There was something cold-blooded and also something noble about the fact that no cartridge was inserted. Instead, we would look at the image on the ground glass under the black cloth, without ever capturing it on film. Experiencing the magic of a picture not taken was the privilege of the artist and his assistant.

It was impossible to create a picture of the kind imagined by the artist en passant. These pictures required time. Having the courage not to press the shutter release also meant showing respect for Balthasar's own art.

*Bern artist Adrian Scheidegger first met Balthasar Burkhard in 1986. Twenty years his junior, Scheidegger was then new to the Swiss art scene, in which Burkhard had been operating since the mid-1960s. Having helped Burkhard install an exhibition and produce the publication* Lob des Schattens *about his travels in Japan, he became Burkhard's assistant, pupil, and friend. He helped Burkhard in the lab and accompanied him on numerous trips all over the world, most notably in the 1990s.*

"The picture not taken," based on the text by Adrian Scheidegger

# Homage to Courbet and the Nineteenth Century

Besides the experimental perspectives he used
for his sculptural body fragments, Burkhard
also increasingly adopts a classical conception
of the image. His individual homages to the
work of Gustave Courbet can be seen as exam-
ples of this classicism. The first paraphrases
appear in Normandy in the late 1980s.

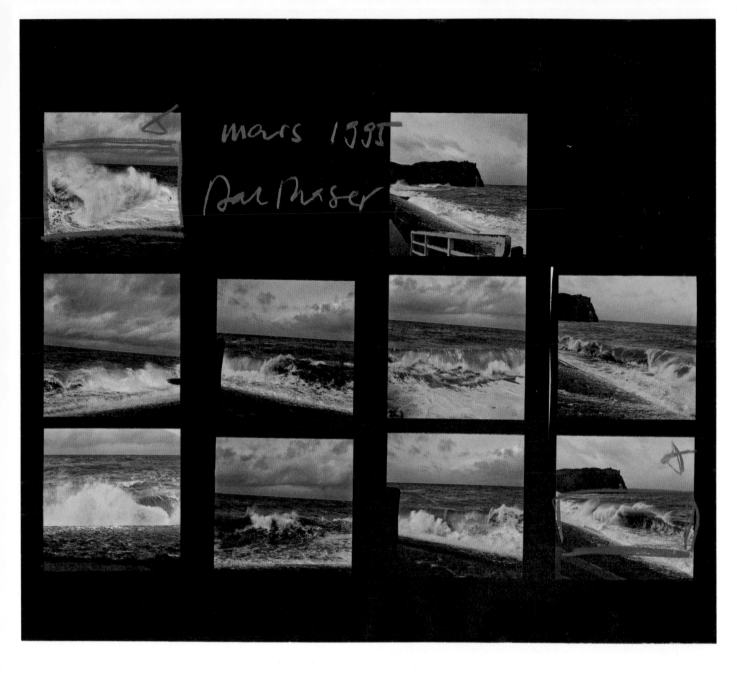

**Contact prints of shots of the beach near Étretat in Normandy, March 1995**

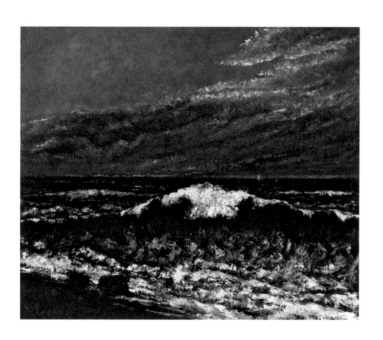

**Gustave Courbet,** *La Vague,* 1870

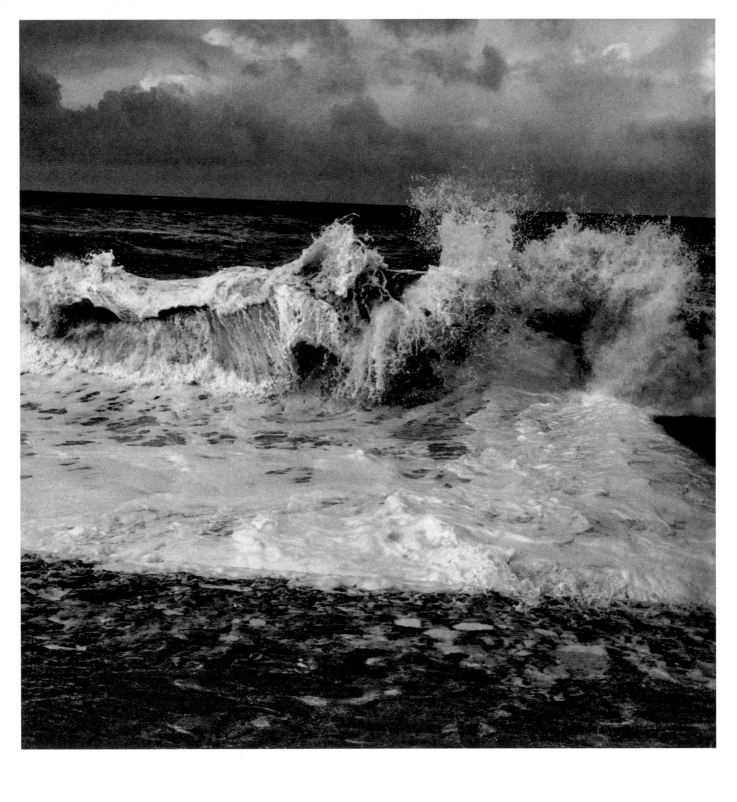

*La Vague, Normandie 1,* 1995

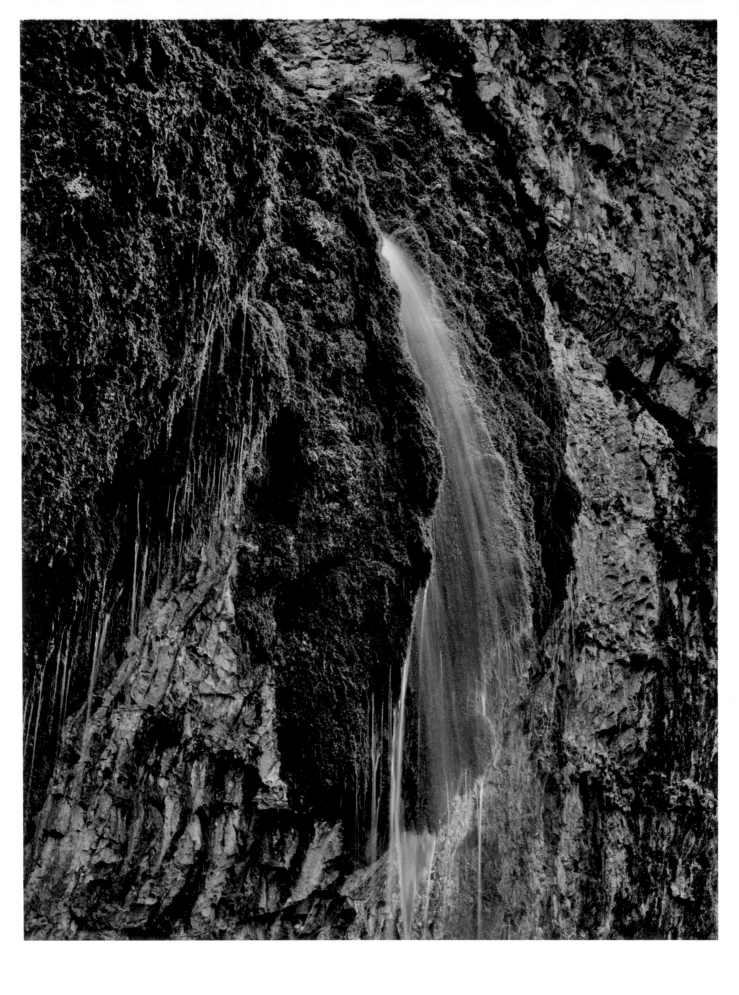

*La Source*, 1988

*L'Origine,* 1988

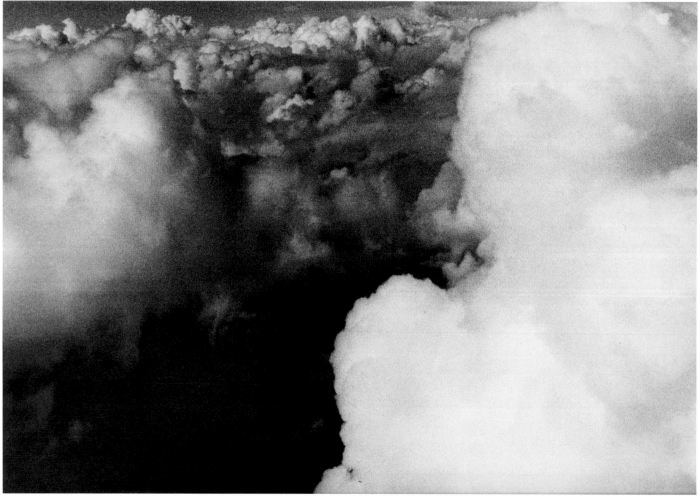

*Aile de faucon*, 2002

# From Balthasar Burkhard to Balthasar Burkhard

Françoise Le Penven: The opening of *documenta 5* is beginning to subside. The party is over. And to prolong it a little, like a troupe of traveling players, you take to the road, following the path that will lead each of you on your own artistic journey.

Jacques Caumont: A little convoy: a van and two cars. James Lee, Harald, Balthasar, Jacques, Violette, and Jennifer. Heading out of Kassel in the direction of Bern. The city that was still in shock from *When Attitudes Become Form*, three years after Szeemann's exhibition.

FLP: Yes, in 1969 objectors had upended a cartload of muck to give "form" to their disgust.

JC: The Bern where Harald Szeemann wanted us to see the exhibition dedicated to his hairdresser grandfather in what had been his barber's shop. The Bern built on a hill overlooking the Aare. And the Bern of Balthasar Burkhard too.

FLP: Balthasar Burkhard, who since *Attitudes* had been turning into the photographer of works generated by ephemeral, fleeting actions, a bit like Alfred Steglitz with *Fountain* in 1917. Without the photo published in *The Blind Man No. 2*, the "sculpture" by "R. Mutt" would simply have remained a myth consigned to the limbo of history—there would have been no possibility of replicating it. In keeping with the performative character of the image defined by Horst Bredekamp,[1] Balthasar began setting up image-acts. He was already more than a documentarist or reporter, wasn't he?

JC: Certainly. In this convoy, I was the unwitting instigator of what was to come and of what happened from the first evening out of Kassel. The opening of *documenta 5* was ushered in by James Lee Byars, standing in the middle of the pediment of the Fridericianum, a living sculpture defying vertigo as he seemed to make gold rain down (p. 70).

FLP: Leaving a residue of pieces of confetti, golden simulacra stamped with a microscopic sentence—isn't that right?

*Apresenceisthebestwork.* In Bern, for James Lee Byars, Art continued, from one place to the next. And always ephemeral …

JC: When Balthasar had photographed James Lee on the pediment of the Fridericianum, he intended to capture the image of Neptune that would give a new lease of life to the performance he was going to direct. A Neptune going down a steep coastal incline leading to a hypothetical Ocean. A performance that wasn't improvised but rather premeditated: James Lee grabbing two trident-like poles from a Kassel construction site that were holding up some barriers to keep out the public.

FLP: Wasn't the element of Water to be at the origin of some of your artistic dialogues?

JC: Years later, in May 1988, a tridentless Neptune brought Balthasar to Grainval, to the Valeuse, the cliffs near Fécamp, the town where I was born. A sublime little hamlet, where, when I was a child, our family would go to an open-air café on Sundays for an evening snack, to enjoy winkles and crabs. This was mentioned to Balthasar in Bern while he was shooting the portrait for us. So he immediately took off in a 2CV, with a short stepladder on the roof, to drive from Bern to the Normandy coast. But a stepladder doesn't allow you to put the camera high enough—that was the devil of it: the perspective! Balthasar went straight off and came back again with a very long telescopic tripod and a real ladder!

FLP: It wasn't James Lee Byars's ladder anymore that Jacques was transporting around and moving to this or that tree in the streets of Kassel according to the whims of the magus, stringing out his miniscule opuscules from a high branch. As time went by, it was immortalized by Balthasar Burkhard in a process of magical co-creation …

JC: Magical for sure, but there at Grainval, looking out over the sea, it was Balthasar who clambered up the ladder to satisfy his desire for a frontal view of this vegetable and mineral source, a natural curiosity of Grainval. A geological "origin of the world" that is not hairy but mossy. Moss through which a fine cascade of freshwater oozes before splashing onto the pebbles, which, as the tide rises, are covered by the brine of the Channel.

FLP: The photograph taken in Bern in 1988 of *L'Origine* (p. 229), the source of the feminine world that will be found alongside that of Grainval at the exhibition—was this idea conceived much later?

JC: The photograph was taken a few months later. Since it is taken from nature, Balthasar Burkhard's *L'Origine* is not only the last extreme of realism à la Gustave Courbet but also, by virtue of its extreme frontality, a "straight photograph" as classified by the pictorialist Edward Steichen. Auguste Rodin, Edward Steichen, and Balthasar Burkhard, are they not kindred spirits in this photographic "origin"?

**Jacques Caumont as Neptune, July 1972**

FLP: I also understand that you had a joint project that should be seen as an extension of *L'Origine*. Or am I mistaken?

JC: No, not at all! But it didn't come off. We wanted to make it in a way that this feminine Origin would be hidden from view, only visible on the sly, as it were. We had come up with a strategy. The mechanism was realized and in place. The right side of the tub in our bathroom in Normandy was equipped with the replica of an Egyptian falcon, which, when turned, caused a double-sided picture frame to pivot. On one side was the Château de Blonay under snow; on the other, hidden when the falcon prevented you from seeing it, Burkhard's rendering of *L'Origine* photographed *con amore*. In October 1989 we went on a scouting expedition to Blonay and Balthasar was due to go back there when the snow came. This idea was somewhat comparable to the background of Courbet's *The Origin of the World*, which originated with Khalil-Bey. Then the project came to a halt when our activities were eclipsed by the work on Duchamp's *Ephemerides*, which the Académie de Muséologie Évocatoire spent five years editing.

FLP: Wasn't it Balthasar who did the cover for the *Ephemerides on and about Marcel Duchamp and Rrose Sélavy*? The background was a view of Venice in the evening twilight …

JC: That's right. In the lab Balthasar superimposed an image of Duchamp's *Le Grand Verre* on the lagoon scenery he had photographed during our visit, a picture taken from a small motorboat on the Grand Canal. With the challenge of the *Ephemerides* now complete, the work was all set to resume. It was about the waves at Étretat, not far from Grainval. This was meant to be followed by the finalization of the version of *L'Origine* with the falcon in the bathroom.

FLP: Another episode in Normandy involving Balthasar was when we did a series of photographic experiments in a naturalist style, shooting snails and a toad …

JC: He had actually come to prepare a "hairy" exhibition. The plan was to photograph my beard and the fleece of a goat! But to my great regret he wasn't able to photograph one of my goats for his bestiary because he hadn't brought along the neutral backdrop that he'd used for the animals he photographed in Hollywood.

FLP: The idea was to have the same neutrality as naturalists, entomologists, and botanists in the style of someone like Fox Talbot. We had the impression that he wanted people to see his photos on their own terms, without actually crossing over into abstraction. Incidentally, the Grainval "subject" is a marvelous example of this, a sort of natural abstraction. This express desire to rid the photo of its artifices, wanting it to be neutral and coming up with ultra-sophis-ticated devices to achieve this—this makes Balthasar a herald of the true image, the Vera Icon. Precisely in the realist style of Courbet, from his *Origin of the World* to his *Wave at Étretat*.

JC: Étretat. The storm warning. The warning from me, as with *Happening & Fluxus* and at *documenta 5*, the warning of … "This is going to happen," "Such-and-such an artist is coming …" When the storm warning was announced, Balthasar came immediately from Bern. We got constantly showered facing out over the stormy seas, whereas Courbet painted the swell from behind a window. And while we're on the subject of the Courbet painting, I always think of the account of Maupassant's visit: "In a large, empty room, a fat, dirty, greasy man was using a kitchen knife to paste lumps of white paint onto a blank canvas. Every now and then he pressed his face up against the window and gazed out at the storm. The waves came up so close that they seemed to batter the house and completely envelop it in the foam and roar of the sea. The saltwater beat on the panes like hail and streamed down the walls. […] This work became 'The Wave' and caused a public sensation."[3]

FLP: We still haven't left Neptune's realm … And what if we were to bring up the origin of all these adventures? Aren't we in the world of Arsène Lupin?

JC: Our meeting? A stop at Cologne on my way back from Hanover to Paris after having put some four thousand of Jean-Pierre Raynaud's pots on the windowsills of the imposing Rathaus, starting on Monday morning. Two sides of a coin: If I was the one who acted as midwife to the ephemeral works by the artists Szeemann had invited, then Balthasar was the immortalizer of the process of making them and of the finished result. Didn't these two sides of the coin dictate our respective approaches to art? Singing the praises of classicism to which the Museum of Obsessions, the Académie de Muséologie Évocatoire, and Balthasar Burkard's pure frontality all dedicated themselves?

*Jacques Caumont is a film director and exhibition maker. His friendship with Balthasar Burkhard began in 1970. He chose the form of a conversation here so as to underscore the different roles that his friend had in the world of art. Caumont talks with Françoise Le Penven, a Duchamp specialist like himself. Their conversation begins with an event that took place after the opening of documenta in 1972.*

1    Horst Bredekamp, *Théorie de l'acte d'image* (Paris, 2015).
2    In 1977 Jacques Caumont and Jennifer Gough Cooper founded the Académie de Muséologie Évocatoire, which remained in existence in Hautot-le-Vatois until 1996.
3    Guy de Maupassant, "La vie d'un paysagiste," *Gil Blas*, September 28, 1886, 1 [translated].

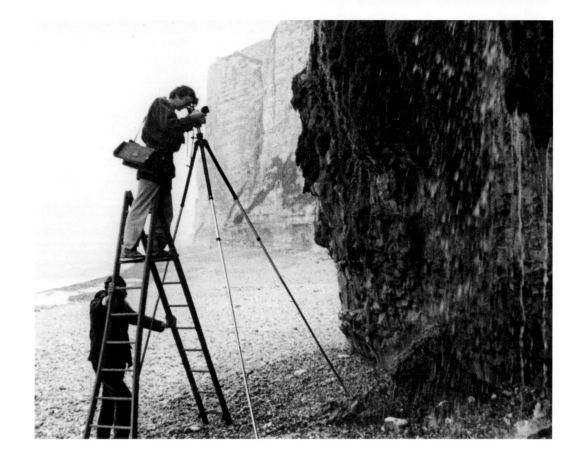

**Taking photographs for *La Source*, 1988**

Abigail Solomon-Godeau

# Corpus or Career? Balthasar Burkhard in Retrospect

*Why Photograph Animals?*
In his thought-provoking essay of 1977 "Why Look at Animals?" the English writer John Berger reflected on the many millennia in the history of animal and human coexistence. "The eyes of an animal," he wrote, "when they consider a man are attentive and wary. The same animal may well look at other species in the same way. He does not reserve a special look for man. But by no other species except man will the animal's look be recognized as familiar. Other animals are held by the look. Man becomes aware of himself returning the look."[1] Berger was not referring to humankind's relation with pets, those animals that the French language more accurately refers to as "compagnons domestiques." Rather, Berger was concerned with the changing relationships within the vast creaturely domain over which (according to Genesis) man has total dominion and with how these relations have historically evolved. "And yet," he wrote, "the animal is distinct, and can never be confused with man. Thus, a power is ascribed to the animal, comparable with human power but never coinciding with it. The animal has secrets which, unlike the secrets of the caves, mountains, seas, are specifically addressed to man."[2]

Be this as it may, we do not know the reason why Balthasar Burkhard decided to produce photographs of animals for a children's book, entitled *"Klick!", sagte die Kamera* ("Click!" Said the Camera), published in 1997. Burkhard's photographs were accompanied by short essays written by Markus Jakob. Certainly the photographs alone offer neither the lure of the anthropomorphic nor the charm that one might expect of a children's book. (This was the task of Jakob, who provided both). On the contrary, as individual prints, and subsequently exhibited in life-size scale, they have the presence and gravitas of portraits, and while the animals have been photographed in moments of stillness, they cannot be mistaken for taxidermic specimens.

The novelty of Burkhard's project should not be underestimated, even if, looking at certain nineteenth-century photographs of prized farm or sporting animals, it seems rea-

sonable to conclude that Burkhard was familiar with this genre and may have intended deliberately to allude to it. But tellingly, Burkhard's bestiary (pp. 180–89) is as far from the recent genre of wildlife or nature photography as it is from vernacular snapshots of pets. Depicted in profile view, against a cloth or canvas backdrop, his animal subjects are detached from any context other than that of their individual staging and their *being*. The animals came from circuses, zoos, a wildlife park, and a ranch. In this respect, this series presents exotic animals no differently from the occupants of the rural barnyard. Scale, excepting a few elements like a bunch of straw, or in several pictures what looks like a piece of wood, is not indicated, so that camel and donkey, pig and elephant occupy equivalent space. Moreover, Burkhard's consistent format functions to establish the formal unity of the series, although, in theory, it could be perpetually expanded. Some of these photographs are perhaps meant to make sly reference to pictorial precedents (the rhinoceros, for example, might refer to Dürer's famous woodcut of 1515, although Burkhard's rhino faces left rather than right; p. 189).[3] But what is striking about these pictures is the effect of sobriety, a quality one observes in the nineteenth-century photographs referred to above. This is reinforced by Burkhard's preference for printing with dark tonalities and a spectrum of rich grays. In the exhibition in 1999 in Grenoble, the life-sized prints were mounted low on the wall and close to the floor, establishing, as Nathalie Boulouch remarked, "une relation d'altérité troublante et forte à l'endroit du spéctateur et de l'éspace d'exposition" (a troubling and strong relation of difference between the space of the beholder and the space of the exhibition).[4] It is one of the achievements of Burkhard's project that it serves as a photographic parallel to Berger's question, "Why look at animals?" The animals' stasis and the attentiveness with which they are observed refuse both sentimentality and anthropomorphism. Which is why Burkhard's animals are very much in keeping with Berger's observation that the "animal has secrets which, unlike the secrets of the caves, mountains, seas, are specifically addressed to man."[5]

*Oeuvre or Projects?*
I have begun this essay with a consideration of this particular series but could have used any number of Burkhard's projects represented in this exhibition. In a somewhat paradoxical manner, this arbitrariness reflects on the strengths of Burkhard's work—there are other series of equal significance and formal invention that a different writer might choose in opening a discussion of his work. But this arbitrary aspect also indicates

**Exhibition poster, Grand Hornu, 1996**

239

some of the difficulties that arise in monographic exhibitions of an individual photographer. For in seeking to represent the breadth of a career that is both identified and unified under the sign of authorship, a number of problems arise when the medium is photography. Indeed, as this exhibition seeks to demonstrate, the fractures and fissures in a photographic career are integrally linked to the medium itself.

This highlights the difficulty of placing the production of a professional photographer, no matter how gifted, into the art historical category of an "oeuvre." Unlike painting, once the medium has been mastered technically, there rarely occurs anything that could be described as an evolutionary artistic development, where one body of work appears to grow organically (so to speak) out of the previous. Rather than evolution, we can, of course, identify departures and changes as the current exhibition reveals. In certain instances, as with Burkhard's technique for printing his photographs in very large-scale formats or printing them on canvas, these came after his professional training. But such innovative technical inventions beg the question of stylistic evolution in the sense that art history routinely employs the concept to track the stages of artistic development.

Although "oeuvre" can designate a single work, more often it signifies the entirety of an individual's production. And as was famously argued by Michel Foucault more than a half-century ago, the concept of an oeuvre is inseparable from that of its totemic figure, the author/artist, each term operating to reciprocally confirm the integrity or the autonomy of the other.[6] But in the particular case of Burkhard, as with most modern photographers, his production is strikingly diverse, encompassing documentary, scenic landscapes, installations, commercial commissions, flags, experimental forms aligned with the plastic arts, aerial photography, innovations of scale in printmaking, artists' books, portraiture and self-portraiture, figure studies, close-ups of flowers, architectural photography, and photographic "translations" of nineteenth-century paintings (e. g., Courbet's 1868 *L'Origine du monde* and his 1870 *La Vague*). It also includes work that was collaborative, as in the case of the large-scale photographs printed on canvas made with Markus Raetz, or the portraits and other works made with Tom Kovachevich in Chicago and Amsterdam.[7] Without the knowledge that these are all the work of Burkhard, it would be impossible to make the kind of identification that art historians, using the tools of connoisseurship, employ in order to establish the identity of the artist's "hand," thus certifying the honorific of authorship. All of which is to say that the medium of photography—and the

work of an individual photographer—more often than not, resists the integrative discourses familiar from art history.

*"Was ist es, eine Photographie
oder ein Bild?"*
Burkhard's work, however, raises some fundamental questions about the nature of the photographic medium. These turn on the tension between the perception of the image, the picture, and the photograph. "Was ist es, eine Photographie oder ein Bild?" (What is this, a photograph or a picture?) is one of the rhetorical questions posed by Rémy Zaugg in his essay for the exhibition catalogue *Ausstellung: Balthasar Burkhard* at the Basel Kunsthalle in 1983.[8] Deceptively simple, the question likewise returns to the debates about the status of art photography since the mid-nineteenth century with residual implications in the present. In German, "Bild" can mean a view, a picture, an image, or an impression. If the word "picture" is understood to refer to a tableau, a painting, a drawing, or a print, it is not merely because these are thought to manifest the work of the artist's hand. It is also because by definition, a picture, like any form of representation, is "other" than the physical or material world from which it derives (but departs). This is why in semiotics, a painting is considered as an icon, a fabricated image that has no necessary relation to what it represents. And if the subject of the picture is not something that the artist could have actually observed in reality (whether a crucifixion or a pure abstraction), it is even more closely identified with the inner world of the artist's imagination or subjectivity as well as the manual skills required for the work's production.

But surely Zaugg's point was that once enlarged so dramatically, Burkhard's pictures cede something of the quality of what we think of as "the photographic" and come closer to being perceived in the more disembodied form of the "image." In Basel, Burkhard's large nudes (*Der Körper I* and *Der Körper II*, pp. 151/52) were fixed directly onto the walls as a composite montage made of large prints; thus, their "picture-ness" and semi-abstraction could be said to have trumped their indexicality. On the other hand, when their support is canvas, they shift into the field of the object, for they are both tangible and substantial, with texture and weight. This contradicts the conventional perception of a photograph, for when looking at it, we do not linger on the surface but read *through* the surface directly to the image itself.

*The Surrealist Heart of Photography*
Depending on the project, Burkhard's photographs seem to oscillate between the formalist

mode of embracing the specificity of camera vision (for example, the extreme close-up that renders the familiar strange), or a more pictorial, iconic approach, exemplified in the large-scale versions of his animals. But even within his animal subjects, he marshaled both forms of depiction.

Consider, for example, Burkhard's series of close-ups of the common garden snail (*Helix aspersa*, pp. 247–49).[9] Depending on which of the exposures are viewed, the mollusk is not immediately identifiable as such, since only parts of its anatomy are depicted. Even in those photographs where the snail is viewed from above, the camera focuses on its unmarked upper surface and the tentacles are cropped out. Burkhard's lighting and cropping, however, function to accentuate the viscosity of the mollusk's nether parts, from whose folds and recesses is secreted a mucous-like substance that minimizes friction when it navigates the ground. Certain of the photos suggest labial folds, or even internal organs. In one exhibition catalogue layout, the photos are joined as a single strip, and the vulvar shapes and surfaces are counterpointed by the smooth quasi-phallic images of the snail's overall shape. In this sequence, it is as though the hermaphroditic snail actually replicated the morphology of female and male organs.

As noted, the animals Burkhard photographed for *"Click!" Said the Camera* belong to a particular tradition in nineteenth-century photography where the animal is depicted in its entirety, in profile view. But his photographs of *Helix aspersa* have an entirely different lineage, which derives from the photographic use of the close-up, the detail, and the effects of decontextualization. Variations on this approach can be seen in Albert Renger-Patzsch and other twentieth-century photographers, insofar as the cropping, the unusual viewpoint, or close-up that transforms the familiar was one of the tropes of modernist photography. The camera's capacity to shift the quotidian into the realm of an alternative, non-empirical reality was equally grasped by photographers in the orbit of surrealism. Susan Sontag went so far as to claim that the affiliation of the medium to surrealism was an inherent capacity of the medium. "Photography is the only art that is natively surreal," she wrote. "Surrealism lies at the heart of the photographic enterprise: in the very creation of a duplicate world, of a reality in the second degree, narrower but more dramatic than the one perceived by natural vision."[10]

In other words, if the "normative" uses of photography operate on the side of what semiology calls the index—the automatic registration of what appears in front of the lens—these other approaches exploit the medium's

capacities to transform its objects into something wholly different. To put it simply, if the normal uses of photography pivot on its transcriptive capabilities, alternatively, its artistic uses are generally situated on the side of the icon, the image. Accordingly, the fact that the photograph has the qualities of both index and icon has long prompted epistemological debates about photography's "essence."

*Working for the Über-curator:*
*Conceptualist Temptations and*
*Photographic Adaptations*

By the time Burkhard was making the kinds of photographs he exhibited at Basel Kunsthalle in 1983, a great deal had changed in artistic, photographic, and aesthetic discourse since the time of his professional training. The use of photography as well as video had by then become increasingly assimilated into contemporary art practices in ways that repudiated its art photography incarnations. A new generation of young artists had emerged, including the "Pictures" generation in the USA, and their use of the medium involved a reflection on its role in mass culture and its ideological instrumentalities. Such reflections had occasionally also been on offer earlier in various conceptualist and post-minimalist practices. In this regard, conceptualism's international variations and protean forms were probably first encountered by Burkhard in the 1960s when he started working for the Bern Kunsthalle, then directed by Harald Szeemann. Serendipitously, Burkhard's position as the Kunsthalle's official photographer inaugurated his long relationship with Szeemann, who became a freelance *Über*-curator after resigning from the Kunsthalle.[11] Szeemann's now-legendary 1969 exhibition at the Bern Kunsthalle, *Live In Your Head: When Attitudes Become Form; Works – Concepts – Processes – Situations – Information,* facilitated Burkhard's entrée into the milieu of contemporary art, exposing him to uses of the medium that lay outside the realms of either conventionally artistic or commercial photography.[12]

Three years later, when Szeemann directed the 1972 documenta (*Questioning Reality – Pictorial Worlds Today*), Burkhard was again well positioned as Szeemann's "court photographer" to observe the production of conceptual and post-minimalist artists. And in addition to his professional role documenting the exhibition and its events, he also made portraits of a number of the participating artists (pp. 68–85).

Obviously, the conceptual, processual, and post-minimal art that Burkhard encountered in Bern, in Basel, in Kassel, in Venice, in New York, and later, in Chicago did not descend from either the modernist or experimental branches

of photography. If there was a shared approach to the use of the medium by conceptual and post-minimal artists, it lay in a principled repudiation of the values underpinning abstract expressionism, as well as aestheticism as such. The issues many of these artists addressed had to do with art's institutionalization, its commodification, its relation to the museum (as an institution of confinement and displacement)—issues that do not seem to have been of any particular interest to Burkhard during his career. However, Zaugg's question, "Was ist es, eine Photographie oder ein Bild?," would turn out to be important for those photographers, like Burkhard, who may have admired conceptual and post-minimal art, but for whom the primacy of the medium *qua* medium, including its artistic possibilities, remained a paramount concern. In this respect, several of the most innovative aspects of Burkhard's work resonate with Zaugg's epistemological query. Although a number of critics have conscripted Burkhard's early work to conceptualism, this is a bit of a stretch. While the term conceptualism covers a multitude of practices, for many artists this involved a dematerialization of the object (art could be an idea, a set of instructions to follow, a purely linguistic proposition, etc.). As Marcel Duchamp had earlier argued, art needed to be liberated from its "retinal" attributes. Other conceptual practices focused on the framing institutions of art, such as the museum and gallery, and indeed the institution of art itself. None of these are aspects of Burkhard's work, with the possible exception of his engagement with the architectural space of the museum. Rather, one of the most salient qualities of his work is its sensual appeal, its impeccable craftsmanship—especially evident in his superb photogravures (p. 233)—and his profound engagement with the formal and technical possibilities of the medium. In these respects, one can better understand his motivation in the 1980s to explore the unstable relations between the picture and the pictorial, the photograph and the image.

*Collaborative Process I:*
*The Canvases*

Nowhere is this more evident than in the collaborative work made by Burkhard with the Swiss artist Markus Raetz in 1969 and 1970 and, subsequently, his installation made with the artist Niele Toroni in 1984 at the Musée Rath.[13] For the former project, the two employed a process by which large-scale photographs were printed directly onto unstretched canvas, which was then treated so as to render it supple. When mounted with clips against the wall, it could drape like a heavy curtain. And, indeed, one of the canvas photographs depicts a curtain, one that covered the glass segments of the door to Raetz's Amsterdam studio where some of the exposures for the first canvases were made (p. 110). (Others were subsequently made in Chicago in 1977, where Burkhard moved after accepting a teaching position, pp. 119–22.) If *Curtain* were a painting, we would say that the nominal subject—a curtain veiling a closed door—alludes to the flatness and verticality of the picture plane. But as a photographically generated image it does something else. Specifically, it obstructs the viewer's vision, the desire to see what is routinely given to be seen, negating the illusion of transparency inherent in the medium. The drape of the canvas and its dark tonalities consequently contradict the norms of both painting and photography. Oscillating between painting's opacity, texture, and materiality, and the photograph's window-like effect and elision of its own paper support, it poses anew the question of whether to locate the image on the canvas or through the canvas, echoing the paradox of photographic transparency.

It is these works on canvas that again return us to Zaugg's question. With their impressive scale, tactile surface, and banality of subject matter (unmade bed, curtained door, and empty studio, pp. 107–10) they are and they are not photographs, they are and they are not pictures. Later, in Chicago, the subjects of these large-scale pictures printed on canvas included the messy back seat of Burkhard's Pontiac car (p. 121) and a chair and TV in an empty room (p. 120). Subsequently, photographs he made of body parts (an ear, a head, limbs, and close-ups of body hair) were also transferred to canvas. Burkhard often reused certain of his photographs, reprinting them on flags or canvas, rescaling, repurposing, and reorganizing them according to the requirements of a given project. The close-up of an ear, for example (probably made by Kovachevich, who also made a number of portraits of Burkhard), was produced in different versions and formats (pp. 137–39), such as a series of flags commissioned for the University of Bourgogne in Dijon.

These works on canvas are best considered as hybrid productions, given their initial fabrication and subsequent transformation, and they indicate one of Burkhard's recurring preoccupations, namely, the exploration of the kinds of relationships possible between the traditional plastic arts and the photographic medium. This is evidenced not only by his adoption of artistic genres—nude, landscape, etc., as well as the canvas support—but also, his use of the word *Entwurf* (sketch, a term from the graphic arts) for his photograph of Kovachevich's son. His

photographic versions of Courbet's *Origin of the World* and *The Wave* are the most literal examples of this preoccupation. It is likely that Burkhard's experience of the international contemporary art world as he documented the exhibitions of Szeemann and Ammann or collaborated with Toroni, Raetz, and Kovachevich made him particularly aware of the discursive and practical divisions between the identity of the professional photographer, the art photographer, and the artist using photography. That particular projects he produced belong to each of these categories returns to the problem of reconciling photographic careers with traditional art-historical terms positing a signature style that functions as a unifying aspect of the production.

### Collaborative Process II:
### The Musée Rath

Nonetheless, it might be argued that the banality of the everyday subject matter in some of the canvas works corresponds to at least one aspect of both conceptualism and post-minimalism. This might be characterized as the desublimation of traditional aesthetic premises, rejecting concepts of "the beautiful," transcendence, artistic autonomy, and symbolism. But if we reflect on the collaboration between Burkhard and Niele Toroni for the exhibition at the Musée Rath one can see how formalism and conceptualism were, in effect, married in what was effectively an installation *avant la lettre*. But was this a marriage of love or a marriage of convenience?

The question is not to do with the personal relations of the men, but the nature of their respective practices. Toroni, like Daniel Buren, conceived his work according to fixed schema. From 1966 on, he named his practice *Travail/Peinture* (*Work/Painting*), and the overall title could refer both to the labor of a house painter and that of an artist, which was, obviously, Toroni's point. His schema determined that the work would always be site specific, that it would always be fabricated by the marking of a surface or support with paint applied by a number 50 brush spaced at regular intervals of 30 cm. As both defined and produced, such a practice conformed to many of the precepts of conceptualism as it emerged in the 1960s, interrogating and rethinking the means and ends of artistic practice and, as a consequence, repudiating the prestige of painting and sculpture.

In their joint exhibition at the Musée Rath in 1984, taking the museum's architecture as the support of their work, Burkhard and Toroni paired their works on four columns in the gallery. Burkhard's contribution consisted of five nearly identical back views of torsos, of ambiguous sex, each measuring 200 x 100 cm, and printed on paper directly attached to the columns. Each of the torsos was subtly modified by a slight shift of torsion at the hip. The exposure was also minimally altered to progress from lighter to darker tonalities. The combined effects of scale, the use of near-multiples, the illusion of volume and three-dimensionality produced by the lighting of the body were all made possible by the particular material and technical features of the photographic medium. In this, and in other respects, it is not conceptualism that defines Burkhard's project but formalism, by which I refer to a commitment to medium specificity and to self-reflexivity.

Counterpointing Toroni's paintings (which are neither pictures nor images) with Burkhard's photographs makes evident their very different orientations, for in taking photographs, the photographer's camera is also, by definition, making images. Toroni's project as an artist is predicated on categorically refusing figuration, as well as refusing to create either an image or a picture. Analogue photography can produce all kinds of images; it can deform, abstract, and stylize, but it cannot *not* produce images, even without a camera (i. e., photograms).

### The Body in Pieces

What is striking about the photographs Burkhard made of body parts during his forty-year career is how the use of cropping, close-up and/or blow-up were so fundamental to his work, whatever the subject (e. g., the neck or foot of a young girl, bamboo stalks, flowers, and so forth). This too is the visual language of photographic formalism.

But that said, in certain instances, Burkhard's photographs of body parts, like his photographs of the snail, achieve a strangeness, an uncanny quality that shatters the cool, deliberate, and statuesque properties of reclining nudes, torsos, legs, and arms. I refer here to the series called *Veins*, depicting the vertical length of an alarmingly thin arm cropped under the shoulder and just above the wrist. The upper arm appears even thinner than the part below the elbow, something one observes in emaciated bodies. Hairless, marble-like where it is unmarked by shadow, this arm, like his torsos, is ambiguously gendered. But the tension with which the veins swell out from the ashen skin has something of the quality of an *écorché*, an anatomical model where the skin has been peeled away to illustrate the veins or muscles underneath. Unlike Burkhard's other legs and arms, there is something about the engorged veins on the fleshless arm that is both riveting and disturbing. While recognizably an arm, it is not the kind of photographic image whose visual *frisson* derives from the viewer's inability

to identify its subject. But its strangeness, and its uncomfortable blurring of the boundaries between inside and outside, recall Sontag's notion of the innate affinity of photography to surrealism. Even more pointedly, I am thinking here of Rosalind Krauss's discussion of the role of photography within surrealism itself. "The special access that photography has to this experience [of surreality] is its privileged relation to the real [...] The experience of nature as sign, or nature as representation, comes 'naturally' then to photography. It extends, as well, to that domain most inherently photographic, which is that of the framing edge of the image experienced as cut or cropped."[14]

I am not arguing that Burkhard's work should be considered "surrealist." Nor does the perception of certain of his photographs as productive of the shock, the estrangement or destabilization of perception dear to surrealism indicate any affiliation on Burkhard's part. The effect I am describing does not have any necessary relationship to intention. Quite the contrary:

This particular and visceral form of response to a given photograph is entirely subjective; like Roland Barthes's *punctum*, different viewers might find the snail or vein photographs entirely unremarkable. The capacity to trigger the perception of the uncanny is merely one further property of the medium that militates against the desire to organize a career into a unified corpus or oeuvre. Consequently, if photographic production by an individual photographer remains resistant to the classifying and categorizing principles that seek to domesticate it, it is because the medium itself remains always in excess of attempts to discipline it.

*Abigail Solomon-Godeau is a US American historian and critic in the field of art and photography. Her essays on the history of photography, with a special emphasis on the aspect of gender, have appeared in magazines, anthologies, and individual publications. They have been translated into a number of different languages.*

1   John Berger, "Why Look at Animals?," in *About Looking* (New York, 1980), 2.

2   Ibid., 6.

3   Julie Enckell Julliard has observed that one of Burkhard's photographs among his various close-ups of a falcon's wing (not part of the animal series) may allude to Dürer's drawing of the same subject. See Julie Enckell Julliard, "From Photography to Photogravures: A Tale of Skins," in *Balthasar Burkhard: Reconnaissances 1969–2007*, exh. cat., Musées de la Ville de Strasbourg (Strasbourg, 2008), 36.

4   Nathalie Boulouch, "Balthasar Burkhard," *Critique d'art* 16 (Fall 2000), 16.

5   Berger, "Why Look at Animals?" (see n. 1), 3.

6   Michel Foucault, "What is an Author?," in *Aesthetics, Method and Epistemology*, ed., James D. Fairbourn, trans. Robert Hurley et al. (New York, 1998).

7   Interestingly, both men were featured in Harald Szeemann's documenta 5 (1972), having already established artistic reputations, but this was years before Burkhard had made the transition from freelance photographer to art photographer and five years before his collaboration with Raetz, although, as I have indicated, he remained active in both domains.

8   Rémy Zaugg, *Ausstellung Balthasar Burkhard*, exh. cat., Kunsthalle Basel (Basel, 1983), 39.

9   These seem to have been photographed on a sheet of glass, since Burkhard photographed both the bottom and the top of the snail. At least one of the snail photographs was blown up for exhibition, as is indicated in one of his maquettes reproduced in the exhibition catalogue *Balthasar Burkhard* (Paris, 1999).

10   Susan Sontag, "Melancholy Objects," in Sontag, *On Photography* (New York, 1977), 52.

11   Burkhard's personal relationships with Szeemann and Jean-Christophe Ammann, who invited Burkhard and Raetz to the seminal exhibition *Visualisierte Denkprozesse* at the Kunstmuseum Luzern (1970), were extremely important for his career, and he subsequently featured in many of their exhibitions. It was with Jean-Christophe Ammann that Burkhard made his first trip to the USA.

12   Szeemann's 1972 documenta included a small number of works where photography was employed (such as the work of Bernd and Hilla Becher), but no art photographers were represented.

13   Burkhard and Toroni had subsequent versions of their collaboration exhibited at Le Coin de Miroir in Dijon in 1984 and at the Staatliches Lehrerseminar Thun in 1986.

14   Rosalind Krauss, "Photographic Conditions of Surrealism," in *The Originality of the Avant-Garde and Other Modernist Myths* (Cambridge, MA, 1985), 86–129, here: 115.

# Morphologies of the World

Even though there is great variety in the photographic projects that Burkhard undertakes in the last two decades of his life, they all share the same spirit of enquiry, in which a wider world is reflected in a macroscopic view of details. The Alps, familiar and remote landscapes, architecture, still lifes, and flowers are all elements in the study of forms and the sensual exploration of visible reality. Burkhard's final publication could have been called "The World Is Beautiful" (like Albert Renger-Patzsch's photographic account of the world in the style of the New Objectivity), but in fact it was titled "The Scent of Desire," a reference to Burkhard's sensual perception of the world.

*Kumano,* 2005

*Klöntal,* 2002

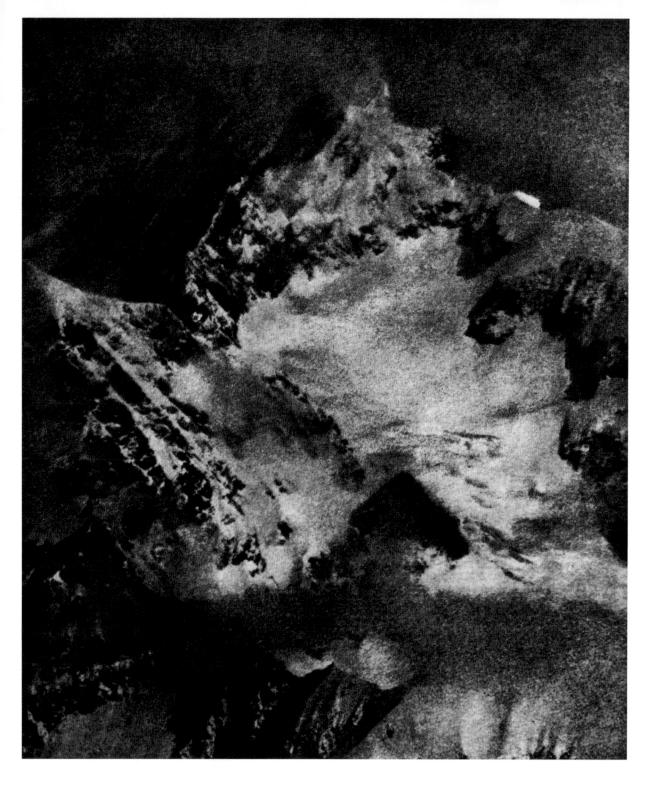

*Alpen,* **1994**

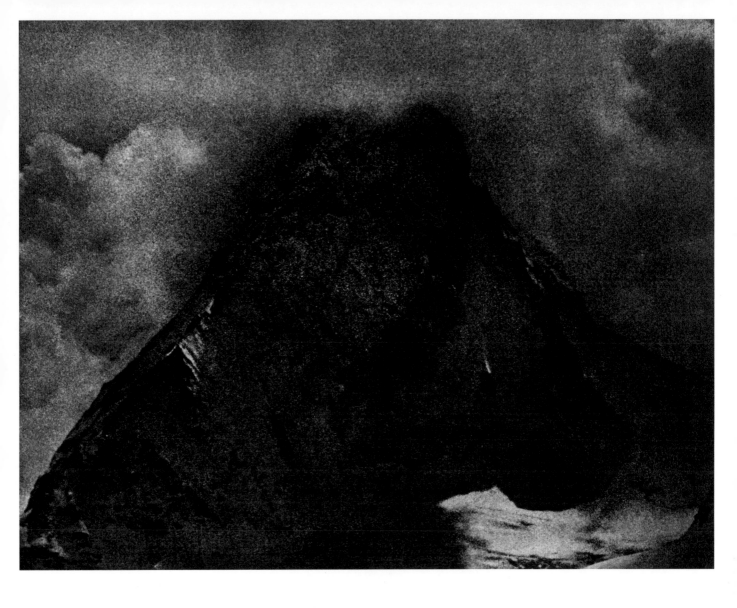

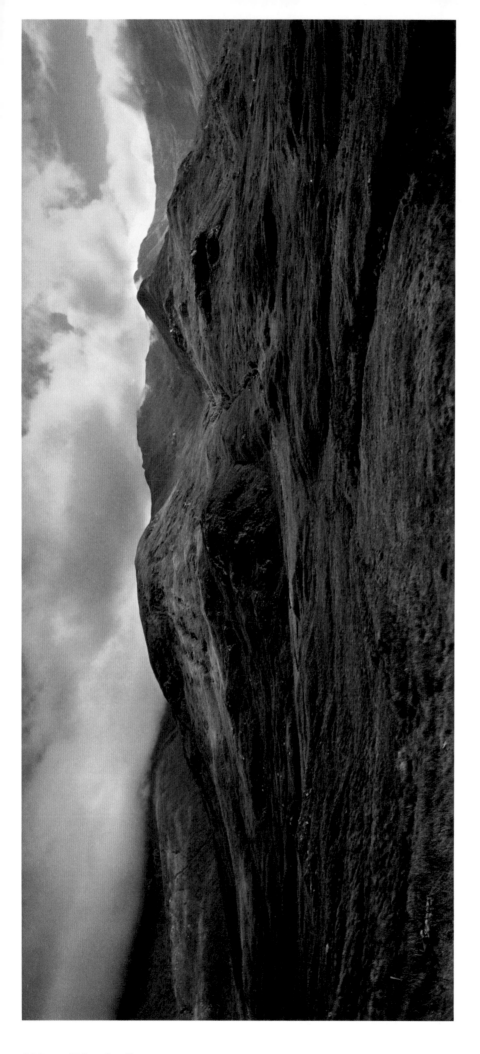

*Schottland*, 2000

**Sweet peas, 2009**

**Poppies, 2009**

**Roses, 2009**

**Japanese irises, 2009**

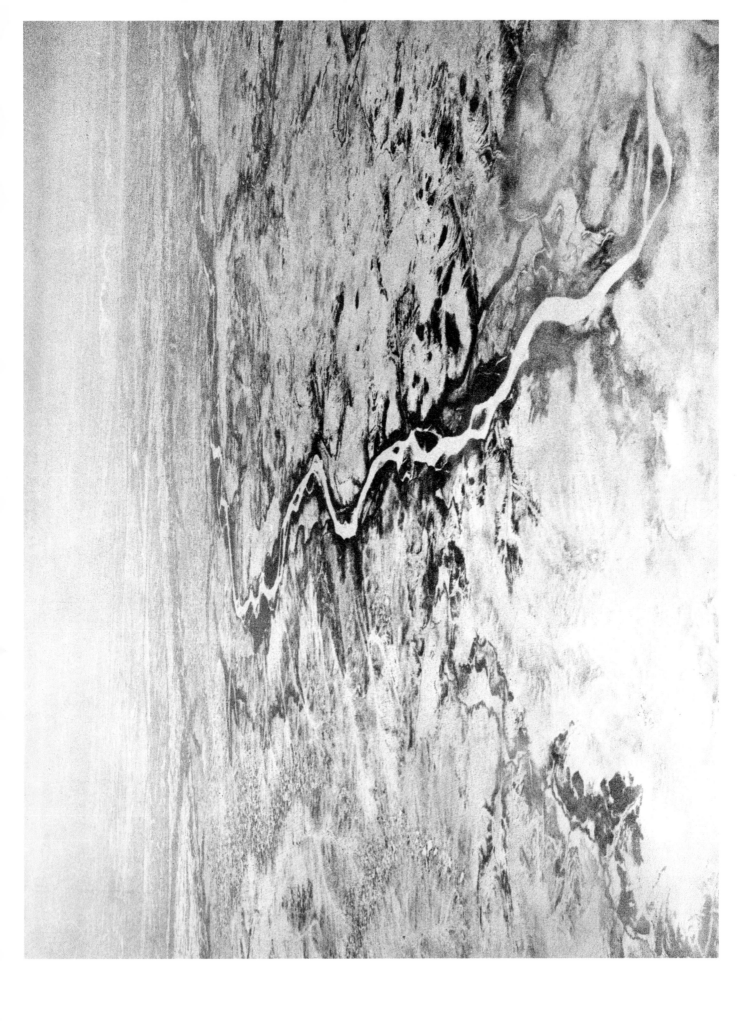

*Fleuve blanc*, 1999

Laurent Busine

# The Public Photographer

Our friendship was something we enjoyed to the full, through long nights and busy days. Balthasar and I were in constant communication and would talk endlessly. We saw our roles—that of the public writer and the public photographer—as closely related. We had dreamed them up together, we compared them constantly, and even swapped them. They were two professions that we thought were among the finest, similar to one another right down to the minutest detail, once their practitioners commit themselves to following a path they love.

We both asked ourselves the same challenging question, which came up frequently during our conversations—how to represent the pressing need of a man or a woman who wishes to declare their love using images or words to some distant person that they long for? I think that we first concretely applied ourselves to this task in 1995 when we designed an album for the Rodolphe Janssen gallery.[1] Balthasar didn't need to add words to his photographs. They said everything we wanted to express. He quickly chose an image that conveyed the body and its beauty: a simple, magnificent picture of the sole of a young girl's foot, which he had taken during a visit to Japan in 1987 (p. 251).[2]

For my part, I had written a text that dealt at length with a different work and tried to penetrate its mystery:[3] "An image that one could scarcely make out, one where it would have been impossible to say what it represented, even whether it had been done with a pencil or using a technique with which I was unfamiliar, or if it might even be an old photograph, a faded carbon print, where the retouching had created a metallic glint."

Then later, at an exhibition at the Palais des Beaux-Arts de Charleroi, we committed more definitely to this rather absurd undertaking.[4] This slim volume, which took the place of a catalogue, contained small-format reproductions of almost all the pictures on display as well as texts giving a detailed description of certain hours or days in the life of the titular *Écrivain public*, a fictional "public writer."

The foot—which is certainly that of the young Japanese girl—reappears in striking fashion in a detailed description that finishes with this statement: "He gave up on this idea, when he realized that it was impossible to describe even a simple beauty spot because, like the countless hairs on the body, it was an indivisible part of creation. To do this, it would be necessary to go back over all the elements of the universe one by one and to define their interconnectedness and reciprocal influences, all the way from humanity's first day to its very last."

Without exception, this insight underpins all the photographs included by Balthasar in the book. Making use of all manner of motifs, the photos speak of the beloved body, and in the images of clouds, waves, cities, springs, mountains, and deserts they are invariably imbued with the idea of the body or a part of the body, whose warmth and formal qualities Balthasar invariably went back to and trained his gaze on.

We knew at this moment that our project was destined to remain incomplete, unless death came calling. And so it was that the last round of the game that we had invented so that we would always have a subject and a dream to occupy our minds and our interminable conversations was brought to a happy conclusion in the last moments of Balthasar's life, which he greeted with courage and clear-sightedness, aware that the inevitable end was upon him.

I was given the task of completing what had been started so many years before in a final posthumous publication:[5] the story of the "public photographer." Balthasar had the opportunity to read it, and we agreed that the book would be accompanied by his last photogravures of flowers and bouquets. It is a tender and melancholic album, wonderfully colored by these moving new works, which once again bear witness to the remarkable capacity that Balthasar had of being able to focus on all the ingredients that make up the world and to find in them what is human, quite naturally and without putting on a show.

The text, which tells the story of an imaginary character, finishes with these words: "Spread across the photographs that he had taken through the course of his life, the women that his loving eye had fallen on were imprinted in his work."

*Laurent Busine is a Belgian art historian and curator. In 1978 he was appointed head of the Palais des Beaux-Arts de Charleroi. In 2002 he became director of the Museum of Contemporary Arts on the historical site of Le Grand Hornu. In his capacity as a patron and friend of Balthasar Burkhard, he mounted the first exhibition of the photographer's urban views in 1999 and organized a solo show for him at Le Grand Hornu. He has generated numerous texts and publications on Balthasar Burkhard.*

1   Balthasar Burkhard / Laurent Busine, *Album*, which appeared in a run of thirty-nine numbered copies, each with one original print; there are also ten numbered copies (I to X) that were not put on sale, published by the Galerie Rodolphe Janssen, Brussels, 1995.

2   *Swiss Artists in Residence in Japan*, Meguro Museum of Art, Tokyo, November 1987.

3   A writer friend of mine once showed me the picture in his apartment.

4   Balthasar Burkhard / Laurent Busine, *L'Écrivain public*, published in conjunction with the exhibition *Balthasar Burkhard* at the Palais des Beaux-Arts de Charleroi, 1999.

5   *Balthasar Burkhard: Nature Morte*, an album containing nine original photogravures printed in a run of thirty-seven copies numbered 1 to 37 and twelve copies numbered I to XII, along with two copies that were not for sale, Edizioni Periferia, Lucerne, 2010.

Florian Ebner

# A Photographer Is a Photographer Is a Photographer

Can a single exhibition do justice to the many faces of a photographer, artist, and master of the art of living?

"Balthasar Burkhard *was* and *is* a photographer. Was—for his reportages and photographs, and for capturing events, the momentary, and the major manifestations of contemporary architecture. Is—because he now uses the camera to create his own images. Images of the body and its parts that are fully authentic—an authenticity that we also find expressed in the static shots of August Sander and others [...]. Burkhard opts for a sense of detachment typical of the New Objectivity (*Neue Sachlichkeit*), even if the subjects he chooses are more than what they represent."[1]

In 1993 the celebrated curator Harald Szeemann—a friend and close associate of Burkhard's—wrote a piece on the large-format banners that had been mounted on the façade of the CAPC museum in Bordeaux for the exhibition *GAS – Grandiose Ambitieux Silencieux* (fig. A). His essay begins with an attempt (quoted above) to differentiate the two personae that were, in his opinion, constituent parts of the photographer's makeup. Szeemann himself derived considerable benefit from the first persona. Indeed, much of his work as a curator would have remained undocumented and, if it were not for Burkhard, would have disappeared without trace. For a long time he himself had little interest in the work of the second persona, focused as it was on the creation of autonomous images. This version of the photographer drew encouragement from other sources, such as Jean-Christophe Ammann, who supported his development at an earlier stage and with greater zeal. It seems that Szeemann consciously avoided making a distinction between the terms "artist" and "photographer." And yet the question arises as to whether Burkhard's "past" and "present" personae as a photographer can be so clearly differentiated. Szeemann's assessment also seems to contain a value judgment, based on the criteria of artistic relevance and significance.

This retrospective of Balthasar Burkhard's work, the first since his death, tells the story of a photographer's emancipation. It also tells of the liberation of photography from its role as "very humble servant" (Charles Baudelaire), its rise to become a self-assured art form, and its triumphal entry into the lofty halls of art. However, when one looks at the relative weighting of the works in this publication, the exhibition makes a particular attempt to avoid any suggestion of a narrative in which it is only the great auteur pieces, "the independent pictures," as Szeemann called them, that determine the value of either one of Burkhard's photographic personae.

When Szeemann wrote the text in 1993, these were the only two roles that stood out for him, that of his former "court photographer"—as he called Burkhard in a letter of recommendation for a position in the USA—and that of the photographer who confidently exhibited his work in the company of artists like Wolfgang Laib and Royden Rabinowitch at the CAPC in Bordeaux.

*Phases 1/2: Eye-witness photographer and documentarist / Sculptor and in situ artist*

Looking at Balthasar Burkhard from today's perspective provides a more nuanced image of him as a photographer, artist, and *Lebenskünstler* (a master of the art of living). Borrowing from the concept of the three ages of man, three phases can be determined, bearing in mind that we are dealing with an oeuvre marked by transitions, and that there are self-referential aspects that make Burkhard's work both fascinating and multifaceted. To start with, there is the young Burkhard,[2] who, having learned his craft from Kurt Blum, drew on the photo-book culture of the 1950s as inspiration for his first stylistic experiments. Galvanized by the revolutionary fervor of the youth generation, he worked with and for other artists, eventually becoming part of Harald Szeemann's entourage and observing how contemporary conceptual artists broke apart the classical exhibition space. Together with Markus Raetz, he took his initial steps as an independent artist and made his first large photo canvases; then, in 1972, in the company of Jean-Christophe Ammann, he got to know the major figures in American art and captured the legendary documenta 5 in the viewfinder of his camera, thus witnessing the great reconsideration and reinvention of art in the second half of the twentieth century.

In the mid-1970s Burkhard was living in Chicago and absorbed with the question of what he really wanted for himself. This marked the transition from the first to the second phase of

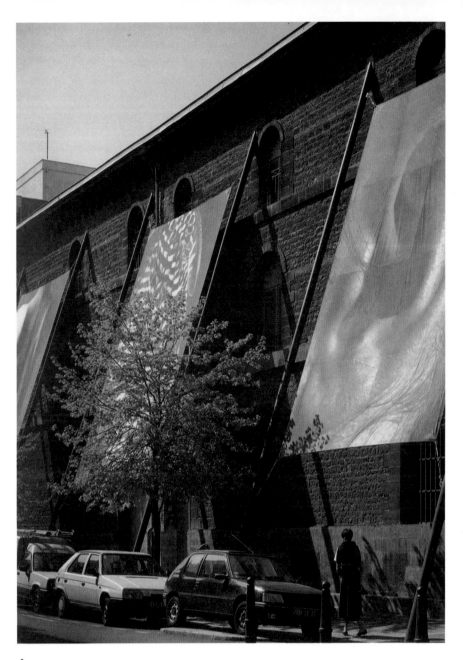

A

A    Installation view of the exhibition
     *G.A.S. – Grandiose Ambitieux*
     *Silencieux*, CAPC Bordeaux, March
     13 – May 23, 1993, curated by Harald
     Szeemann; Balthasar Burkhard,
     Untitled, 1992, serigraph on polyester
     canvas, six banners (mouth, nose,
     arm, foot, back, wing)

his career. What Burkhard had always wanted was to make it big. Europe and the medium of photography quickly became too restrictive for him. It is more than just a coincidence that while in Chicago the thirty-two-year-old Burkhard worked on making it as a solo artist, while at the same time dreaming of a career as a Hollywood actor. His dreams of the big screen did not materialize—he only appeared once as an actor under Urs Egger's direction. However, when the canvas of the movie screen eluded him, it was replaced by the photo canvas, onto which he enlarged variants of the headshots that had been among the contents of his actor's "application box." It was these canvases that made headlines both at the Zolla/Lieberman Gallery in Chicago in 1977 and back in Europe at the Centre d'art contemporain in Geneva in 1980.

The beginning of the second phase in Burkhard's career thus had a lot to do with a shift in the mood of the times and with his exponential zoom up into the realms of the monumental. Szeemann had called him the photographer of the present and now his time had come: the time of the photographic sculptor, of the in situ artist, whose large-format photographs now occupied the spaces that had been called into question and iconoclastically emptied by the conceptual art generation fifteen years previously, at a time when Burkhard's own photography—and the medium itself— was still discreetly documentary in character. Now the medium profited from a renewed desire for the large still image that emerged in the wake of the brittle conceptual years of the 1970s. It is the phase in Burkhard's career that assured him of his place in the annals of photography, with the brilliant solo appearance in 1983 at the Kunsthalle in Basel and the minimalist show with Niele Toroni at the Musée Rath in Geneva in 1984.

The first review to give a convincing account of this intensive phase of his work can be found in the catalogue edited by Ulrick Loock, director of the Kunsthalle Bern, which was published in 1988. Besides Burkhard's photographic panels, the book gives equal weight to the installation photos laid across a double spread and completely filling the pages. It is this precise interplay between the work and its presentation as the dominant element in the space that clearly articulates the sculptural quality of this phase in Burkhard's oeuvre.

A photograph is a photograph is a photograph—yet as constituent parts of the architecture and of the space, Burkhard's photographic fragments turn into something else: "It is thus both appropriate and makes eminent sense to view and reflect on Balthasar Burkhard's photographs in the context of fine art, not because he has adopted the practices of painting, for example, but, on the contrary, because these pictures imply moments of self-reflection and self-criticism within the photographic medium that relate, under the specific conditions of the medium, to different, yet comparable practices in painting and sculpture, inasmuch as, while operating in the medium of reproduction, they produce images that are not mere reproductions."[3]

This is the final sentence in Loock's text, which sought to conclusively locate Burkhard's work for the exhibition in the Kunsthalle Bern within the realm of art. His photos no longer documented the work of other artists, as they had done twenty years earlier, but were now aesthetic objects in their own right. At the same time Loock identified an ambition that photography had pursued in different shapes and forms since the avant-garde movements of the 1920s: the desire to discover in the visible realms of reality the reflection of something else, to transcend the things that are represented. Alfred Stieglitz called this phenomenon "equivalents," while Minor White talked about photographing "things for what else they are." In Burkhard's case, this metamorphosis initially had to do with fragmentation and transposition onto another scale—the photographic fragment of the body attains the sculptural quality of the autonomous art object.

While he was in Japan in 1987, Burkhard integrated cultural signifiers and elements of the landscape in his reduced, heavily abstracted fragments. Gradually Burkhard exchanged the radicality and abstraction of his body pictures for symbols of the sensual, and the monumental force of his photographs of the body gave way to a pronounced classicism. The photographer had found his *maniera*, the palette of his gray tones, and his way of seeing. He no longer attempted to answer the question of what constitutes a good image merely in the studio but rather explored it in the most diverse corners of the world.

*Phase 3: The sensuality of the world and the photographic surface*

Among the documents that show "Balthasar Burkhard at work" are two pictures that could not be more different. In one photograph from 1988, taken when Burkhard was visiting Jacques Caumont in Normandy, we see him lying on the floor photographing a toad (fig. B). The other picture was taken a decade later in 1999 from a helicopter above Mexico City during the shoot that produced the photographic panels and video installation *La Ciudad* (fig. C). Here we see Burkhard adopting two totally different attitudes: in the one, he observes the world from a worm's-eye perspective, using the camera's macro

B

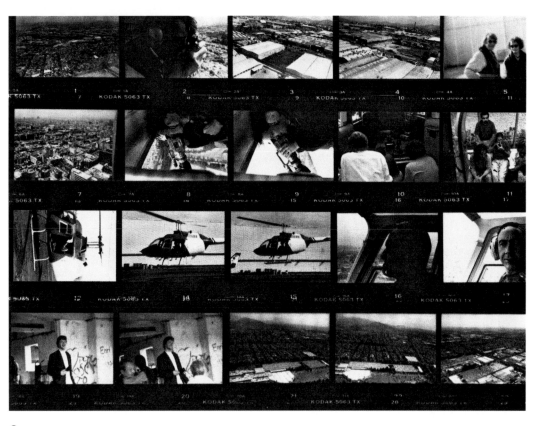

C

B    Jennifer Gough-Cooper, *Hommage à
Jean-Pierre Brisset à Warelwast,* 1988
(Balthasar Burkhard photographing
a toad; the ironic title is an allusion to
an author who played an important
role for Marcel Duchamp.)

C    Shooting *La Ciudad*, ca. 1999, strips
of negatives (whereabouts unknown)

setting; in the other he assumes a bird's-eye view of modernity, looking down from an airplane on a contemporary version of Babel.

In their totally contrasting styles, the setups that Burkhard chooses here, rather than being mutually exclusive, are more like a bracket around the last twenty years of his creative output. There is the extreme close-up, which the photographer developed in the latter part of the 1980s, and which evolved out of his earlier pictures of body fragments, such as the shot of his ear. The motifs include human body hair, parts of animal bodies, like the wings of a falcon or a swan, as well as a series of snail pictures that could have erotic associations. Burkhard's work gives explicit license to this reception—indeed he did a photographic remake of Courbet's painting *L'Origine du monde* (p. 229). His references to the French painter are a clear indication of the photographic understanding that he had at that time of the image and of the world. The large-format works *La Source* and *La Vague* are, in the first instance, photographic panels drawing on motifs by the realist painter (pp. 225, 227). Yet, set beside the close-up of a woman's genitalia —*L'Origine*—these pictures also become symbolic of an organic, sensual vision of the world.

Burkhard's annotations on Gustave Courbet are part of a classicism that found a fixed place in the photographer's later work. His preoccupation with the portrait is another expression of this. Using this strict (mostly frontal) form, he photographed friends, associates, and artists he was close to. The classical shot also leaves space for irony: witness the wonderfully sleepy look on Lawrence Weiner's face (p. 179), which passes the photograph off as a kind of anti-portrait. His animal pictures from the mid-1990s can also be regarded as portraits, even if they are less concerned with the individual than with the type. The descriptive shots he took with his subjects in profile were reminiscent of the traditional approach to depicting animals that had its roots in the nineteenth century.

The aerial views ultimately had their origins in the pictures Burkhard took of mountains in the early 1990s. The nod to his father, who took photographs as a pilot in the Swiss air force, should not be overlooked here—Burkhard senior was referenced in an issue of *Camera* magazine back in 1971 (p. 94). The view from above is a view of the modern age. When directed at megacities, it is also a view of the failure of this modernity. The shot reveals the sheer immensity of urban agglomerations and their structures. As an artist, Burkhard is not interested in analyzing urbanism; instead, the large panel image is a symbol, a look back at an old motif of the city, the great Moloch, the modern Babylon. The only way for Burkhard to realize his series on global

metropolises was on the back of a commission he carried out for the USM company, taking pictures in the major cities of the world for advertising campaigns. These aerial shots were complex photographic undertakings, which would not have been possible without Burkhard's studio in the 1990s and 2000s and his loyal and resourceful assistants Adrian Scheidegger and René Wochner.

Various catalogues that Burkhard published in the last ten years of his life illustrate how the photographer imagined his different series and work complexes, and the extent to which body fragments, architectural shots, close-ups, and the landscapes he perennially photographed were an expression of a common morphology of the visible world. Burkhard's work, however, does not pursue any encyclopedic interest—of the kind apparent in Albert Renger-Patzsch's *Die Welt ist schön*—but is based on the formal resonance between macroscopic and microscopic views of the world; it dissolves these forms of the visible in the high-quality black and white he uses, in an idiosyncratic range of gray tones that is emphatically different from the high-contrast images of the 1970s. We may see this too in the somewhat grainy surfaces of the photogravure that captivated Burkhard at the time. The soft contours of these pictures fit into a motivic world of landscapes and flower studies, in which transience, melancholy, and stillness provide the dominant undertone.

Comparing this retrospective, which is simply called *Balthasar Burkhard*, with the last major solo exhibitions mounted in Burkhard's lifetime makes it clear that the current show takes the whole of his oeuvre into account, adopting a perspective that also featured in the comprehensive catalogue *Éloge de l'ombre* published in 1997.[4] The focus of our exhibition is not on his late works, as in the most recent publications, but rather on his early years, about which little is known, and on Burkhard's role as a participant observer of Switzerland's bohemian milieu. Particular attention is paid to the interactions and different roles and relationships that are a feature of Burkhard's photographs at the time, to the extent that they perpetuate themselves in other artistic forms. When, for example, the apparently private portraits of Esther Altorfer not only figure as a window display for the Loeb department store but also serve as a model for the graphic illustrations by Markus Raetz. Or when the shot of clods of earth that forms part of the illuminated object *Live in Your Head* and pops up in the poster motif for *When Attitudes Become Form* (pp. 100/101) also makes an appearance in the photographic discourse in *Camera* magazine in 1971. It is the seemingly secondary, artistic quality of the photographs

that has a crucial influence in the pictorial dialogue, so much so that it is also evident in the work of artists like Franz Gertsch, especially in his 1970 painting *Kranenburg* (p. 45), which memorializes Burkhard the photographer and this form of photography.

The exhibition takes a particular interest in the interactions within Burkhard's work. His approach to detail, which he at once fragments and monumentalizes—as is the case, for example, in *The Arm*—suddenly reappears in his commissioned works, for instance in the visual language that underpins the three photographic ensembles of the Ricola buildings. (pp. 198–201) In this case, Burkhard's artistic approach in his independent works translates wonderfully well into practical projects—this raises the question of whether the use of canvas as a medium for presenting USM furniture in various large buildings that are emblems of modernist architecture (pp. 202–5) was not also something of a decorative betrayal of his own early work, even if it was a highly productive bit of treachery.

Certainly, this exhibition seeks to give more importance to the early Burkhard, or rather to the photographer's work as a whole, but at the same time it does not dissimulate his desire to leave photography behind. The fact that he nonetheless enlarged the headshots that he did together with Tom Kovachevich for his Hollywood applications, magnifying them into autonomous landscapes of his face, just under different circumstances, is another of Burkhard's brilliant gambits—a photographer who was at once a *Lebenskünstler* and, in the nicest possible sense, a trickster and impostor. He always aimed high and, just as importantly, he was also a sensitive artist who took both art and life to the limit and at times found himself looking into the abyss: a small photo showing a frontal view of a store on which we can read the words *Vinos y Licores "El Oro"* was placed on the last page of the Grenoble catalogue of 1999—an ironic reference to one of the ingredients of their artistic expeditions and journeys.

The works that were produced up until 2009 and after Szeemann's 1993 text, which I cited at the beginning of this essay, added another, third persona to Burkhard the photographer—one who reverted to a more classical approach, took an interest in historical techniques, and pursued a more representational path; one who also sold editions of his photographs via galleries and ran a regular factory operation. At the end of his text, Szeemann wrote about Burkhard's large-format canvas and banner showing the motif of his ear: "An ear is an ear is an ear is an ear—that was the avantgarde view—but an ear is also a face, a sculpture, a landscape, and a piece of concert house architecture—and herein lies the novelty."[5] To do justice to Balthasar Burkhard's creative oeuvre, we might paraphrase this observation: A photographer is a photographer is a photographer is a photographer, but a photographer is also a documentarist, a sculptor, an entrepreneur, and, ultimately, a *Lebenskünstler*.

*As head of the Photographic Department at the Museum Folkwang in Essen, Florian Ebner instigated the exhibition project on Balthasar Burkhard and the accompanying publication in collaboration with Vida Burkhard, the artist's widow. Since July 2017 he has been head of the Photography Department at the Centre Pompidou in Paris.*

I am indebted to Vida Burkhard for the trust she has shown in this project and for her willingness to share her view of things, as well as to Adrian Scheidegger and René Wochner for the lively portrait they painted of Balthasar Burkhard.

1   Harald Szeemann, "Balthasar Burkhard," in *G.A.S. – Grandiose Ambitieux Silencieux*, exh. cat., CAPC musée d'art contemporain de Bordeaux (Bordeaux, 1993), 15 [translated].
2   For more on this, see the essay in this book by Martin Gasser.
3   Ulrich Loock, "Photographische Bilder – monadische Torsi,"

in *Balthasar Burkhard*, exh. cat., Kunsthalle Bern / Kunsthalle St. Gallen / Musée municipale La Roche-sur-Yon (Bern, 1988), 46.
4   *Éloge de l'ombre*, exh. cat., Kunstmuseum Bern / Musée Rath (Geneva/Baden, 1997).
5   Szeemann, "Balthasar Burkhard" (see n. 1).

Photo credits: B: Archives AME; C: Published in: *Balthasar Burkhard*, exh. cat., Musée de Grenoble (Grenoble, 2000), 91.

# List of works reproduced

Unless otherwise stated, all the works reproduced here are from the Estate Balthasar Burkhard. Works by other people are attributed to their authors, and Burkhard's collaborations with other artists are listed as "with." The measurements are provided in the format height × width.

1  Jean-Christophe Ammann: Balthasar Burkhard, Venice Beach, USA, 1972, gelatin silver print on paper, 22 × 14.5 cm / 29.7 × 21 cm

2  Film sequence with Jean-Frédéric Schnyder and Balthasar Burkhard, Davos, 1970/71, gelatin silver print on paper, 15.5 × 23.3 cm / 21 × 27.9 cm

3  Photo booth portraits of Balthasar Burkhard and Walo von Fellenberg, Lyons, May 3, 1966, gelatin silver prints on paper, 29 × 19.5 cm

4  Self-portraits of Balthasar Burkhard with his father Markus Burkhard, ca. 1970, 3 gelatin silver prints on paper, each 8.5 × 10.5 cm / 29.7 × 21 cm

5  Pablo Stähli: Balthasar Burkhard, ca. 1970, in *Visualisierte Denkprozesse*, ed. Jean-Christophe Ammann, catalogue to the exhibition of the same title, Feb. 15 – Mar. 29, 1970, Kunstmuseum Luzern, Lucerne, 1970, p. 11

—  Pablo Stähli: Balthasar Burkhard, ca. 1970, in *La Suisse à la septième Biennale de Paris 1971*, ed. Jean-Christophe Ammann, catalogue for the Biennale de Paris, Lucerne, 1971, p. 18

6  Christina Gartner-Koberling: Balthasar Burkhard making the *Snakeskin Box*, Chicago, 1976, scanned from slide transparency

—  Christina Gartner-Koberling: Balthasar Burkhard in his first New York apartment, 1970s, scanned from negative

7  Unknown photographer: Balthasar Burkhard in Bern, April 28, 1972, photographed from a catalogue and printed on photographic paper, 20.4 × 28.3 cm

—  with Thomas Kovachevich: Balthasar Burkhard, 2 (self-)portraits from the *Snakeskin Box*, Chicago, 1976, slide transparency, 3.6 × 2.4 cm, and Polaroid, 10.7 × 8.8 cm

8  Jennifer Gough-Cooper: Balthasar Burkhard on the beach during the shoot for *La Source*, 1988, C-print, 10.2 × 12.2 cm, Archives AME (Académie de Muséologie Évocatoire, archives réunies par Jennifer Gough-Cooper et Jacques Caumont)

—  Jennifer Gough-Cooper: Balthasar Burkhard during the shoot for *La Vague*, Étretat, 1995, C-print, 10 × 15 cm, Archives AME

9  Adrian Scheidegger: Balthasar Burkhard in Bern, 1990s, scanned from negative

—  Unknown photographer: Balthasar Burkhard and Adrian Scheidegger during the shoot for *"Click!" Said the Camera* at the Circus Knie, August 1995, scanned from negative

—  Rafael Buess: Vida and Balthasar Burkhard, Chicago, 2004, scanned from Polaroid

15  *Schulreise*, 1952, 2 contact strips, gelatin silver prints, 12.7 × 30.5 cm and 11.5 × 30.5 cm

16/17  *Haus Distelzwang*, ca. 1963, 2 gelatin silver prints, each 42 × 34 cm

18/19  From the 7-part leporello *Das Klassenzimmer*, 1962, gelatin silver prints on card, 17 × 23.5 cm and 17 × 15 cm / 17 × 47 cm

20–23  From the 7-part series *Auf der Alp*, 1963, plate 5: gelatin silver print on card, 23 × 47.3 cm / 65 × 48 cm; plate 7: 3 gelatin silver prints on card, 27.3 × 53 cm, 25 × 20.7 cm, 20.7 × 18.5 cm / 65 × 53 cm; plate 4: 3 gelatin silver prints on card, each 21 × 32 cm / 65 × 53 cm; plate 1: gelatin silver print on card, 35.3 × 53 cm / 65 × 53 cm

24–27  From the 8-part series *London Bar*, 1964/65, gelatin silver print on card, 36 × 52 cm / 64.5 × 52 cm, 3 gelatin silver prints on card, 32 × 17 cm and 16.4 × 23.4 cm / 64.5 × 52 cm, gelatin silver print on card, 34.5 × 29 cm / 64.5 × 52 cm, gelatin silver print on card, 35.7 × 52 cm / 64.5 × 52 cm

28  Esther Altorfer, Bernese artist, ca. 1967, 2 gelatin silver prints on MDF, 69.8 × 30.5 cm and 58.7 × 59.7 cm

—  Esther Altorfer with feather boa, window installation in the Loeb department store, Bern, 1967, in Peter R. Knuchel, *30 Jahre Loeb Schaufenster*, Bern, 1995, p. 57

29  Esther Altorfer, ca. 1967, gelatin silver print on paper, 9.7 × 14.3 cm / 28.1 × 21 cm

30  Esther Altorfer, ca. 1967, gelatin silver print on MDF, 60 × 42 cm

31  Markus Raetz: Esther Altorfer, ca. 1967, graphic interpretation based on a photograph by Balthasar Burkhard, hand-colored photocopy, 28 × 21 cm

45 Franz Gertsch: *Kranenburg*, 1970, dispersion paint on unprimed half-linen, 200×300 cm, Aargauer Kunsthaus, Aarau

46 Martial Raysse, French Pavilion, Venice Biennale, 1966, gelatin silver print on paper, 16×24 cm / 21×29.7 cm

— Yayoi Kusama in her installation *Narcissus Garden*, Venice Biennale, 1966, gelatin silver print on paper, 16×24 cm / 21×29 cm

47 Roy Lichtenstein and journalists in front of Lichtenstein's *Temple of Apollo*, American Pavilion, Venice Biennale, 1966, gelatin silver print on paper, 16×23 cm / 21×29.7 cm

— Jean-Frédéric Schnyder, Françoise and Harald Szeemann, Venice, 1968, gelatin silver print on paper, 15.5×23 cm / 21×29.7 cm

48 Markus Raetz during recordings made for the exhibition *Wege und Experimente* in the Kunsthaus Zürich, 1968, gelatin silver print on paper, 16×25 cm / 21×29.7 cm

— Installing the exhibition *Jesús Raphael Soto* at the Kunsthalle Bern, May 1968; L–R: Françoise Chevalier, Jesús Raphael Soto, Harald Szeemann, Jean-Frédéric Schnyder, gelatin silver print on paper, 16×24 cm / 21×29.7 cm

49 Wrapping by Jeanne Claude and Christo, Kunsthalle Bern, 1968, gelatin silver print on paper, 19×28 cm / 21×29 cm

— Jean-Frédéric Schnyder during the shoot for the film *22 Schweizer Künstler*, dir. Peter von Gunten, February 1969, gelatin silver print on paper, 16×21 cm / 21×29 cm

50 Jakob Tuggener (with Burkhard's camera): Film matinée in Balthasar Burkhard's apartment, Junkerngasse in Bern, February 1972; L–R: Urs Stooss, Markus Raetz, Balthasar Burkhard, Harald Szeemann, Violette Moser, gelatin silver print on paper, 17×27 cm / 21×29 cm

— Film matinée in Balthasar Burkhard's apartment, Junkerngasse in Bern, February 1972; L–R: Trix Wetter, Jakob Tuggener and his wife, gelatin silver print on paper, 15×22 cm / 21×29 cm

51 Photo stop, Klösterlistutz, summer 1967; L–R: Balthasar Burkhard, Elisabeth Hoffmann, Markus and Monika Raetz, Esther Altorfer, [unidentified woman], Peter Saam, gelatin silver print on paper, 14×20 cm / 21×29 cm

— Harald Szeemann and James Lee Byars in front of the Café du Commerce, Bern, 1972, gelatin silver print on paper, 11.5×17 cm / 21×30 cm

52 In Franz Gertsch's studio, 1973/74, gelatin silver print on paper, 18×26 cm / 21×30 cm

— Franz Gertsch and Jean-Christophe Ammann, 1971, gelatin silver print on paper, 14.5×22 cm / 21×29.5 cm

53 Trip to Amsterdam, 1969; L–R: Urs Lüthi, Balthasar Burkhard, and Jean-Frédéric Schnyder, gelatin silver print on paper, 16×25 cm / 21×30 cm

54 Exhibition opening *When Attitudes Become Form*, Kunsthalle Bern, 1969, Alighiero Boetti, *Io che prendo il sole a Torino il 24–2–1969*, scanned from slide transparency

— Joseph Beuys during the exhibition opening, scanned from slide transparency

55 Installing the exhibition *When Attitudes Become Form*, Kunsthalle Bern, 1969, Richard Serra, *Splash Piece*, scanned from slide transparency

— Exhibition *When Attitudes Become Form*, Kunsthalle Bern, 1969, Richard Serra, *Close Pin Prop*, *Shovel Plate Prop*, *Sign Board Prop*, scanned from slide transparency

56 Peter Saam burning his army uniform in front of the Kunsthalle with the help of Michael Heizer (left), exhibition *When Attitudes Become Form*, Kunsthalle Bern, 1969, 2 scans from slide transparencies

57 Constructing Michael Heizer's installation *Cement Slot* behind the Kunsthalle Bern, exhibition *When Attitudes Become Form*, Kunsthalle Bern, 1969, scanned from slide transparency, The Harald Szeemann Archive and Library (for pp. 54–57)

58 Opening of the exhibition *Happening & Fluxus* at the Kölnischer Kunstverein, 1970, curated by Harald Szeemann, gelatin silver print, 14×21 cm

— Allan Kaprow in the installation *Yard* at the exhibition *Happening & Fluxus*, gelatin silver print, 14×21 cm

59 Charlotte Moorman, Nam June Paik, and Harald Szeemann (left) at the exhibition *Happening & Fluxus*, gelatin silver print, 14×21 cm

— Al Hansen and Harald Szeemann at the exhibition *Happening & Fluxus*, gelatin silver print on paper, 14.1×21.2 cm / 20.5×29 cm

60 In Andy Warhol's Factory, 33 Union Square, New York, 1972, gelatin silver print on paper, 14.8×21.8 cm / 20.5×29.1 cm

— Visitors in front of the painting *John* in the *Chuck Close* exhibition at the Museum of Contemporary Art Chicago, 1972, gelatin silver print on paper, 17.6×23 cm / 21×29.8 cm

61 Jean-Christophe Ammann and John DeAndrea at Denver airport, February 1972, gelatin silver print on paper, 22.2×14.6 cm / 29.8×21 cm
— Jean-Christophe Ammann, USA, 1972, gelatin silver print on paper, 15×10.5 cm / 29.5×21 cm
62 Sculptor Lucas Samaras, New York, 1972, gelatin silver print on paper, 14.5×21.5 cm / 20×28.5 cm
— Artist John C. Fernie in San Francisco, 1972, gelatin silver print on paper, 14.6×22 cm / 20.5×29.2 cm
63 John DeAndrea in his studio; behind him to his right the unfinished sculpture *Sitting Woman*, 1972, gelatin silver print on paper, 14.7×22.1 cm / 21×29.8 cm
64 Ed Ruscha with the poster he designed for documenta 5, USA, 1972, gelatin silver print on paper, 22.2×14.7 cm / 29.2×21 cm
65 Jean-Christophe Ammann in Andy Warhol's Factory, 33 Union Square, New York, 1972, gelatin silver print on paper, 14.9×21.9 cm / 20.5×29.1 cm
— Andy Warhol's Factory, 33 Union Square, New York, 1972, gelatin silver print on paper, 14.7×21.8 cm / 20.4×29.1 cm
68 James Lee Byars and Paul Cotton in front of the Fridericianum, documenta 5, Kassel, 1972, gelatin silver print on paper, 26×17 cm / 30×21 cm
69 Paul Thek at documenta 5, Kassel, 1972, photographed from Polaroid, gelatin silver print on paper, 12×15 cm / 29×20 cm
— Paul Thek with Clyden Malloch, Richard [surname unknown], Ann Wilson, and Wahundra in the installation *Ark, Pyramid*, Kassel, 1972, 3 gelatin silver prints on paper, each 8.6×11 cm / 29×19 cm
70 James Lee Byars on the pediment of the Fridericianum, documenta 5, Kassel, 1972, gelatin silver print on paper, 17×26 cm / 21×30 cm
71 Paul Thek, *Ark, Pyramid*, documenta 5, Kassel, 1972, magazine clipping on paper, 19×29 cm / 21×30 cm
— Paul Thek in the installation *Ark, Pyramid*, documenta 5, Kassel, 1972, gelatin silver print on paper, 17×25 cm / 21×30 cm
72 Marcel Broodthaers at the entrance to *Musée d'Art Moderne, Département des Aigles, Section d'Art Moderne*, documenta 5, Kassel, 1972, gelatin silver print on paper, 17×26 cm / 21×30 cm
— Marcel Broodthaers at the exhibition set-up, gelatin silver print on paper, 17×26 cm / 21×30 cm

73 Panamarenko in front of *Aeromodeller* (1969–71), documenta 5, Kassel, 1972, gelatin silver print on paper, 14.2×10 cm / 29.7×21.1 cm, 2 gelatin silver prints on paper, each 9.8×13.8 cm / 28.2×19 cm
74 Anatol Herzfeld during his performance *Arbeitszeit*, documenta 5, Kassel, 1972, gelatin silver print on paper, 17.3×25.6 cm / 20.9×29.9 cm
— Ben Vautier in the *Thinking Room*, documenta 5, Kassel, 1972, gelatin silver print on paper, 17×26 cm / 20.9×29.9 cm
75 Unknown photographer: Harald Szeemann, Balthasar Burkhard, Claes Oldenburg, and Kasper König (L–R) at documenta 5, Kassel, 1972, gelatin silver print on paper, 17×26 cm / 21×29.5 cm
— Harald Szeemann, the final day of documenta 5, Kassel, October 8, 1972, gelatin silver print on paper, 17.3×25.7 cm / 21×29.5 cm
76 Richard Serra in *Circuit*, documenta 5, Kassel, 1972, 2 gelatin silver prints on paper, each 12×16.5 cm / 20×29 cm
77 Joseph Beuys at documenta 5, Kassel, 1972, 2 gelatin silver prints on paper, each 17×26 cm / 21×30 cm
78 Mariette Althaus: Performance of *Prince of Peace* by Paul Cotton and Eugenia Butler as *Trans-Parent Teacher's Ink.*, documenta 5, Kassel, 1972, Paul Cotton, carried by Sigmar Polke, gelatin silver print on paper, 17.5×26 cm / 21×30 cm
— 2nd from right: Sigmar Polke; background right: Harald Szeemann, gelatin silver print on paper, 17×26 cm / 21×30 cm
79 Gilbert & George at documenta 5, Kassel, 1972, gelatin silver print on paper, 26×17 cm / 30×21 cm
— Naked Paul Cotton [with unidentified woman], documenta 5, Kassel, 1972, gelatin silver print on paper, 26×18 cm / 30×21 cm
80 Beatrice and Mario Merz in the Fridericianum; in the background, a work by the artist consisting of Fibonacci numbers, documenta 5, Kassel, 1972, gelatin silver print on paper, 18×26 cm / 21×29.5 cm
— Ben Vautier at the Hercules monument, documenta 5, Kassel, 1972, gelatin silver print on paper, 18×26 cm / 21×29.7 cm
81 David Medalla and John Dugger at Dugger's *People's Participation Pavilion*, documenta 5, Kassel, 1972, gelatin silver print on paper, 17.4×25.8 cm / 21×29.9 cm
— Ingeborg Lüscher, documenta 5, Kassel, 1972, gelatin silver print on paper, 17.3×25.6 cm / 21×29.8 cm

**Fotowerke Balthasar Burkhard**

**Philip Guston**

(1913–1980) Spätwerk

8.5. – 19.6.1983

# Kunsthalle Basel

Täglich durchgehend von 10–17 Uhr, Mittwochabend bei freiem Eintritt und Führung von 19.30–21.30 Uhr.

Pfingstsonntag geschlossen

KUNSTMUSEUM ☆ LUZERN

## VISUALISIERTE DENKPROZESSE

15. Februar bis 29. März 1970
Täglich von 10–12, 14–17, Donnerstag
von 20–22 Uhr Montag geschlossen

BALZ BURKHARD, GIANFREDO CAMESI
LUCIANO CASTELLI, H. HUBER
HERBERT LIENHARD, URS LÜTHI
DIETER MEIER, GERALD MINKOFF
MARKUS RAETZ, P. B. STÄHLI
ALDO WALKER

### SONDERAUSSTELLUNG

Überlegungen zum Städtebau
A. HENGGELER, A. LOSEGO, P.F. ALTHAUS

Überlegungen zum Systembau
TEAM 66

Gestaltung: Peter Adam / Siebdruck: Paul Fischer Luzern

82 Sarah and Piotr Kowalski in the installation *Mesure à prendre* by Piotr Kowalski, documenta 5, Kassel, 1972, gelatin silver print on paper, 17.5×25.8 cm / 21×29.9 cm

— Christian Boltanski and Annette Messager, documenta 5, Kassel, 1972, gelatin silver print on paper, 17.5×25.9 cm / 21×29.9 cm

83 Kasper König and Claes Oldenburg in front of the *Maus Museum*, documenta 5, Kassel, 1972, gelatin silver print on paper, 18×26 cm / 21×30 cm

— Claes Oldenburg in the *Maus Museum*, documenta 5, Kassel, 1972, gelatin silver print on paper, 16.8×25.6 cm / 21×29.9 cm

84 Staff passes for Violette Moser and Balthasar Burkhard, documenta 5, Kassel, 1972, each 7.5×14.8 cm / 29.9×21.9 cm

85 Unknown photographer: Balthasar Burkhard in Richard Serra's *Circuit*, documenta 5, Kassel, 1972, gelatin silver print on paper, 17.5×25.8 cm / 21×29.9 cm

— Unknown photographer: Balthasar Burkhard, James Lee Byars, Jennifer Gough-Cooper, [unidentified man], Paul Cotton, Marlis Grüterich, [unidentified woman], documenta 5, Kassel, 1972, gelatin silver print on paper, 17.3×25.6 cm / 21×29.9 cm

87 Michael Heizer, *Bern Depression*, which featured in *When Attitudes Become Form*, Bern, 1969, in the background Harald Szeemann, scanned from slide transparency

89 Daniel Buren, *Affichages sauvages*, in situ street installation in Bern, 1969, part of the exhibition *When Attitudes Become Form*, Kunsthalle Bern, scanned from slide transparency, The Harald Szeemann Archive (pp. 87, 89)

93 Cover of *Camera* 5, May 1971, 29×22.5 cm; on the cover: *Himmel* [Sky], 1969

94/95 Double-page spread, inside *Camera* 5, May 1971, pp. 4/5, 29×45 cm

96 *Himmel* [Sky], winter 1969, the original picture used for the cover of *Camera* 5, May 1971, gelatin silver print, 20×29.5 cm

97 Markus Burkhard: Glacier landing, 1928 (vintage), here 8.5×13.5 cm; later gelatin silver print, 10×15 cm

— Unknown photographer: Burkhard's father as an aircraft pilot, invitation to an exhibition of Balthasar Burkhard's work at the Galerie Blancpain Stepczynski Bouvier, November 25, 1999 – January 31, 2000, 15×21.5 cm

98/99 Landscape photographs, 1969 (published in the magazine *Camera* 5, May 1971), 3 gelatin silver prints, 30×24 cm, 24×30 cm, and 16.2×25.6 cm

100 Work depicted: *Live in Your Head* / *When Attitudes Become Form*, Edition LOEB, 1969, poster montage on wood with neon, poster, 128×91×18 cm, Galerie Arting, Bern, ca. 1969, gelatin silver print, 24×14 cm

— *Erde*, 1969, gelatin silver print, 52×72 cm

101 *When Attitudes Become Form*, Kunsthalle Bern, 1969, exhibition poster

102 with Markus Raetz: *Kassetten* [Cassettes], 1970, gelatin silver print, 25×19.8 cm

103 Letter from Balthasar Burkhard and Markus Raetz to Jean-Christophe Ammann during the project *Die ersten hundert Tage der Siebziger Jahre*, January 1, 1970, in *Visualisierte Denkprozese*, ed. Jean-Christophe Ammann, catalogue to the exhibition of the same title, Feb. 15 – Mar. 29, 1970, Kunstmuseum Luzern, 1970

104 Letter from Balthasar Burkhard to Jean-Christophe Ammann as proposed contribution to the exhibition catalogue *Visualisierte Denkprozese*, January 19, 1970, A4 paper

105 Photographs (incl. portraits of Rolf Iseli and Franz Eggenschwiler) as possible contribution to the catalogue *Visualisierte Denkprozese* (not published), January 19, 1970

106 Installation views: Balthasar Burkhard and Markus Raetz, *Das Papier* [Paper] (work, see p. 109) and *Bodenfolge*, from the exhibition *Visualisierte Denkprozese*, Kunstmuseum Luzern, 1970, 2 gelatin silver prints, 14.6×20 cm and 13.6×19 cm

107 with Markus Raetz: *Das Bett* [Bed], 1969/70, photo canvas, 200×260 cm, Elisabeth and Jacques Mennel, Zurich

108 with Markus Raetz: *Das Atelier* [Studio], 1969/70, photo canvas, 240×321 cm, Kunstmuseum Luzern and Musées d'art et d'histoire, Geneva

109 with Markus Raetz: *Das Papier* [Paper], 1969/70, photo canvas, 200×260 cm, Kunstmuseum Bern

110 Installation view *Der Vorhang* [Curtain], exhibition *Visualisierte Denkprozese*, Kunstmuseum Luzern, 1969/70, scanned from negative, work depicted: photo canvas, 246.5×186 cm

111 Markus and Monika Raetz, Gerry and Rolf Weber, Amsterdam, 1970, gelatin silver print on paper, 14.7×21.6 cm / 21×29.7 cm

Matisse, Giacometti –
Judd, Flavin, Andre, Long
Kunsthalle Bern
17.8.–23.9.1979

**Balthasar Burkhard** L'école de Nîmes Hôtel Rivet 10 Grand'rue
19 décembre 1990 / 31 janvier 1991 14h/18h

# Musée de La Roche sur Yon  15.4. - 17.6.89
# Balthasar Burkhard

288

202/203 *Chapelle du Centre de la Vieille Charité, Marseille, Architektur von Pierre Puget* and *Los Angeles, Architektur von Richard Neutra*, both 1998, 2 gelatin silver prints, each 102.5×80 cm, Einfache Gesellschaft Sammlung Paul Schärer, Muri

205 Barcelona Pavilion, designed by Ludwig Mies van der Rohe, 1995, scanned from original negative

207 Tokyo [28], 2000, gelatin silver print, 160×127 cm

208 Los Angeles [16], 1999, gelatin silver print, 125×158 cm

209 Mexico City [17], 1999, gelatin silver print, 110×132 cm

210 London [01], 1998, diptych, gelatin silver prints, each 239×117 cm

211 Mexico City [volcano], 1999, gelatin silver print, 136.7×267.7 cm, Fondation Cartier pour l'art contemporain, Paris

212 Mexico City [freeway], 1999, gelatin silver print, 136.7×276.7 cm, Fondation Cartier pour l'art contemporain, Paris

213 Los Angeles [7], 1999, gelatin silver print, 30.4×40.5 cm

214 Desert, 2000, gelatin silver print, 100×123 cm, Galerie Sfeir-Semler

215 Desert Namibia, 2000, gelatin silver print, 125×250 cm, Galerie Sfeir-Semler

216/217 From the cycle: *Wüsten in Namibia* [Deserts in Namibia], 2000/2001, 2 gelatin silver prints, 125×249 cm, E.ON Global Commodities SE, Essen

218 Los Angeles [12], 1999, gelatin silver print, 24×30.5 cm

219 Installation view *La Ciudad*, in the exhibition *Café des rêves*, Helmhaus Zürich, 2011; work depicted: *La Ciudad*, 1999, 3-channel film projection with sound, duration 12 m. 19 s.

223 Contact prints of shots of the beach near Étretat in Normandy, March 1995, gelatin silver print, marked with red crayon, 34×30.5 cm

224 Gustave Courbet, *La Vague*, 1870, oil on canvas, 45×59 cm, Museum Folkwang collection, Essen

225 *Welle (La Vague, Normandie 01)* [Wave], 1995, diptych, gelatin silver prints, each 248×125 cm, Museum Franz Gertsch, Burgdorf

227 *La Source* [Source], 1988, gelatin silver print, 199×141 cm

229 *L'Origine* [Origin], 1988, gelatin silver print, 28.8×36.7 cm

230 *Nuages 8* and *5* [Clouds], 1999, 2 gelatin silver prints, each 32.1×48.1 cm

231 *Nuages 10, 12, 13, 11,* and *7* [Clouds], 1999, 5 gelatin silver prints, each 32.1×48.1 cm

233 *Aile de faucon* [Falcon's Wing], 2002, photogravure, 90×72 cm

235 Jacques Caumont as Neptune, Bern, July 1972, C-print, 19×12.6 cm, Archives AME

— Jennifer Gough-Cooper: Documenting the creation of *La Source*, 1988, C-print, 10.2×12.2 cm, Archives AME

239 *Balthasar Burkhard*, Le Grand Hornu, 1996, exhibition poster, 44×59.5 cm

247 *Escargot* [Snail; 16], 1991, photogravure, 75×62 cm

248/249 Untitled, from *Escargot*, 1991, 2 gelatin silver prints, 56×23 cm and 30×34.5 cm, Fotomuseum Winterthur

250 Rio Negro, 2002, photogravure, 60×48 cm

251 Untitled [Japan], 1987, gelatin silver print, 113.5×79 cm, private collection, Switzerland

252/253 *Kumano*, 2005, 2 gelatin silver prints, 44.5×33 cm and 69×58 cm

254 *Klöntal*, 2002, triptych, 3 gelatin silver prints, each 224×102.6 cm, Fotomuseum Winterthur collection, donation from Volkart Stiftung

255 *Bernina*, 2004, triptych, 3 gelatin silver prints, each 240×100 cm, Galerie Tschudi, Zuoz

256/257 *Berge* [Mountains], 1992/93, in 2 parts, gelatin silver prints, each 135×152 cm, Galerie Sfeir-Semler

258/259 *Japan* [14] and [13], 1987, 2 gelatin silver prints, each 49.5×34 cm

260/261 From the portfolio *Alpen* [Alps], 1994, 2 photogravures, 78.5×62.5 cm and 62.5×78.5 cm, Fotostiftung Schweiz collection

262/263 *Schottland 2* [Scotland 2] and *Schottland 3* [Scotland 3], 2000, 2 gelatin silver prints, each 125×250 cm

264 Sweet peas [Flowers 07], 2009, C-print, 129×129 cm

265 Poppies [Flowers 03], 2009, C-print, 129×129 cm

266 Roses [Flowers 08], 2009, C-print, 129×129 cm

267 Japanese Irises [Flowers 01], 2009, C-print, 129×129 cm

269 *Fleuve blanc* [White River], 1999, photogravure, 69×75 cm

281 *Balthasar Burkhard–Philip Guston*, Kunsthalle Basel, 1983, exhibition poster, 128.2×90.5 cm

— *Visualisierte Denkprozesse*, Kunstmuseum Luzern, 1970, exhibition poster, 82×57.4 cm

282 *50 Jahre Kunsthalle Bern*, Kunsthalle Bern, 1968, exhibition poster, 128,1×90.8 cm

— *Atelier 5*, Architekturmuseum in Basel, 1986, exhibition poster, 128×90.5 cm

# Biography

1944 Born in Bern
1961–62 Apprenticeship with Ernst Christener
1963–64 Apprenticeship with Kurt Blum
1964 First Swiss scholarship for applied art
From 1965 Documents the Kunsthalle Bern for Harald Szeemann
From 1968 Photographer for the Atelier 5 team of architects in Bern
1969 First co-productions with Markus Raetz
1972 First trip to the USA with Jean-Christophe Ammann
— Swiss scholarship for applied art
1975–78 Lives in Chicago and works, among other things, as a visiting lecturer at the University of Illinois, Chicago
1978 Main character in Urs Egger's short film *Eiskalte Vögel* (*Icebound*)
1979 Lives in New York
1982 Returns to Switzerland
1983 Swiss art scholarship
1987 Artist-in-Residence, Tokyo
1989 Moves to Boisset-et-Gaujac, France
— Receives prize from the Banque hypothécaire du Canton de Genève
1990–92 Visiting lecturer at the École supérieure des beaux-arts de Nîmes
1995 Returns to Switzerland
— Photographer for USM Haller
2000 Travels to the Namibian desert
2002 Travels to Brazil
2004 Travels to Chicago
2005 Travels to Shanghai, Cuba, and Japan
2007 Travels to Seville
2010 Dies in Bern

# Exhibitions

Group Exhibitions (GE) and Solo Exhibitions (SE), Selection

1969 *Photo actuelle suisse*, Musée de la Majorie, Sion (GE)

1970 *Creative Photography*, Galerie Impact, Lausanne (GE)

— *Visualisierte Denkprozesse*, Kunstmuseum Luzern (GE, cat.)

1971 7ème Biennale des Jeunes de Paris, Parc Floral, Paris (GE)

— *The Swiss Avant Garde*, The New York Cultural Center, New York (GE, cat.)

1974 *Photographie in der Schweiz von 1940 bis heute*, Kunsthaus Zürich (GE, cat.)

1975 *Tatort Bern*, Kunstmuseum Bern (GE, cat.)

1977 *Photo Canvases '77*, Zolla/Lieberman Gallery, Chicago (SE)

1980 *Portraits*, Centre d'art contemporain, Geneva (SE)

1982 *Mise en Scène*, Kunsthalle Bern (GE)

— *Der Arm*, Galerie Toni Gerber, Bern (SE)

1983 *Ausstellung: Balthasar Burkhard* (also: *Fotowerke*), Kunsthalle Basel (SE, cat.)

1984 *Balthasar Burkhard – Niele Toroni*, Musée Rath, Geneva (SE, cat.)

— *Ideen – Prozess – Ergebnis, Reparatur und Rekonstruktion der Stadt*, International Building Exhibition, IBA Berlin (GE, cat.)

1985 Opening at the Volksbad, Kunstverein St. Gallen (GE)

1986 *Intervention*, installation together with Niele Toroni for Atelier 5, Staatliches Lehrseminar Thun (GE)

— *Mit erweitertem Auge: Berner Künstler und die Fotografie*, Kunstmuseum Bern (GE, cat.)

1987 *Blow-up: Zeitgeschichte*, Württembergischer Kunstverein, Stuttgart; Kunstverein Hamburg; Haus am Waldsee, Berlin; Frankfurter Kunstverein, Frankfurt am Main; Kunstmuseum Luzern; Rheinisches Landesmuseum Bonn (GE, cat.)

— *Swiss artists in residence in Japan*, Meguro Museum of Art, Tokyo (GE, cat.)

— *Drapeau d'artistes*, Musée d'Art et d'Histoire, Geneva (GE)

1988 *Balthasar Burkhard*, Kunsthalle Bern (SE, cat.)

— *Zeitlos – Kunst von heute im Hamburger Bahnhof*, Hamburger Bahnhof, Berlin (GE, cat.)

1989 *Balthasar Burkhard*, Kunsthalle St. Gallen (SE)

— *Miroir 89*, Musée de Carouge, Centre d'art contemporain, Geneva (GE)

1990 *Balthasar Burkhard*, Hôtel Rivet, École supérieure des beaux-arts de Nîmes (SE)

— *Wichtige Bilder: Fotografie in der Schweiz*, Museum für Gestaltung, Zurich (GE, cat.)

— *Schweizer Kunst, 1900–1990, aus Schweizer Museen und öffentlichen Sammlungen*, Kunsthaus Zug (GE, cat.)

1991 5th Architecture Biennale, Venice (GE, cat.)

— *Autrement dit: Les artistes utilisent la photographie*, Caserne de la planche, Fribourg, Switzerland (GE, cat.)

— *Le Consortium collectionne*, Chateau d'Oiron (GE, cat.)

1992 Expo '92, Swiss Pavilion, Seville

— *Tribute to …*, Kunsthalle St. Gallen (GE)

— *Pour un musée d'art moderne et contemporain*, Musée Rath, Geneva (GE, cat.)

1993 *Architektur von Herzog & de Meuron*, Museum Wiesbaden; Musée de Grenoble (GE, cat.)

— *Les 7 jours de l'art à l'Université*, Université de Bourgogne, Dijon

— *GAS – Grandiose ambitieux silencieux*, Centre d'arts plastiques contemporains, Bordeaux (GE, cat.)

1994 *Balthasar Burkhard*, Kunsthaus Zug (SE, cat.)

— *Zeitgenossen*, Kunstmuseum Bern (GE)

1995 *Balthasar Burkhard & Sophie Ristelhueber*, Le Consortium, Dijon (GE)

1996 *Im Kunstlicht: Photographie im 20. Jahrhundert*, Kunsthaus Zürich (GE, cat.)

— *Comme un Oiseau*, Fondation Cartier pour l'art contemporain, Paris (GE, cat.)

1997 *Éloge de l'Ombre*, Musée Rath, Geneva (SE, cat.)

— *Animaux et Animaux*, Museum zu Allerheiligen, Schaffhausen (GE, cat.)

— *Wege zur Kunst: Wege zur Sammlung*, Migros Museum collection in the Kunsthalle Bern (GE)

— *Balthasar Burkhard*, Galerie Liliane & Michel Durand-Dessert, Paris (SE)

— *Die Schwerkraft der Berge*, Aargauer Kunsthaus, Aarau; Kunsthalle Krems (SE, cat.)

1999 *Balthasar Burkhard*, Espace d'art contemporain (les halles), Porrentruy (SE)

— *Balthasar Burkhard*, Palais des Beaux-Arts de Charleroi (SE, cat.)

— *Balthasar Burkhard*, Musée de Grenoble (SE, cat.)

- *Missing link: Menschen-Bilder in der Fotografie*, Kunstmuseum Bern (GE)
- *Ciudad*, Musée d'art moderne et contemporain, Geneva (GE)
- *New Natural History*, National Museum of Photography, Bradford (GE, cat.)
- 1st Triennial of Photography Hamburg 1999, Galerie Sfeir-Semmler, Hamburg (GE)
- *Animal*, Musée Bourdelle, Paris (GE, cat.)
- *Le siècle du corps: Photographies 1900–2000*, Culturgest Lisbon, Musée de l'Elysée, Lausanne (GE, cat.)

2000 *Arquitectura sin sombra*, CCCB, Barcelona, Monasterio de la Cartuja de Santa María de las Cuevas, Seville (GE, cat.)
- *Desert & Transit*, Kunsthalle zu Kiel (GE, cat.)
- *Domiciles: De la maison à la ville, de la construction à la ruine*, Centre d'art contemporain de l'Yonne, Perrigny (GE, cat.)
- *Le Désert*, Fondation Cartier pour l'art contemporain, Paris (GE, cat.)
- *Dédales: Polyphonie du labyrinth*, Maison de la culture d'Amiens (GE, cat.)
- *Luftbilder Landbilder*, Kunsthaus Langenthal (GE)

2001 *Le siècle du corps*, Musée de l'Elysée, Lausanne (GE, cat.)
- *Trade: Waren, Wege und Werte im Welthandel heute*, Fotomuseum Winterthur (GE, cat.)
- *Balthasar Burkhard – Voyage*, Kunstmuseum Thun (SE, cat.)
- *Sense of space*, 8th Noorderlicht Photo Festival, Noorderlicht, Groningen

2002 *L'herbier et le nuage*, Musée des arts contemporains, Le Grand Hornu (GE, cat.)
- *Wallflower – Grosse Fotografien*, Kunsthaus Zürich (GE, cat.)
- *L'immagine ritrovata*, Museo Cantonale d'Arte, Lugano (GE, cat.)
- *Rio Negro*, Galerie Tschudi, Zuoz

2003 *Rio Negro*, Gallery of Contemporary Art and Architecture – House of Arts of the City of České Budějovice (SE)
- *Standpunkt 1: Balthasar Burkhard*, Kirchner Museum, Davos (GE, cat.)
- *Arte scienza mito: Da Dürer a Warhol*, Museo di arte moderna e contemporanea di Trento e Roverto, Roverto (GE, cat.)

2004 *Héliogravures 1991–2003 et autres travaux photographiques*, Musée d'art moderne et contemporain, Geneva (SE)
- *Omnia*, Kunstmuseum Bern (SE, cat.)
- *Vagues II – Hommages et digressions*, Musée Malraux, Le Havre (GE, cat.)
- *Paysage en poésie*, Col de la Croix, Leysin (GE, cat.)

- *Animaux: Von Tieren und Menschen*, Seedamm Kulturzentrum, Pfäffikon (GE, cat.)

2005 *Atelier 5*, Kunsthalle Bern (GE)
- *Wolkenbilder: Die Erfindung des Himmels*, Aargauer Kunsthaus, Aarau (GE, cat.)
- *Vom General zum Glamour Girl – Ein Portrait der Schweiz*, Schweizerische Landesbibliothek, Bern (GE, cat.)
- *Nützlich, süß und museal: Das fotografierte Tier*, Museum Folkwang, Essen (GE, cat.)

2006 *Two Mountains – Naoya Hatakeyama and Balthasar Burkhard*, Tokyo Art Museum, Tokyo (GE, cat.)
- *Spectacular City: Photographing the Future*, Netherlands Architecture Institute, Rotterdam (GE, cat.)
- *In den Alpen*, Kunsthaus Zürich (GE, cat.)
- *Six Feet Under: Autopsie unseres Umgangs mit Toten*, Kunstmuseum Bern (GE, cat.)

2007 *Songlines: Balthasar Burkhard*, Museum Franz Gertsch, Burgdorf (SE, cat.)
- *Gustave Courbet*, Galeries nationales du Grand Palais, Paris (GE, cat.)
- *Affinità e complementi: Opere dai musei svizzeri in dialogo con la collezione del Museo Cantonale d'Arte Lugano*, Museo Cantonale d'Arte, Lugano (GE, cat.)
- *Tierisch: Wenn der Mensch auf "den Hund" kommt*, Haus für Kunst Uri, Altdorf (GE)

2008 *Reconnaissances 1969–2007*, Musée d'art moderne et contemporain, Strasbourg, Musée Jenish, Vevey (SE, cat.)
- *Comme des bêtes*, Musée cantonal des Beaux-Arts, Lausanne (GE, cat.)
- *Diana und Aktaion: Der verbotene Blick auf die Nacktheit*, Museum Kunst Palast, Düsseldorf (GE, cat.)
- *Notation: Kalkül und Form in den Künsten*, Akademie der Künste, Berlin; ZKM, Karlsruhe (GE, cat.)
- *REAL*, Städel Museum, Frankfurt am Main (GE)

2009 *Water in Photography*, Huis Marseille, Museum voor Fotografie, Amsterdam (GE)

2010 *Scent of Desire*, Museum im Bellpark, Kriens (SE, cat.)

2011 *Balthasar Burkhard: Voici des fruits, des fleurs, des feuilles et des branches*, Musée des Arts Contemporains de la Communauté française de Belgique, Le Grand Hornu (SE, cat.)

2012 *Das Atelier: Orte der Produktion*, Kunstmuseum Luzern (GE)

# Colophon

This book is published in conjunction with the exhibition *Balthasar Burkhard*.

Museum Folkwang
October 14, 2017 – January 14, 2018

Fotomuseum Winterthur/Fotostiftung Schweiz
February 10 – May 21, 2018

Museo d'arte della Svizzera italiana, Lugano
June 9 – September 2, 2018

*Editors*
Tobia Bezzola, Museum Folkwang
Peter Pfrunder, Fotostiftung Schweiz
Thomas Seelig, Fotomuseum Winterthur
Marco Franciolli, Museo d'arte della
Sivzzera italiana

*Catalogue*

Concept: Florian Ebner, Martin Gasser,
Thomas Seelig
Research, coordination, editing: Florian Ebner,
Martin Gasser, Svenja Paulsen,
Thomas Seelig, Stefanie Unternährer,
Katharina Zimmermann, Petra Steinhardt
Texts: Laurent Busine, Jacques Caumont /
Françoise Le Penven, Florian Ebner,
Martin Gasser, Ralph Gentner,
Jennifer Gough-Cooper, Tom Holert,
Markus Jakob, Thomas Kovachevich,
Adrian Scheidegger, Thomas Seelig,
Abigail Solomon-Godeau, Hendel Teicher,
Stefanie Unternährer
Manuscript editing (German): Tanja Milewsky
Manuscript editing (English): Svenja Paulsen
Translations, proofreading: Simon Cowper
Copyediting: Greg Bond, Mike Hembury
Design: Helmut Völter
Scans and reproductions: Tanja Lamers,
Jens Nober (Museum Folkwang, Essen);
Katharina Rippstein, Nicole Somogyi,
Lukas Stadelmann (Fotostiftung Schweiz);
Julius Barghop, Essen
Image editing: Andreas Langfeld;
Marlon Quattelbaum/Turbo Gestaltung;
Antje Kharchi, Michael Kleine, Judith Lange,
Reiner Motz/Steidl image department
Production: Bernard Fischer, Gerhard Steidl
Overall production and printing: Steidl,
Göttingen

*Exhibition*

*Museum Folkwang, Essen*
Director (to November 30, 2017): Tobia Bezzola
Executive director (from December 1, 2017):
Hans-Jürgen Lechtreck
Head of Photographic Department (to June 30,
2017) and exhibition curator: Florian Ebner
Curatorial assistants: Stefanie Unternährer,
Katharina Zimmermann (on a scholarship
from the Alfried Krupp von Bohlen und
Halbach-Stiftung), Svenja Paulsen
Conservation: Christiane Schneider,
Frederike Breder, Silke Zeich
Coordination, organization:
Hans-Jürgen Lechtreck, Petra Steinhardt,
Christina Buschmann
Organizational support (from November 1,
2017): Franziska Kunze (on a scholarship
from the Alfried Krupp von Bohlen und
Halbach-Stiftung)
Registrar: Susanne Brüning
Exhibition design: Tricatel. Kerkenrath & Grädtke
Communications and marketing: Anka Grosser
(head), Anna Littmann, Asja Kaspers

*Fotomuseum Winterthur*
Director: Thomas Seelig (to December 31, 2017),
Nadine Wietlisbach (from January 1, 2018)
Research curator: Doris Gassert
Digital curator: Marco de Mutiis
Exhibition organization: Therese Seeholzer
Press office and communications: Melinda Por
Museum technical staff: Oliver Gubser,
Benedikt Redmann
Art handling and registrars: Andrea Hadem,
Herbert Weber
Alfried Krupp von Bohlen und Halbach-Stiftung
scholarship: Erec Gellautz
Interns: Anna Büschges, Anna Konstantinova

*Fotostiftung Schweiz*
Director: Peter Pfrunder
Conservation / Curator: Martin Gasser
Research assistant: Sabine Münzenmaier
Communications and media: Sascha Renner
Intern: Helen Rüegger
Community service intern: Marco Ravicini
Library: Céline Brunko, Matthias Gabi (head)

*Museo d'arte della Svizzera italiana, Lugano*
Director: Marco Franciolli (to December 31,
2017), Tobia Bezzola (from January 1, 2018)
Development and coordination: Guido Comis,
Diego Stephani
In collaboration with: Cristina Sonderegger
Registrars: Maria Pasini, Ludovica Introini
Conservation and restauration:
Sara De Bernardis, Giorgia Fasola, Giulia Presti
Education: Benedetta Giorgi Pompilio,

Isabella Lenzo Massei, Stefanie Fink,
Alice Nicotra, Valentina Pusterla
Secretariat: Valentina Bernasconi
Technical staff and exhibition setup:
Pascal Campana, Graziano Gianocca,
Alessandro Lucchini, Salvatore Oliverio,
Ivan Spoti, Alessio Trisconi
Communications and marketing: Gregory Birth,
Alessio Manzan, Alessio Vairetti, Alice Croci
Torti, Anna Poletti, Anna Domenigoni,
Tosca Codiroli, Matteo Sapienza
Reception: Danilo Pellegrini, Manuela Marrone,
Marina Piattini, Christian Riva

*Cover image*
Balthasar Burkhard / Markus Raetz: *Das Bett*,
1969/70

Museum Folkwang
Museumsplatz 1, D-45128 Essen
www.museum-folkwang.de

Fotomuseum Winterthur
Grüzenstrasse 44+45, CH-8400 Winterthur
www.fotomuseum.ch

Fotostiftung Schweiz
Grüzenstrasse 45, CH-8400 Winterthur
www.fotostiftung.ch

Museo d'arte della Svizzera italiana, Lugano
LAC Lugano Arte e Cultura
Piazza Bernardino Luini 6, CH-6901 Lugano
www.masilugano.ch

Steidl
Düstere Str. 4, D-37073 Göttingen
mail@steidl.de / www.steidl.de

ISBN 978–3–95829–342–7
Printed in Germany by Steidl

Museum Folkwang

**Foto_museum**

**Fotostiftung Schweiz**

**MASI**Lugano

The exhibition is sponsored by:

schweizer kulturstiftung

The exhibition in the Museum Folkwang
is supported by:

Main partner of Fotomuseum and
Fotostiftung Schweiz:

VONTOBEL-STIFTUNG

Further support by Swiss Mobiliar
Cooperative Company, Avina Stiftung,
Jean Genoud, Walter Haefner Stiftung,
Dr. Werner Greminger-Stiftung,
Burgergemeinde Bern, and ArsRhenia Stiftung.

Main partner MASI Lugano:

*Image rights*
Estate Balthasar Burkhard; Rafael Buess (p. 9); Thomas Burla (p. 142); FBM Studio Zürich (p. 219); Christina Gartner-Koberling (p. 6); Jennifer Gough-Cooper (pp. 8, 235, 275); Jürg Hafen (pp. 134/35); Thomas Kovachevich (p. 7; with Balthasar Burkhard: pp. 122, 124, 129); Ludwig Kuffer (p. 221); Museum Folkwang (p. 224); Violette Pini (p. 296); Adrian Scheidegger (p. 9); Pablo Stähli (p. 5); T & A Weber AG, Thun (p. 28)
For images from the exhibition *When Attitudes Become Form* (pp. 54–57, 87, 89): © J. Paul Getty Trust, Getty Research Institute, Los Angeles (2011.M.30)
For reproductions of works by: Kurt Blum (p. 34): © Fotostiftung Schweiz / VG Bild-Kunst, Bonn 2017; Marcel Broodthaers (p. 72): © The Estate of Marcel Broodthaers / VG Bild-Kunst, Bonn 2017; Daniel Buren (p. 89): © DB / VG Bild-Kunst, Bonn 2017; John DeAndrea (p. 63): © John DeAndrea; Franz Gertsch (p. 45): © Franz Gertsch, Rüschegg, photo: Jörg Müller; Yayoi Kusama (p. 46): © YAYOI KUSAMA; Roy Lichtenstein (p. 47): © Estate of Roy Lichtenstein / VG BildKunst, Bonn 2017; Paul Thek (pp. 69, 71): © The Estate of George Paul Thek, courtesy Alexander and Bonin, New York; Joseph Beuys (p. 54), Alighiero Boetti (p. 54), John Dugger (p. 81), Piotr Kowalski (p. 82), Mario Merz (p. 80), Markus Raetz (pp. 102, 106–10), Martial Raysse (p. 46), Richard Serra (pp. 55, 76), Benjamin Vautier (p. 74): © VG Bild-Kunst, Bonn 2017
Every effort has been made to ascertain and contact all the copyright holders, and we apologize for any errors or omissions in the above list. We ask any copyright holders that we were unable to locate to contact the publisher.

*Acknowledgments*
To Balthasar Burkhard's close associates and companions: Vida Burkhard; Adrian Scheidegger; René Wochner; Markus Raetz; Christina Gartner-Koberling; Ralph Gentner; Hans-Peter Litscher; Thomas and Elenor Kovachevich; Jacques Caumont; Jennifer Gough-Cooper; Hendel Teicher; Violette Pini; Ingeborg Lüscher
To all those who have loaned works: Estate Balthasar Burkhard; Aargauer Kunsthaus, Aarau; Académie de Muséologie Évocatoire, archives réunies par Jennifer Gough-Cooper et Jacques Caumont; Archive Jacques Caumont, Münchenstein; Atelier 5, Bern; Ludovic Chauwin, MAMCS, Strasbourg; Le Consortium, Dijon; E.ON SE, Essen; Fondation Cartier pour l'art contemporain, Paris; Fotomuseum Winterthur; Fotostiftung Schweiz, Winterthur; Galerie 94, Baden; Galerie Arting, Bern; Galerie Beaubourg, Paris; Galerie Tschudi, Zuoz; Christina Gartner-Koberling, Berlin; Kunstmuseum Bern; Kunstmuseum Luzern; MAMCO, Musée d'art moderne et contemporain, Geneva, and Kunstsammlung des Bundes; Elisabeth and Jacques Mennel, Zurich; Musée de Grenoble; Musées d'art et d'histoire, Geneva; Museum Franz Gertsch, Burgdorf; Sammlung Ricola, Laufen; Luc Robert, Athenaz; Einfache Gesellschaft Sammlung Paul Schärer, Muri; Sfeir-Semler Gallery, Hamburg; Walder Wyss Ltd., Bern; Trix Wetter, Zurich, and to all those who prefer to remain anonymous
For research, suggestions, and support: Stuart Alexander, New York; Regula Altherr Copini, Winsum; André Bernard, Guggenheim Foundation, New York; Peter J. Betts, Hinterkappelen; Peter Breil, Atelier 5, Bern; Nicolas Brulhart, Kunsthalle Bern; Lea Brun, Emmanuel Hoffmann-Stiftung, Schaulager, Basel; Linda Conze, Berlin; Patricia Crivelli, Bundesamt für Kultur, Bern; Urs Dickerhof, Biel; Claudius Dorner, Essen; Marion Fey, Stadtarchiv Köln; Thomas Neuhaus and Georg Niehusmann, Folkwang Universität der Künste, Essen; Susanne Friedli, Bern; Ursula Gasser Crettenand, Musées cantonaux du Valais; Jean Genoud, Epesses; Isotta Poggi and Tracey Schuster, The Getty Research Institute, Los Angeles; Bernhard Giger, Kornhausforum Bern; Erika Häberli Blum, Bern; Nadine Hahn, Estate Jean-Christophe Ammann, Frankfurt; Sylvie Henguely, Weinfelden; Herzog & de Meuron, Basel, Stefanie Manthey and Esther Zumsteg; Katrin Hüpeden, Cologne; Roger Humbert, Basel; Alice Jaeckel, Schweizerisches Institut für Kunstwissenschaft, Zurich; Markus Jakob, Barcelona; Martin Jürgens, Rijksmuseum, Amsterdam; Kasper König, Berlin; Thilo Koenig, Rome; Ludwig Kuffer, Cologne; Roman Kurzmeyer, Sammlung Ricola, Laufen; Sascha Laue, Baden; Loeb AG, Bern, Sara Reimke, Brigitte Richter and Vildana Suljkovic; Mario Lüscher, Zurich; Fritz E. Maeder, Bolligen; Marco Massafra, Schauspielhaus Bochum; Andreas Münch, Bundesamt für Kultur, Bern; Museum Wiesbaden, Roman Zieglgänsberger and Martina Frankenbach; Prof. Marcel Odenbach, Cologne; Anna-Maria Papadopoulos-Schori, Zurich; Peter Pfrunder, Zug; Matthias Pühl, Vitra Design Museum, Weil am Rhein; Hugo Ramseyer, Oberhofen; Katharina Rippstein, Fotostiftung Schweiz, Winterthur; Simon Roth, Musées cantonaux du Valais; Jacques D. Rouiller, La Sarraz; Helen Sager, Rombach; Sören Schmeling, Kunsthalle Basel; Rolf Schroeter, Zurich; Heinz Stahlhut, Kunstmuseum Luzern; Eveline Suter, Kunstmuseum Luzern; Beatrice Thönen, Galerie Kornfeld, Bern; Maria E. Tuggener, Uster; Videocompany, Zofingen, Aufdi Aufdermauer, Dimitri Fischer; Clara von Waldthausen, Kayleigh van der Gulik, Magdalena Pilko, University of Amsterdam; Marianne Walter, Kölnischer Kunstverein